FROM STATEN ISLAND TO TIMES SQUARE
AND ALL THE SLEAZE BETWEEN

By Nick Cato

HEADPRESS

A HEADPRESS BOOK
First published by Headpress in 2019
headoffice@headpress.com

SUBURBAN GRINDHOUSE
From Staten Island to Times Square and all the Sleaze Between

Text copyright © NICK CATO
This volume copyright © HEADPRESS 2019
Cover design : MARK CRITCHELL : mark.critchell@googlemail.com
Book layout & design : Ganymede Foley & Mark Critchell

10 9 8 7 6 5 4 3 2 1

A CIP catalogue record for this book is
available from the British Library

ISBN 978-1-909394-66-7 (paperback)
ISBN 978-1-909394-67-4 (ebook)
NO-ISBN (hardback)

HEADPRESS. POP AND UNPOP CULTURE.

Exclusive NO-ISBN special edition hardbacks and other
items of interest are available at HEADPRESS.COM

Table of Contents

iii

Table of Contents

Table of Contents

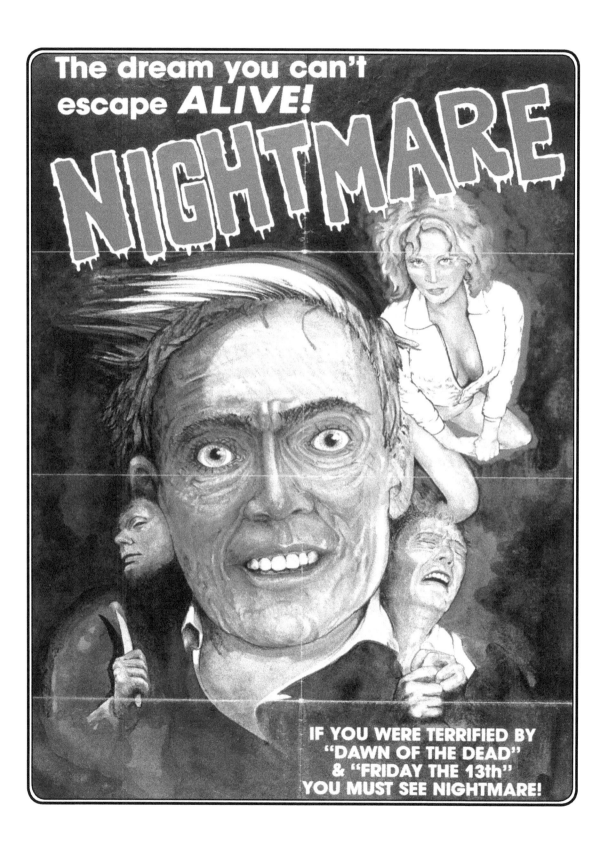

Introduction

I t amazes me when I realize how much SHEER VOLUME of movies there are out there. I'm one of those people who got their film history education by watching tons of movies on TV, and then, in the 1980s, during the VHS boom, renting as many movies as humanly possible, taking in the good and the awful, the classics and the abominations. Doing what I could to become a sort of walking encyclopedia of cinema.

And then I talk to someone like Nick Cato, or our mutual friend, William Carl, and they'll mention movies that either I still haven't had a chance to see yet, or (even more baffling) movies I haven't even heard of, and then I realize I am not even close to knowing everything that's out there. And I'm mainly talking about movies from the 1970s and 80s, and a big chunk before then. In this day of lots of movies going straight to DVD and OnDemand, I am so far behind on current output, I won't even try to catch up.

But Nick is one of those guys, like me, who devoured everything he could find about movies, with a big emphasis on horror movies and genre films (science fiction, action, and the downright surreal). He knows his stuff, and one of the things I learned when he started writing his column "Suburban Grindhouse Memories" is that, despite the video boom of the 80s, he saw a ton of these flicks on an actual theater screen, in places like the (now defunct) Fox Twin Cinema or the (now defunct) Amboy Twin Cinema on Staten Island. I always look forward to the name of the theater he saw one of these gems in, and it's almost always "now defunct," just like all those grindhouse movie theaters that used to be a part of Times Square. All gone now.

Because Nick knows his stuff, and because I knew he'd dig up things I might be interested in checking out, I was more than happy to extend an invitation to him to write this column. One of the points of the (now defunct) Cinema Knife Fight website was giving movie nuts like Nick an outlet for their movie memories. The actual "Cinema Knife Fight" column itself was me and Michael Arruda reviewing new movies, mostly horror and sci-fi stuff when it was

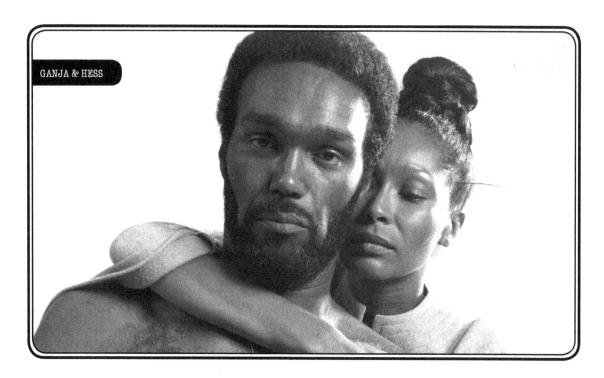

GANJA & HESS

available. But when we grew that column into a whole website over 10 years ago, we knew we couldn't write something new every day, which is why our staff was so important to us. They kept the site fueled with new content, and they turned in some really entertaining prose in the process.

Nick's column even introduced me to a few movies I've come to consider favorites, like Don Dohler's FIEND (1980), a movie Nick didn't care for, but which I love, because it's so damn goofy. And GANJA AND HESS (1973), a serious milestone in so-called "Blaxploitation" cinema, featuring Duane Jones (yes, the guy from Romero's original NIGHT OF THE LIVING DEAD) in an unusual take on the vampire legend.

The column itself began in early 2010 with Nick's recollection of going to see a Brazilian softcore sex film called GISELLE (1980) which opens with "horse trainers watching two horses humping (full horse penetration is shown!)" He was a freshman in high school at the time, on a double-date, expecting to see just another lame teen sex comedy. Boy, did he get a surprise! From that first column, I knew this was going to be something different.

In these pages, you'll also see him champion the 1981 horror flick NIGHTMARE

(also known as NIGHTMARES IN A DAMAGED BRAIN), a movie he's raved about for almost as long as I've known him. At first, it seems like any other slasher flick from that time period, and then, *whoa that ending*! In fact, over the years, I've come to associate the movie so much with him, that even the mention of it reminds me of Nick (which is probably how some people think of me when someone mentions BLOOD SUCKING FREAKS, 1976).

I was happy to hear that Nick was putting out a book of his collected Suburban Grindhouse Memories. In these pages you'll meet lots of knife-wielding psychos, women-in-prison, strange aliens, fiends, sexy kung fu mamas, witches, flamethrower wielding vigilantes, and more.

Nick grew up on Staten Island—which we jokingly refer to as MILLIGAN'S ISLAND because trash-film director (and Times Square grindhouse icon) Andy Milligan used to make movies in a big house there. He'd film everything from horror movies to weird period pieces, all in the same place. I remember we tracked it down and it's now a crack house. But growing up on the Island means that, for some reason, Nick was able to see more horror and exploitation flicks on the big screen than I ever did, and he was close enough to New York City to sometimes venture into Times Square during its heyday as the Mecca of grindhouse cinema, as well.

So get some popcorn with lots of butter and a Big Gulp, and let's go back in time to the (now defunct) Amboy Twin Cinema, and watch Nick's Suburban Grindhouse Memories unravel.

L.L. Soares
July 2019

A Word from the Author...

he term GRINDHOUSE should bring two things to mind: *1*) Sleazy theaters located in shady parts of the city where films were shown so often they eventually *grinded* down to scratchy, worn looking prints, and *2*) Cheap exploitation films (or B-movies as they're commonly called). Grindhouses existed almost everywhere and weren't exclusive to big cities. Even in respectful small towns you could usually find at least one theater which happened to show one film that wasn't part of the mainstream, and while they might not have shown the film enough to grind it to dust, they still featured fare seldom seen outside of big cities. And in the late 70s/early 80s here in New York's smallest, most conservative borough (Staten Island), we actually had a few genuine grindhouses.

In this (hopefully) entertaining book, I'm going to take you back to a time when you could see unusual, uncut films in a theater on any given day; a time when you could see something like ZOMBIE ISLAND MASSACRE in theater No. 2, while AMADEUS played next door in theater No. 1. And while suburban grindhouses might not have been as scary an experience as urban grindhouses (and I've been to both countless times), most of the films I saw at these theaters usually featured at least one or two delinquents causing problems in the audience, as well as outside the theater, before or after the film (and these experiences often helped shape your opinion of the film itself). "Audience participation" was not limited to THE ROCKY HORROR PICTURE SHOW (just ask anyone who saw PINK FLAMINGOS or THE HARDER

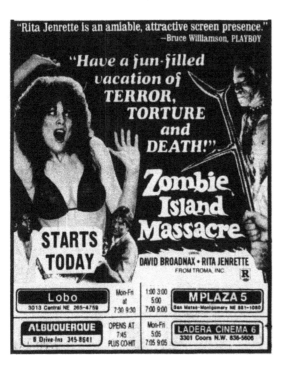

THEY COME at midnight screenings several years before ROCKY HORROR had even been released).

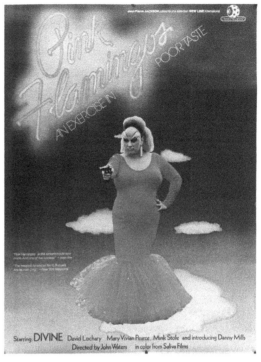

While I'm a big fan of DVDs and Blu-rays (especially with all the nifty extras), there's just NO substitute for seeing a good, trashy B-movie in a theater … and the trashier the venue, the better (although after you read my interview with director Frank Henenlotter, you might question that).

Maybe you were there at the time and had similar experiences as the ones shared in this book. Or maybe you're a younger reader who hasn't been to a film outside of a multiplex and can't understand what the big deal is about theaters of the past. Whatever your case, chances are you wouldn't be reading this if you weren't a little bit interested in genre films. It was my goal in writing this column for the Cinema Knife Fight website to give a little taste of what it was like to see these types of films in a setting that actually enhanced the viewing experience (sometimes for better, sometimes for worse, but mostly for the better in my case). Films and film-going were just more fun before the advent of cable TV and the home video revolution (let alone Netflix and other streaming services). If you can't see that by the time you get to the end of this book, perhaps *The Man* has truly infected your brain…

Please be aware, as you read through my hectic memories, that most of these reviews were written between 2010–2015, so mentions of certain films being available only on DVD may have changed when they were upgraded to Blu-ray a year or two after these columns first appeared.

Welcome to my Suburban Grindhouse Memories…

A Guide to Staten Island's Movie Theatres

FROM THE LATE 70s TO THE LATE 80s

In my Suburban Grindhouse Memories column, I often mention the name of the theater where I saw the film in focus. As of this writing, Staten Island has three movie theaters, and I dread when I have to go to any one of them (although an Alamo Drafthouse is currently under construction). All are multiplexes (one with 16 screens) and the smallest stands on the grounds of a former supermarket. But during my main Island theater-going days (1975-1990), there were many more theaters to choose from, and even the twin theaters had more personality than the newer multi-screened monstrosities.

Amboy Twin Two small theaters, one of which often featured fare such as ZOMBIE ISLAND MASSACRE, PREPPIES (both 1984), TENTACLES, STARSHIP INVASIONS (both 1977), and for some reason in 1981 featured a re-release of the original TEXAS CHAIN SAW MASSACRE (1974). If you had cash, they let you in. This was the best place for underage patrons to be admitted to R-rated films.

Fox Twin Two theaters a bit larger than the Amboy Twin, this place featured midnight movies (such as THE ROCKY HORROR PICTURE SHOW (1975), some porno titles, and "unedited" Little Rascals bloopers). Among some of the classics I saw there were GISELLE, A TASTE OF SIN, NIGHTMARE (all 1981), MOTHER'S DAY (1980), and PSYCHO 2 (1983) that featured a line so long we were practically three blocks away from the place. I also saw a terribly edited version of Lucio Fulci's 1981 classic THE BEYOND (titled SEVEN DOORS OF DEATH) when finally released in the U.S. in 1983. It was usually easy to get into R rated films if you were underage.

Hylan Twin Two large theaters with one of the biggest lobby/refreshment areas on the island. This theater featured HEAVY METAL, ESCAPE FROM NEW YORK (both 1981), CREEPSHOW (1982), and mainly big budget fare. It was challenging to get into R rated films if you were underage.

Island Twin Two mid-sized theaters, and home to midnight movies longer than any other theater on the island. Among their usual midnight offerings were ROCKY HORROR, DAWN OF THE DEAD (1979), URGH: A MUSIC WAR (1981), and PINK FLOYD THE WALL (1982). They also handled most of Romero's films (such as KNIGHTRIDERS (1981) and DAWN OF THE DEAD, some art house titles, and the usual mainstream fare). If you were under 17, getting into R rated films was rough, except for the midnight showings. Go figure.

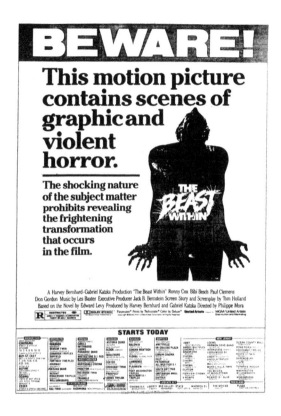

Rae Twin The MOST difficult theater for underage patrons to get in, yet for some reason they let us all in to 1982's THE BEAST WITHIN (which I believe was unrated) with no problem. The Rae handled most of the horror films, including FUNERAL HOME, PARASITE, MADMAN (all 1982), and every other slasher film out there. We often had to look for adults to buy our tickets. When THE WARRIORS (1979) originally screened, they turned anyone away who wasn't over 17, even if you were with an adult. I hated this place.

The Lane Theater One of the island's (now landmarked) single-screen cinemas. The Lane featured a HUGE screen and a balcony as big as the floor section. While they showed mainly mainstream releases (as a kid I saw KING KONG (1976), ROLLERCOASTER (1977) a couple of SINBAD films, and EVERY WHICH WAY BUT LOOSE (1978) there), they also showed FRIDAY THE 13TH PART 4 (1984), DAY OF THE DEAD (1985), and DEMONS (1986). Their lobby area was tremendous and the theater still operates today as a comedy club / church depending on what day you go.

NEWEST, LUXURIOUS, EXCITING

Jerry Lewis Cinema

IN

HILLSBOROUGH CLUB PLAZA
ROUTE 206
359-4480

OPENS WEDNESDAY !!!

PREMIERE SHOWING

RELAXING, INTIMATE ATMOSPHERE

SOFT PLUSH CHAIRS

PLENTY OF FREE PARKING

DUSTIN HOFFMAN "LITTLE BIG MAN" Panavision® Technicolor® GP

DAILY AT 7:00 and 9:15

The newest in the Jerry Lewis Cinema chain of beautiful, luxury theatres. Designed for your pleasure and entertainment and epitomizing the ultimate in Motion Picture Theatre comfort and intimacy.

Richmond Theater Another huge, single-screen theater with not as many seats as the Lane. Most 007 films played there, as did THE EVIL DEAD (1982), CITY OF THE WALKING DEAD (1983) and HOUSE BY THE CEMETERY (1981). Getting in was weird: they admitted everyone to EVIL DEAD in 1982, but a year later were turning people away from CITY OF THE WALKING DEAD, which wasn't half as gory or crazy.

The Jerry Lewis Cinema Probably the closest thing the island had to an urban-like grindhouse, the Jerry Lewis featured midnight movies (such as THE CRAZIES [1973], NIGHT OF THE LIVING DEAD [1968] and some porn titles), and was also home to Fulci's ZOMBIE when first released in the States. I was a tad too young to go there without an adult, but most of my friends and a few cousins who were older attended all the time.

The St. George Theater Another landmarked single-screen theater, they showed mainstream fare plus Godzilla films and horror classics such as THE EXORCIST (1973). The interior of the St. George is absolutely beautiful, and many live shows were performed by doo wop bands and comedians such as George Carlin over the years. Today it opens on occasion for art shows, concerts, comedians, and their annual Halloween screening of THE ROCKY HORROR PICTURE SHOW with local horror rock band The Flesh Junkies providing pre-show fun and "Time Warp"-direction during the film. I had the absolute pleasure of seeing GODZILLA VS. MEGALON there around 1974 with my brother and old man.

WHAT <u>NOT</u> TO SEE ON A HIGH SCHOOL DATE

Double dating when you're a freshman in high school can always provide some unwanted challenges; money, a car, and in this case, the right film to see to make two teenaged couples happy. My buddy and I figured we were lucky when we found a double feature listed at a local cinema of a new teen comedy called GOIN' ALL THE WAY (1982), along with some mushy-looking flick titled GISELLE (1980). We figured we'd enjoy the laughs of the first film and the girls could enjoy the sappiness of the second. Man, were we ever wrong.

For starters, the first film up was GISELLE, which turned out to be a Brazilian softcore sex film disguised in its newspaper ad as a gothic romance. Without any warning, it begins with horse trainers watching two horses humping (full horse penetration is shown!) before the first couple make love under a small waterfall...talk about being instantly blindsided. Embarrassed beyond belief, I sunk into my chair as our dates said, "What kind of movie is this?" Thankfully everyone laughed—nervously—and we continued to make fun of the overdubbing and horrendous acting for the remainder of this unforgettable sequence. Being a film geek, I attempted to pay attention to whatever plot there might have been, but between my date's constant looking at me to make sure I wasn't enjoying the nudity too much, and my buddy's

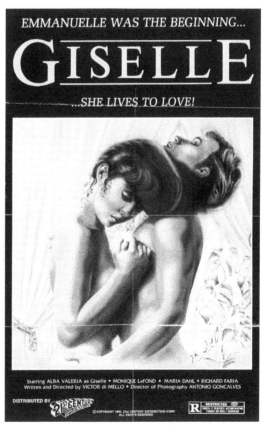

EMMANUELLE WAS THE BEGINNING...

GISELLE

...SHE LIVES TO LOVE!

Starring ALBA VALERIA as Giselle • MONIQUE LafOND • MARIA DAHL • RICHARD FARIA
Written and Directed by VICTOR di MELLO • Director of Photography ANTONIO GONCALVES

DISTRIBUTED BY 21st CENTURY
©COPYRIGHT 1981, 21st CENTURY DISTRIBUTION CORP.
ALL RIGHTS RESERVED

R RESTRICTED
UNDER 17 REQUIRES ACCOMPANYING
PARENT OR ADULT GUARDIAN

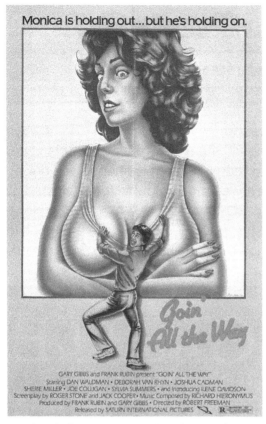

Monica is holding out...but he's holding on.

Goin'
All the Way

GARY GIBBS and FRANK RUBIN present "GOIN' ALL THE WAY"
Starring DAN WALDMAN • DEBORAH VAN RHYN • JOSHUA CADMAN
SHERIE MILLER • JOE COLLIGAN • SYLVIA SUMMERS • and introducing ILENE DAVIDSON
Screenplay by ROGER STONE and JACK COOPER • Music Composed by RICHARD HIERONYMUS
Produced by FRANK RUBIN and GARY GIBBS • Directed by ROBERT FREEMAN
Released by SATURN INTERNATIONAL PICTURES R

tapping me on the leg whenever the onscreen couples switched positions, I nearly lost my mind.

What followed this twisted opening were 80-some odd minutes of poorly overdubbed foreign trash cinema, packed with sex and some out of place violence. There was lesbian sex, gay sex, threesomes, even one sequence where a young boy is seen zipping his pants up after he leaves some guy's office. How this piece of depravity ever found its way on an American teen comedy double bill will forever remain a mystery. Director Victor di Mello (who acts in Brazil to this day) is responsible for this perverse oddity, which eventually found its way to U.S. video stores under the VHS title of HER SUMMER VACATION.

I can only imagine how many young teens rented this and lost their lunch to the infamous opening horse-hump fiasco. Title character GISELLE (played by Brazilian actress Alba Valeria) despite being extremely easy on the eyes, managed to give me a guilt complex that lasted for the remainder of my high school years.

The main feature, GOIN' ALL THE WAY, was a so-so FAST TIMES AT RIDGEMONT HIGH (1982) rip-off, not all too funny and highly forgettable. But I don't think any of us were focused on it after being assaulted by the Brazilian-sleaze that had come into our little neighborhood Twin Theater for a single week.

Who says grindhouses never existed in the suburbs?

UPDATE: In the summer of 2017, I managed to find a copy of GISELLE on DVD. While the opening horse sex scene wasn't as graphic as I remembered, it's still intense, shocking, and way out of place in this type of film. I had to fast forward through the rest of the film, though, and viewing it as an adult who has seen just about everything it's actually kind of boring.

Suburban Grindhouse Memories No 2

MAKING OUT IN THE BACK ROW WHILE ZOMBIES ATTACK

I n 1983, most horror film fans had plenty of slasher films to choose from. The countless FRIDAY THE 13th and HALLOWEEN rip-offs seemed endless, and along with the hot new phenomenon known as home video rentals, there were more available than at any other time in history. What horror fans didn't have a healthy supply of were zombie films. 1979's DAWN OF THE DEAD, followed by 1980's ZOMBIE, then 1982's EVIL DEAD left theater goers thirsting for more. It was at this time that I saw an ad in my local paper for a film called CITY OF THE WALKING DEAD. My pulse skyrocketed. Phone calls were made. My friends and I were going to the first showing on Friday night (and it was a good thing: the film only ran for one week).

Known on DVD as NIGHTMARE CITY, Director Umberto Lenzi's take on the zombie thing was way ahead of its time. The zombies (referred to as both vampires and nuclear-spill victims in the film), unlike Romero's undead, are lightning fast and use all kinds of weapons (including machine guns). Two of them even drive. But these Eye-Talian creatures aren't out for flesh or guts: they crave blood to replace their rapidly depleting blood quality due to their nuclear plasma problem. Despite how hi-tech the plot sounds, CITY OF THE WALKING DEAD turned out to be a laugh-a-minute, poorly overdubbed gore-fest that was responsible for turning me into a lover of "so-bad-it's-good" films. I often wondered why this wasn't titled CITY OF THE RUNNING DEAD, considering how fast these suckers moved throughout the film.

The film played in my hometown at the long-defunct Richmond Theater (now the site of a dollar store), a great looking single-film cinema with a humongous screen and three big sections of seating. While they featured mostly mainstream films, they always played whatever kind of horror or exploitation film was out at the time...for one week only (Lucio Fulci's infamous HOUSE BY THE CEMETERY played shortly after this).

At one point in the film, a friend of mine (who had been yakking to some girl sitting behind us since before the opening trailers) disappeared. When the film

slowed down for a second, I turned around to look for him and saw someone eating his face. I was nervous for a few seconds and then realized life wasn't imitating the art playing out across the screen: my buddy was making out with the aforementioned girl who apparently didn't appreciate fine European cinema. Too bad, because both of them missed out on:

- An amazing opening sequence where a plane-full of pasty-faced zombies attack the military and police at an airport while two hippy-looking news reporters stand twenty feet away without getting a scratch;

- The General's artist wife sculpting a gruesome, zombie-looking bust and claiming she has no idea what made her sculpt it;

- Two zombies wiping their mouths after sucking their victim's blood;

- A group of "Solid Gold" type dancers slaughtered during a live TV show taping;

- At least 6 scenes of zombies stabbing women in the breasts. After recently re-watching this film on DVD, I'm convinced the director had an anti-boob fetish;

- A zombie priest knocking down our news reporter protagonist with a large church candle;

- A zombie artist getting her head blown in half... then falling to the ground with her head intact and a small bullet hole between her eyes;

And this was all for starters.

CITY OF THE WALKING DEAD (the title I prefer) is one of the most asinine, ridiculous zombie films ever made. Yet it's also one of the most entertaining. The film was shot in Rome in 1980, just a year after THE CHINA SYNDROME, which explored nuclear issues in a less violent and slightly more serious tone. I'm willing to bet Umberto Lenzi was somehow attempting to capitalize on this (then) hot topic, despite his inability to tell his version with good acting or

coherent continuity. And the influence doesn't stop there; Lenzi features a graphic spike-to-the-eyeball scene to rival the classic eyeball-splinter moment in Fulci's ZOMBIE, plus a few helicopter-filmed long-shots of the undead running across fields (a la Romero's DAWN OF THE DEAD).

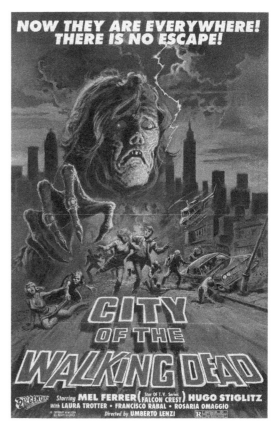

I was disappointed at one thing that's missing from the DVD release (at least the one I own, which is from Holland; the film has been released on several VHS and DVD labels over the years); in the 1983 theatrical American release, the large amount of zombie headshots during the final sequence at an amusement park featured the sound of breaking glass whenever a bullet turned a zombie's head into mush. Only one shot on my EC Entertainment DVD featured a semi-dish-clanking sound. If anyone has any information about this crucial missing sound effect, please contact me. (Outside, after the film, nearly everyone seemed to be talking about these goofy sound effects).

As the lights came on and the credits rolled, I chatted about a few scenes with an older guy who was sitting in front of me and my two friends, while my other friend was still sucking face with that girl in the back row.

To say you met your girlfriend at a zombie movie is classic.

To say you saw an Umberto Lenzi film in an American Grindhouse in 1983 is PRICELESS, even as I tried to shake off the "it was only a dream" ending and the film's general horrendous dialogue.

UPDATE: In 2012 I attended a 35mm screening of this under the title NIGHTMARE CITY in NJ, and there were no headshot/breaking glass sounds. Perhaps I imagined this? No. I didn't!

Suburban Grindhouse Memories No 3

"WHAT'S IN A TITLE? NOTHING!"

 984. One year before they shot and released their seminal hit, THE TOXIC AVENGER, Troma Films was responsible for the theatrical distribution of one of the most misleading titles in the history of the horror film. The poster promised everything from "Toe-Tapping Machete Head Dances!" to "Fabulous Air-Conditioned Tiger Pits!," but ZOMBIE ISLAND MASSACRE basically delivered 95 minutes of mind-numbing boredom after flashing Rita Jenrette's butt and boobs in an early shower scene (a bit of a controversy at the time as she was the former wife of then South Carolina congressman John Jenrette). When a nude scene from a politician's wife (a Democrat, no less!) is the highlight of a film, you know you're in for a B-flick to test the limits even of B-flick aficionados.

I barely made it.

I attended a Monday night screening at Staten Island's now long-defunct Amboy Twin Cinema, arguably the easiest theater on the east coast for underage patrons to be admitted to an R-rated film; this small neighborhood theater wouldn't have lasted a week during the Guliani administration. With maybe four other people in attendance (one a friend), we stretched out in anticipation of the coming Zombie Island Massacre. And guess what? There were NO zombies! There was NO massacre! *But at least there was an ISLAND.*

And on this Caribbean island, a bunch of American tourists hit a swanky hotel before taking a boat to a smaller island to see an authentic voodoo ritual. "Yes!" my buddy said in anticipation of the coming ghoul attack, still excited from the sight of Rita's swaying schnoobs.

Naturally, one couple leaves the group and winds up dead...but not from zombies. The rest of the tourists find the tour bus driver is gone, and eventually their tour guide vanishes, too.

What follows are painfully lifeless (full pun intended) scenes of the tourists getting picked off one by one as they try to make their way through the woods (because, after all, why would anyone want to stay put until help arrives?). ZOMBIE ISLAND MASSACRE quickly turns into the lamest FRIDAY THE 13th-type of stalker film

you've ever seen. And we never really see how the tourists are being killed; after hearing their annoying screams, we see quick flashes of their corpses (very darkly lit). We have no idea if they're actually dead or just taking a nap (I mean, this IS supposed to be a vacation). The money the film crew must've saved on lighting (and script writers) during this production could have financed TITANIC.

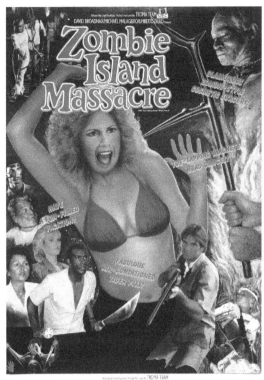

At one point in the film, what looks like a man dressed in bushes is seen sneaking up on the tourists. One guy in front of me yelled out, "THAT'S a zombie?" His 2-second comment provided more entertainment than anything seen during this clunker's entire running time.

To make matters worse (and more baffling in light of the film's title), ZOMBIE ISLAND MASSACRE attempts to throw the audience a curve ball by turning into a semi-crime drama. At this point I was an inch away from demanding my money back. But I just HAD to stick it through. I had to see if there'd be any final-frame zombie attack or a last-minute massacre during the final credits. I'd even have been happy if the voodoo "priest" would have done something besides hide behind the poor lighting.

When it comes to titles that are better than the actual film, NO ONE can beat Troma. ZOMBIE ISLAND MASSACRE turned out to be one of the worst films in their huge arsenal (I'd rather sit through A NYMPHOID BARBARIAN IN DINOSAUR HELL [1991] three more times each than have to sit through ZOMBIE ISLAND MASSACRE again even for a quarter of its running time).

If memory serves correctly, even the popcorn was stale that night.

In the world of Grindhouse cinema, you're going to run into some turkeys (okay, MANY turkeys). If I had to make a top 10 list of all-time worst Grindhouse films, this would most likely make the top five.

Suburban Grindhouse Memories No 4

BILL GUNN: A TRUE FILMMAKING GENIUS

n the early 1970s, "blaxploitation" cinema was all the rage on the grindhouse circuit (be they urban OR suburban). When director Bill Gunn was approached to make a film in the vein of BLACULA, he took the money and did something far more serious. Instead of trying to make an exploitative quickie, Gunn went for the gusto and delivered an artistic deep-thinker that (to this day) has many who see it believing it's a vampire film. It isn't. In fact, Gunn went all-out as he wrote, directed, and stars in this surreal, nightmare of a film that requires at least three to four viewings before even half of what it has to offer will hit you.

Since I was only five years old when GANJA & HESS was originally released, it was a treat to finally see this for the first time at a revival theater in April of 2010. This was the first time that I knew—halfway through a screening—that I'd have to see what I was watching again (and as soon as possible) just to keep my train of thought (this turned out to be one of the most challenging films I've reviewed yet). So I purchased a DVD the next day and watched it three more times.

The film follows Dr. Hess Green (played by legendary NIGHT OF THE LIVING DEAD star, Duane Jones), his new assistant George (Bill Gunn), and his assistant's wife, Ganja (the lovely Marlene Clark). Despite what some reviewers have said (I'm assuming they saw one of the several, heavily edited/re-titled versions), Hess DOES NOT become addicted to blood AFTER being stabbed by his assistant; the very beginning of the film scrolls these titles (over some magnificently eerie music): "Doctor Hess Green … Doctor of Anthropology, Doctor of Geology … While studying the ancient Black civilization of Myrthia … was stabbed by a stranger three times … one for God the Father, one for the Son … and one for the Holy Ghost … stabbed with a dagger, diseased from that ancient culture whereupon he became addicted and could not die … nor could he be killed." So, for the record, Hess is already addicted to blood when his suicidal assistant George moves in; Hess is a wealthy anthropologist living in a tremendous mansion

(African American stereotypes don't exist in this film, instantly banishing a "blaxploitation' label from it). He even manages to stop George's first attempt at suicide; George (apparently aggravated at this) eventually attacks Hess with the ceremonial dagger Hess had brought back from Africa. Hess survives, but George ends up shooting himself in Hess' bathroom. When Hess discovers George's body, we see him fall to his knees and lap his blood (the main scene I'm assuming has caused many to label this a vampire film).

George's wife Ganja shows up at the Hess mansion to wait for her husband (Hess has him stored in a freezer in the basement). And this is where GANJA & HESS truly becomes strange. After discovering her husband in the freezer and assuming Hess killed him, she ends up believing Hess' testimony of George's suicide and she helps Hess to bury him.

Ganja & Hess fall in love, get married, and Hess eventually makes her a part of the "Myrthia" tribe, bringing its 'blood curse' upon her (one edited version, released in the 80s on VHS as BLOOD COUPLE, gave the film a standard (and false) vampire-film packaging). Things get even stranger when Hess brings a man home for Ganja to feed on (she ends up having an affair with him first) and Hess begins to doubt his Christian roots when he finally begins to feel guilt after feeding from a young mother–guilt that nearly leads him to a nervous breakdown.

It should be pointed out here that while everything I've just described is happening, the incredibly spooky score by Sam Waymon, along with some

dazzling cinematography (I swear Dario Argento was inspired by much of this) helps to give GANJA & HESS a constant aura of surreal darkness that won't leave your mind anytime soon. One commentary track I listened to on the "GANJA & HESS: THE COMPLETE EDITION" DVD (Image Entertainment) mentioned that the opening sequence is told from 12 points of view (after re-watching it, I'm betting this is why so many are turned off to the film early on—it's truly unlike anything you've seen before). And this is just one thing that makes GANJA & HESS such a unique–and challenging–film.

GANJA & HESS is a film about religious identification and one man's realization that he has strayed from the faith of his upbringing. After making peace with God at a church service, he attempts to bring Ganja with him. The film's final moments feature Hess' death and Ganja contemplating her own life: to me it's apparent she likes what Hess has turned her into by smiling when she visualizes the dead man Hess had brought home for her running naked out of their pool. And being a sequel-less film, we're left to consider and debate if this is so.

Again, this is NOT a vampire film. It's an intense, unusual study of a millionaire who, despite having all there is to have in this world, is haunted by what lies beyond this life. And yet despite this underlying theme (as well as a church service scene that goes on for WAY too long), I don't think it was Gunn's intention to make an evangelical film (and if it was, I'd like to know what church–in 1973– approved of extended shots of full frontal male and female nudity, pagan blood drinking, and an artistic-look at suicide).

Watch GANJA & HESS. Then watch it again, even if you don't like it the first time. Despite a few slow stretches, the film has plenty to offer to those who take the time to contemplate and dig out its treasures.

I can't remember the last time a film has caused so much conversation between my friends and me. GANJA & HESS, despite its all-black cast, is NOT a blaxploitation film. It is a genuine hybrid of horror and art house filmmaking that stands alone. It cannot (and will not) ever be duplicated.

This is a true gem from Bill Gunn, and a gem I'll surely be revisiting again and again.

UPDATE: I attended the short run of a "restored version" in the spring of 2018 at the Quad Cinema in Manhattan. The film holds up well and I notice new things every time I see it. Kino Lorber released the restored version to Blu-ray.

Suburban Grindhouse Memories No 5

NORMAN BATES SHOULDA SUED...

ugust 1982. Horror fans my age were looking for one last kick before entering our freshman year of high school. Many of us wouldn't own a VCR for at least another year. The slasher film craze was in full effect, but a film that seemingly came out of nowhere began its kamikaze advertising campaign on late night television:

The TV commercial featured a zoom-out of the film's poster art with a man's voice saying something like "Funeral Home is so shocking we can't even show you ONE SECOND of what goes on in it! We DARE you to see FUNERAL HOME!" Despite my best efforts, I couldn't find this clip anywhere on the web...I'm curious to see if it's included on any DVD editions as an extra.

Needless to say, FUNERAL HOME turned out to be another fine example of false advertising. But being pre-freshman (and a horror fan who didn't need much conning), my friends and I hit the theater on opening night (at Staten Island's now defunct Rae Twin Cinema) and one of my buddies (the only non-horror fan of the group) still isn't talking to me, even though I offered to pay his bus fare home.

FUNERAL HOME turned out to be a tedious, slow-moving turd about some girl who goes to her grandmother's small town to help her open a bed and breakfast business. The place has been converted from Granny's old family business, the town's funeral home (cue PSYCHO music). Not long after the granddaughter arrives, she hears Granny talking to herself and to her husband as if he were still alive. Yep, Granddad's been dead a while but Granny refuses to believe it (at this point—even at my young age—I rolled my eyes).

I remember the audience laughing over the fact this new "tourist home" seemed continually crowded; the small town it was in had only one attraction of even partial interest: a lake, where the film's ONLY excuse for its R-rating takes place (a bloated corpse is seen drifting by a startled swimmer—come to think of it, the film could have been rated PG with no problem!). One thing about a suburban (and urban) grindhouse in New York: if you're lost or missed anything happening on screen, just be patient; it's only a matter of time before some loud-mouthed schmuck

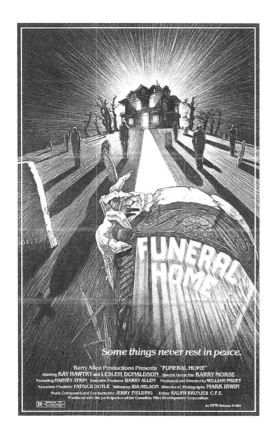

who's as lost as you are will openly ask what's going on as if he's sitting in his living room. And SOMEONE's bound to answer louder than the asker just to shut the guy up (just wait till my forthcoming review of 1990: THE BRONX WARRIORS to see this rude cinematic practice taken to its limit).

Back to FUNERAL HOME: Between the great (false) TV commercial and the creepy poster we stared at for a half hour waiting to get in to the sold-out theater, we had expected some kind of zombie film. What we got was 90 minutes of complete boredom, broken by a few unintentionally funny scenes of Granny's mentally challenged groundskeeper that, to this day, make me wonder if he wasn't a truly mentally challenged person (and, if not, the man should have received some kind of bad-film acting award). My early suspicions were proved right in the completely suspense free climax: FUNERAL HOME was basically some kind of "homage" to PSYCHO (1960), complete with the granddaughter discovering Gramps's rotted corpse as Grandma chases her through the basement. If memory serves right, someone even slaps the room's lamp, sending the lighting into swing mode, creating a blasphemous PSYCHO-finale rip off that must've made Hitchcock roll over and puke in his coffin.

With its complete absence of gore, nudity, profanity, suspense, AND plot, the producers of FUNERAL HOME had audacity advertising this PG-rated snooze fest as an R-rated horror film. But thanks to some well-timed popcorn-throwing at Gramps's corpse (had someone come to an earlier show that day?) and some funny commentary from my fellow suburbanites, I still had a much better time than I would a couple years later at ZOMBIE ISLAND MASSACRE.

If any PSYCHO fans seek this out of curiosity, remember to drink a 4-pack of Red Bull beforehand. But you'll probably *still* fall asleep.

"OH, I LOVE YOU, TRASH!"

982. The (now defunct) Island Twin Theater sat neatly between the Staten Island Mall and the world's largest garbage dump (that's also—thankfully—now defunct). The Island (as we locals called it) was one of the only theaters in my area to faithfully feature midnight movies every weekend throughout most of the late 70s and early 80s. They also managed to get some of the most god-awful film fare this side of 42nd Street.

Case in point: I'm scanning the local paper one Friday after school (I believe it was early freshman year) when I spot a very attractive ad in the movie section. Before I finished reading the title of the film, my friend and I called each other simultaneously and made plans to meet in front of the theater. To my surprise, this horrendously overdubbed Italian import managed to attract a near sell-out crowd.

In 1990, the Bronx is declared a no-man's land. Gangs (that look as vicious as Sesame Street characters) now rule the borough. I'm assuming everyone was expecting something like Walter Hill's 1979 classic THE WARRIORS, but instead we got a cheap-imitation mixed with elements of ESCAPE FROM NEW YORK (1981) and A CLOCKWORK ORANGE (1971) (Well, one of the gangs reminded me of the Droogies from Kubrick's classic ...).

Hot shot gang leader "Trash" (who walks around like there's a 9-foot pole shoved in his rectum) falls for some cutie-pie named Ann (who has run away from a rich family for this rat-hole). When Trash finds out the police are planning to raid their turf in an attempt to get Ann back (we eventually discover she's the President's daughter!), he and his crew attempt to get Ann to the head of the main gang, the Tigers, who are led by The Ogre (played by blaxploitation icon Fred Williamson). Along the way they battle some of the lamest gangs you've ever seen, including one group of goofballs on roller skates (with the audacity to call themselves 'The Zombies') that had the audience in hysterics.

Vic Morrow shows up as a mercenary on a mission to rescue Ann (sadly, Morrow died the same year this film was released while filming TWILIGHT ZONE: THE MOVIE). His presence here is welcome; aside from Williamson, he's

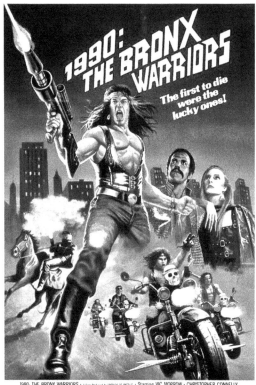

1990: THE BRONX WARRIORS • A Film Produced by FABRIZIO DE ANGELIS • Starring VIC MORROW • CHRISTOPHER CONNELLY
FRED WILLIAMSON • MARK GREGORY • with STEFANIA GIROLAMI • Screenplay DARDANO SACCHETTI • ELISA LIVIA BRIGANTI • ENZO G. CASTELLARI
Directed by ENZO G. CASTELLARI © 1982 DEAF INTERNATIONAL FILM s.r.l. UFDC UNITED FILM DISTRIBUTION COMPANY

the only other actor in the whole film who can actually act.

There are some cheap thrills during a few fight sequences, plenty of so-bad-it's-funny acting, but what everyone I saw this with remembers the most is a line said by Ann to her newfound gang-banger boyfriend (keep in mind she says this in a 100% serious tone):

"Oh, I love you, Trash!"

Was director Enzo G. Castellari seriously trying to put some kind of romance in this thing? Granted, this silly line could be due to the translators … but I'm willing to bet it didn't sound any less ridiculous in its original Italian language.

Some great lines I remember hearing hurled at the screen during various scenes:

"Yeah! Crack that wuss on the skates!"

"Why does that guy walk like he has a 9-foot pole shoved in his rectum?"

(I kid you not–some older guy in attendance with his two young kids said this. I laughed for about three weeks afterward and still quote it almost daily—even in an earlier section of this article in case you're just joining us.)

After Trash gives some poorly executed talk to his gang on a beach, another older guy yelled, "This asshole must be up for an academy award!"

I wish I had a tape recorder; I'd say around 20 minutes into this one, when the crowd realized this wasn't going to be another WARRIORS-quality film, the comments came fast and furious. The only character who got any respect was Fred Williamson's Ogre...although a few people insulted his outfit.

And yet despite the insults and wise-cracks, I didn't see ONE PERSON leave the theater. For some reason this crowd was ON THEIR GAME; they weren't going to let a pointless, poorly overdubbed turkey ruin their night out at the

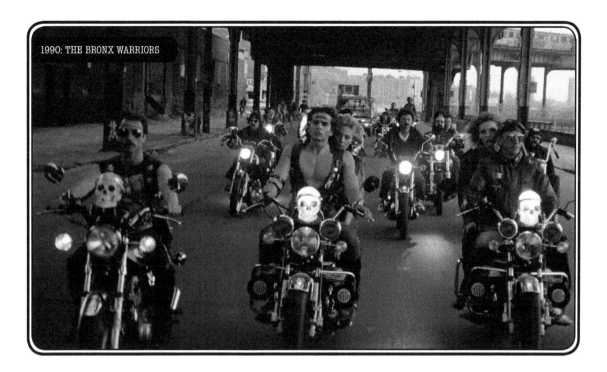

1990: THE BRONX WARRIORS

movies. Instead, this packed suburban grindhouse made 1990: THE BRONX WARRIORS their bitch for its 89 minute running time, creating the closest alternative experience to THE ROCKY HORROR PICTURE SHOW (1975) that I've ever been to (granted, I'm assuming it was only for the showing I was fortunate enough to be at, but MAN, what a ride!).

I sometimes wonder—if this film was given a chance to tour the midnight circuit around the country—if it wouldn't have found a ROCKY HORROR-ish cult audience. From reviews I've read online, it seems to have had a healthy following on VHS and continues to on DVD. The amount of goofy scenes and colorful characters almost BEG a bunch of nut-job theater goers to come to a screening dressed as the Riders, or the Tigers, or the Zombies (and also dares some long-haired freak to come with a 9-foot pole inserted in his rectum). But unless there's some theater in the films' home turf of Italy doing this, I strongly doubt this phenomenon has occurred.

Whether you're a gang film completist or just a fan of poorly overdubbed cinematic Euro-trash, 1990: THE BRONX WARRIORS is a riot and a half ... and one of the most fun times I've ever had at a theater.

THE GRINDHOUSE GOES RURAL!

The first time I saw Tobe Hooper's iconic classic THE TEXAS CHAIN SAW MASSACRE (1974) was during a 1981 re-release. The film freaked out my friends and I, and I couldn't wait to see it again. My wish was granted a few months later when my family took a trip to North Carolina. We were there for close to two weeks and I had grown a bit tired of the church picnics and (seemingly) constant community softball games. Imagine this young suburbanite's thrill when he scanned the local paper one day to see an ad for a double-bill of THE TEXAS CHAIN SAW MASSACRE and something called HITCH HIKE TO HELL (1977). I was excited enough at the prospect of seeing CHAIN SAW again (remember this was a few years before the VHS boom of the early '80s) and was ecstatic about this second feature that was mentioned in small type at the bottom of the ad.

Now my only problem (being I was only 13 at the time) was to con either my dad or one of my older cousins into taking me. Thankfully, I showed the ad to one of my "cuzzin's" (that's Southern for "cousin") and he said he'd take me and tell my parents I was staying at his house that night — but to keep my mouth shut.

To make matters better, the films played at a drive-in that had one of the coolest "snack bars" I ever saw: right next to the popcorn/soda concession

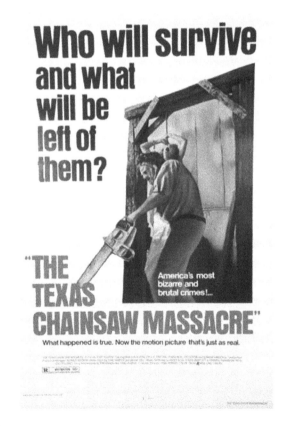

Who will survive and what will be left of them?

America's most bizarre and brutal crimes!...

"THE TEXAS CHAINSAW MASSACRE"

What happened is true. Now the motion picture that's just as real.

stand, some old guy was bar-b-queuing chicken, burgers, and ribs! YEE-HAW!

So, with a well-done burger and a large Coke, my cuzzin' and I (along with a few of his friends) kicked back as the first feature, HITCH HIKE TO HELL, began.

While I've seen my share of trash on TV up to this point in my life, HITCH HIKE TO HELL was my first exposure to something THIS BAD on the big screen. After some really silly opening song, we're introduced to Howard, a nerdy-looking mama's boy (cue PSYCHO music) who delivers laundry for a living in a van that looks like it's about to break down at any moment. Howard picks up a seemingly endless line of hitch hikers...and while I haven't seen this one since attempting to sit through it a second time on VHS in the late '80s (I FF through most of it), I recall Howard would strangle certain hitchers to death if he found out they didn't like their mothers! Yep, there's PSYCHO-influence-a-plenty here, along with just about no gore, blatant gay-bashing, and near-talent-free acting, with the exception of Russell Johnson

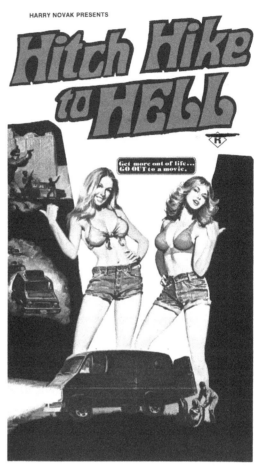

as a police captain (you read that right—the same Russell Johnson who played The Professor on GILLIGAN'S ISLAND!). I still recall the warm, silent air of the drive-in bursting into laughter the moment he came onto the screen.

While HITCH HIKE TO HELL is a total waste of celluloid (even for most lovers of bad films), there's one sequence that, to this day, I can't believe happened (keep in mind that this film was shot in 1968, shelved for two years

until 1970 for a limited release, then was more widely released in 1977, until finally resurfacing as a co-feature for TEXAS CHAIN SAW MASSACRE in 1981, shortly before finding a home on VHS thanks to exploitation king Harry Novak's former video company): While Howard picks up mostly older teenagers, he eventually meets up with an eleven or twelve-year-old female runaway. It's never shown what Howard did to the poor kid, but the Professor—err—I mean the police captain—finds her dead body in a dumpster at the end of the film. Although her lifeless body is only shown for a split second, the audience I saw this with groaned in disapproval. I remember my stomach dropping a notch as I attempted to digest my burger and believe that this nerdy character would TRULY have it in him to kill a young girl just for running away from home! Amazing that this plotless, scare-free "horror" film actually had a jolt in it.

HITCH HIKE TO HELL is a horrible film. It's tedious for most of its running time, and I'm betting the majority of horror fans wouldn't bother with it even at the mere mention of an (implied) child murder. But, considering this chunk of sleaze was filmed in 1968, at the dawn of the hippie love generation, it'll make you believe these producers took the bad brown acid long before it was available at Woodstock. Regardless of all its faults, it's nonetheless an interesting piece of semi-groundbreaking underground American horror.

And to this day I never told my old man my cuzzin' took me.

(NOTE: For those of you who just HAVE to see this, Something Weird Video released it on a deluxe DVD edition with a second equally-as-bad feature, KIDNAPPED COED. It's out of print now so it may cost you on the second hand market. YOU HAVE BEEN WARNED.)

Suburban Grindhouse Memories No 8

INTERGALACTIC HANDGUNS

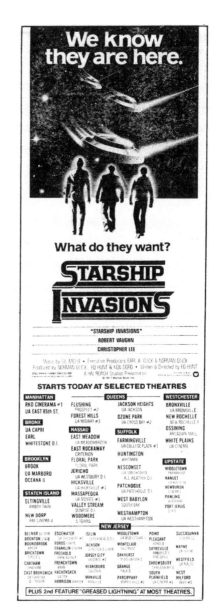

I f you were 9-years-old and loved to go to the movies, 1977 was a GREAT time to be alive; plenty of PG-rated genre films were released that year, most notably the very first STAR WARS, the cheesy but fun EMPIRE OF THE ANTS, and, a personal favorite of mine, ORCA (I mean, you can't beat a killer whale biting off Bo Derek's already broken, casted leg, can you?).

Just five months after the release of STAR WARS, another potential sci-fi classic made its way into theaters. Lured by (not only) its title, but by one of its stars (Christopher Lee), I went opening weekend to see STARSHIP INVASIONS ("We Know They are There, Advanced Beyond our Imagination!" claimed the official film poster). With R2D2 and Darth Vader fresh in mind, the poster and tagline for this one made it sound a bit more intelligent than Lucas's classic, and the TV commercial (which featured quick shots of spaceships chasing each other) had me (and I'm sure many other STAR WARS fans) thrilled; surely we were in for another blast of intergalactic goodness.

However, STARSHIP INVASIONS (surprise, surprise) turned out to be NOTHING like STAR WARS. For starters there are hardly any spaceship battles until the final minutes, and by then most of the crowd had abandoned hope.

I kept hope alive until the final reel, thanks to a plot that intrigued even my fourth-grade mind: A dying race of aliens attempt to take over the Earth by sending out a telepathic ray that causes humans to commit suicide. Fortunately, there's another race of aliens (known as the "League of Races") who have set up base in the Bermuda Triangle and are here to protect humanity from harm (I can't recall exactly WHY...but the more I try to remember this film the more I feel like finding a DVD to re-watch it).

What stuck in my young mind all these years later are the scenes of suicide which must've freaked parents out who took their kids expecting to see another Luke Skywalker-ish extravaganza. One sequence in particular features a farmer sticking a handgun into his mouth and blowing his brains out. Being a PG-rated film in 1977, there was no gore shown, but this didn't stop the audience (including myself) from gasping out loud. As an (already) twisted youngin', I was instantly drawn into the darkness and gloom this alleged sci-fi film had to offer.

Robert Vaughn plays Professor Duncan, a member of the good alien team. Naturally Christopher Lee is the head of the bad guys, but sadly he's wasted here with a ridiculous outfit and an army of robots that look straight out of an old Buck Rogers serial (the audience cracked up whenever one of them came on screen. The complexity of C3P0 had apparently spoiled us all).

While STARSHIP INVASIONS is no masterpiece, the interesting plot helped it succeed despite its low budget. It's one of the darkest sci-fi films from this era, and the aforementioned scenes of suicide pressed the boundaries of a PG-rating. By combining popular 70s topics such as UFOs, telepathy and the Bermuda Triangle, the film also serves as a 70s keepsake of sorts. The final "starship" battle between the good and bad aliens MAYBE looked a step or two above an old ATARI video game, but unlike the majority of patrons who purchased a ticket expecting another STAR WARS, this here young trash-film hound left the theater quite the happy camper.

And unlike that song on the first Ozzy album, STARSHIP INVASIONS didn't inspire me to commit suicide ... although I can't say the same for the others in attendance, many of whom booed and walked out before the final reel.

PREPPING FOR FAILURE!

984: Just a year after the third PORKY's film, it seemed there was still a market for the teen sex comedy. Films such as FAST TIMES AT RIDGEMONT HIGH and lesser known gems such as H.O.T.S. and SPRING BREAK had whet teenage boys' appetites (and pants) for such film fare. Needless to say, when I spotted the ad for PREPPIES on a Friday in my local paper, calls were made and a small crew got together to hit the Amboy Twin Cinema (yes, yet another now defunct theater here on toxic Staten Island that always let the underage into R-rated features).

Despite being directed by Chuck Vincent (a semi-famous porn director) and being co-produced by the Playboy Channel, PREPPIES features little nudity and almost no sex (hence stretching its inclusion into the "teen sex comedy" genre). There are a couple of topless scenes thrown in to grant it its R-rating, but when it comes to a COMEDY, you need more than a few jiggling can cans: you need humor.

PREPPIES doesn't have much.

The plot actually had potential for a laugh-fest: Three college friends need to pass an exam or they'll be expelled. Their girlfriends are hoping they pass so they'll become doctors/lawyers (talk about a couple of self-serving dates!).

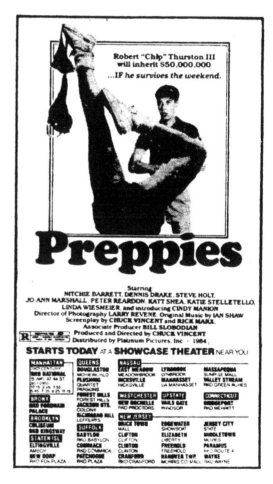

There's also a mention that one (or all) of these guys are set to inherit a lot of moolah. Things get silly (or at least they try to be) when someone hires a group of girls to go into the college and distract our sophomoric heroes from passing their final exam. Oh yes … this is gonna be classic…

…Ummm, no. Sure, the set up WAS there. PREPPIES has the genuine feel of a fun summer-time T&A comedy, but due to the non-acting skills of the ENTIRE cast (along with a horrible script), the film only gets off the ground for a scene or two.

In one instance, one of our henpecked protagonists is humiliated by his rich girlfriend; she makes him kiss her butt and feet through a glass door. It's the only time I remember the audience laughing, but I actually felt bad for the guy (and not only because I have an ANTI-foot fetish). I think even back then I was wondering how this schmuck would feel 20 years from now if his kids saw this. What would he say to them? Would he try to destroy copies of the film when it came to VHS (this was still at a time when digital video discs and MP3's were a long way off)? Would he somehow try to deny that was really him on the screen?

Did I really just put that much thought into this STUPID film?

Anyway, PREPPIES tried to cash in on the (then) trend of teen sex comedies, but failed miserably. When a flick that includes a bondage-S&M antagonist with a machine gun, and tons of cute girls dancing to generic 80s music, fails to deliver, it's safe to say the teen sex comedy had jumped the shark.

Thankfully, a few years later, SUMMER SCHOOL (while not a sex comedy) came back to give the summer comedy a much needed re-boot.

PREPPIES is strictly for lovers of bad acting and wasted boobies. And even then, you're taking a chance. I think I'm gonna go re-watch a much better T&A flick, SPRING BREAK (1983), just to get the memory of PREPPIES out of my head…

MODERN MEMORIES: ALL ABOUT EVIL

n 1984, Deborah Tennis's father ran the Victoria Theatre, a revival house that also featured vaudeville-like mini-shows, especially at the kiddie matinees. One day he made Deborah sing for the kids and she was so nervous she ended up peeing herself onstage and was nearly electrocuted when the stream hit a frayed electrical line.

Flash forward to present day: Deborah is now a librarian. She keeps the Victoria Theatre alive at night out of love for all her father had taught her about show business. Then her witch of a mother comes by one night to tell her she's putting the theatre up for sale. Having had enough of her mother's abuse (which has been going on since childhood) Deborah Tennis (pronounced, Deb-bore-AH Ten-Niece) takes a pen and jabs it into mom's neck. As rage takes over, she jumps on her body and begins stabbing her multiple times until the lobby floor is covered in blood.

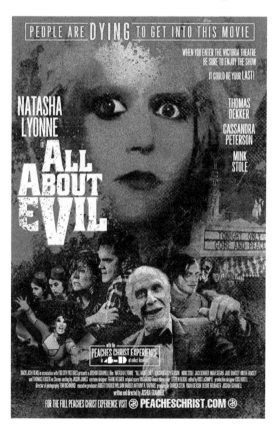

Meanwhile, the audience is chanting for the film to start (a revival of BLOOD FEAST). The Victoria's projectionist is out getting something to eat, so Deborah runs upstairs (covered in her mother's blood) and attempts to put the film on. She accidentally hits the security camera button, and the audience is treated to an unusually realistic film: the footage of Deborah killing her mother.

With growing insanity and a father-taught love for entertainment, Deborah (along with her trusty projectionist, Mr. Twigs) begins to shoot short films that they show every Friday night before the main feature; the films also serve as Public Service Announcements. A highlight is when one unlucky patron is forced to star in a little ditty they title A TALE OF TWO TITTIES (Deborah bases all her films on literary classics she spends most of the daytime reading).

The gruesome twosome eventually recruit a derelict cameraman named Adrian (after watching him beat down an old woman in the street) and sexy Goth-looking twins named Veda and Vera (on the day they're let out of prison). After several shorts the crew plans their first full-length film, GORE AND PEACE, and what they have planned for the audience itself is, in the words of one theatre patron, "So Jonestown!"

Thomas Dekker plays Steven, a young film fanatic who is infatuated with Deborah's films until one of his friends (the non-horror fan Judy) goes missing and he believes she's being held hostage at the theatre. Cassandra Peterson (yes, the legendary Elvira) plays Steve's clueless mother, and cult film icon Mink "Pink Flamingos" Stole plays Deborah's librarian boss (and what happens to her body during the ending is the stuff gore-film fans live for).

ALL ABOUT EVIL (2010) is the product of Peaches Christ (a.k.a. director Joshua Grannell), a cult-film fan who has finally delivered his own full-length feature; but unlike the countless films out there that TRY to be something special, this one actually is. Sure, it's a tribute to the films of H.G. Lewis and Ted V. Mikels, but it doesn't stop there. Grannell has taken what inspired him, and by adding a fantastic cast (especially the hysterical Natasha Lyonne as Deborah) has created what could potentially become a genuine cult hit. The characters are all memorable, the gore scenes are over the top but not done tastelessly, and most surprising, being a horror comedy, the film works quite well. The audience I saw this with laughed when they were supposed to and gasped during the more serious kill scenes. While there are posters of the director's favorite films seen in the background during most of the film, cult film fans will have a ball when they notice onscreen tributes to everything from BLOOD FEAST (1963) to BLOOD SUCKING FREAKS (1976) to CHAINED HEAT's (1983) toilet-stall kill sequence all the way down to the finale's ode to KING KONG (1933).

In a nutshell, ALL ABOUT EVIL is a pure blast of comedic cult-horror fun.

I was among the lucky few who saw this complete with the "Peaches Christ Experience in 4-D!" which is a Rocky Horror-like pre-show featuring Peaches and a theatre full of monsters and drag queens who sing, dance, and introduce the film (and being Natasha Lyonne is a New Yorker, the NY screening had a wonderful introduction to Natasha's work, right before she came out in character as Deborah Tennis and rocked the place to the ground).

But opening stage show aside, ALL ABOUT EVIL (the film itself) is highly recommended if you like horror comedies that are actually funny and if you want to see how a "tribute/homage" film can still go on to become its own thing (hey Rob Zombie ... take note!).

With a first feature so well done, Joshua/Peaches has surely set the bar quite high for himself ... here's hoping he has another one this cool hiding up his dress ... or in his super-bouffant hairdo.

A chat with All About Evil creator

PEACHES CHRIST

 UBURBAN GRINDHOUSE (SG): I was lucky enough to attend the Midnight Mass premiere of your film ALL ABOUT EVIL in NYC and was blown away. Can you tell us a little history about Midnight Mass?

PEACHES CHRIST (PC): MIDNIGHT MASS is a movie event that I created back in 1998. I was inspired by the San Francisco tradition of vaudeville mixed with cinema. The 60s' drag-troupe The Cockettes used to do these incredible film events at the Palace Theatre and I'd heard all about them so the MIDNIGHT MASS was born out of that idea. We stage

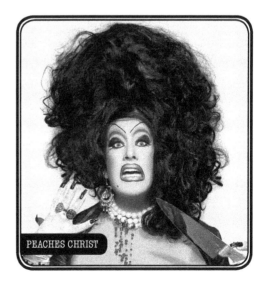

PEACHES CHRIST

elaborate productions before our favorite movies and the pre-show can take the form of theatrical spectacular, or celebrity idol worship, or fan costume contest- or sometimes all of the above. It's as much about the audience as it is the performers because cult movies only exist if there's a cult of followers wanting to celebrate and worship the cinema they love. We merely build the Church for this to happen in.

SG: ALL ABOUT EVIL pays homage to many grindhouse films. What are some of your favorites and why?
PC: FASTER PUSSYCAT! KILL! KILL! is at the top of the list because Tura Satana as Varla is my favorite onscreen female lead of all time- she's sexy AND violent and there's never been anyone else like her. I also love Doris Wishman's DOUBLE AGENT '73 because it's absurd and it's woman-made exploitation starring the giant talent that is Chesty Morgan. I have so much respect for Doris Wishman and she is part of the inspiration for the Deborah character in ALL ABOUT EVIL. Of course early John Waters films rule my school and Ted Mikels' THE DOLL SQUAD is another favorite. I love strong female leads.

SG: Did you grow up with any grindhouses in your area? If so, any fond memories you can share?
PC: The closest thing to a Grindhouse theatre I had was the mom and pop videostores in my Maryland communities where you could find the old Herschell Gordon Lewis VHS tapes in giant clamshell boxes and other rare and random goodies on cassette. Every weekend I hosted my own little film festival in my parent's basement. I don't think my parents could have imagined what we were actually watching. One time, a friend's mother caught us watching PINK FLAMINGOS when we were in the eighth grade and ended up chewing out "mom" over at "Mom's Video" for renting it to us.

SG: Natasha Lyonne is one of my favorite actresses. How was she to work with on ALL ABOUT EVIL?
PC: She was awesome, as you'd expect. Natasha was someone I'd always hoped would play the part but never thought we'd actually get because of the size of her career, but she responded to the script and we met and just really clicked. She got the movie and the character and is such a powerhouse

of talent. She's also totally hilarious and we've stayed close friends over the years. I really love her.

SG: I'm also a big Mink Stole fan and was thrilled to see her in your film. I assume we're both big John Waters fans?

PC: I grew up in Maryland and I went to catholic school until I went to college and so discovering John Waters and the Dreamlanders really changed my life. He's been my biggest idol ever since I was a kid. It's still surreal to me that through MIDNIGHT MASS I've been able to meet both Mink Stole and John and have become friends with them and get to do normal things with them like have a sandwich or see a movie.

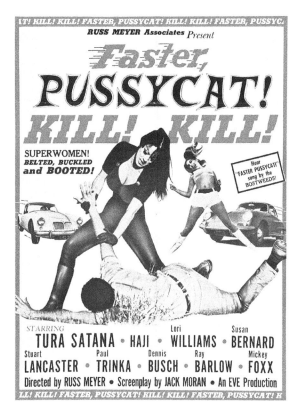

They're both super generous and I really couldn't have asked for better role models or friends. I still like to think I'm their biggest fan. Their films have shaped my life.

SG: What's the future of Midnight Mass, and do you have any more grindhouse-type films in the works?

PC: MIDNIGHT MASS outgrew the Bridge Theatre where it ran from 1998 to 2010 and we moved it to San Francisco's historic movie palace The Castro Theatre where we now perform regularly for audiences that have 1,000+ attendees. If you had told me this was going to happen back when we started I'd never have believed you. Recently we did a show with Ricki Lake where we celebrated the 20th Anniversary of Serial Mom. Coming up is our NC-17th Annual Showgirls event where we offer FREE lap-dances with every large popcorn.

I'm also working on a super glamorous and violent feature film screenplay right now and really hope we get to make the movie in the near future.

Suburban Grindhouse Memories No 11

A (NEARLY) MONSTER-LESS MONSTER MOVIE

etween the years 1980 and 1986, I was obsessed with an ABC-TV sitcom called TOO CLOSE FOR COMFORT. Not only did it feature the hysterical Ted Knight and Deborah Van Valkenberg (better known to cult film freaks as Mercy from 1979's THE WARRIORS), it also introduced the world to the unbelievably beautiful actress, Lydia Cornell, who starred as Ted Knight's daughter for the first five seasons. Being a 12-year-old heterosexual when this show first aired, I was instantly ga-ga over Lydia Cornell. Did I mention Lydia Cornell was a beautiful actress? Even if TOO CLOSE FOR COMFORT wasn't half as funny as it was, I still would have tuned in just to see Lydia Cornell.

Imagine how my pulse-rate skyrocketed during my freshman year of high school when I saw an ad in my local paper for a horror film called BLOODTIDE (1982). Looking closely at the credits, I saw Lydia Cornell's name. I then noticed the film was rated R. *Lydia Cornell was in an R-rated film.* Did I mention that I was ga-ga over Lydia Cornell?

Needless to say, my (underage) friends and I once again hit the (now defunct) Amboy Twin Cinema (their tag line should have been, "Give us Five Bucks, We'll Let You In!") on opening night, hoping to see Lydia Cornell get chased by some kind of sea monster … maybe even naked.

The plot is simple enough: a scuba diver looking for treasure off a Greek isle accidentally unleashes an ancient sea creature that happens to be looking for virgin sacrifices (relax … it's not a quarter as exciting as the set up promised). James Earl Jones (I guess he didn't make enough money the same year playing CONAN's arch enemy) stars as Lydia Cornell's boyfriend (hey, who says wealth doesn't have its benefits?). Like the rest of the cast (which includes Jose 'THE SENTINEL' Ferrer), Jones is wasted in this slow-moving waste of celluloid that isn't even saved by its nice scenery and exotic locale.

So why did I decide to dedicate an entire column to BLOODTIDE, arguably one of the most forgettable "horror" films of the 80s? Well, it surely isn't due

36

to the sea creature, who (and I'm not joking here, folks) is seen for MAYBE a total of five seconds of screen time in a bubbly-underwater sequence; the thing looked like a stone gargoyle statue with the head of that Bald Eagle Muppet (remember him?). Apparently any money the producers dropped into this celluloid abomination went to Mr. Jones's paycheck and the cost of flying the cast and crew to Greece. It SURELY didn't go into creature FX, and it DEFINITELY didn't go into fulfilling the dreams of Lydia Cornell's adolescent fans.

As Jones's girlfriend Barbara, Lydia Cornell has little screen time, although one scene had the mostly-male audience cheering in anticipation as she hits the beach in a tiny white bikini, then removes her top and starts working out. We see most of this through the eyes of someone spying on her from the nearby rocks. But our cheers quickly turned to jeers when the only nudity shown was a slight peek at the SIDE of one of her breasts. Why BLOODTIDE, with its absence of nudity and laughable "gore" (i.e. a few "red-water" shots) received an R-rating is anyone's guess.

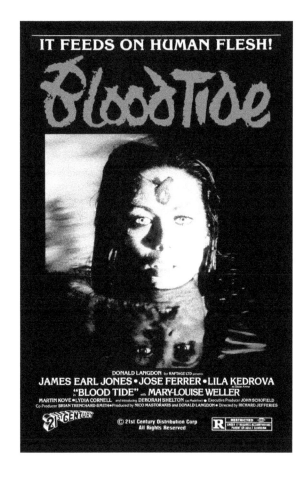

So as another cinematic turkey was verbally abused by my friends and me during the closing credits, I began to anticipate seeing Lydia that coming Tuesday night on television. The simple HOPE this film gave us of (possibly) seeing Lydia in the buff was enough to make the film a memorable one . . . NOT a good memory, but an interesting one that gave us a little bit of a thrill, which is more than I can say for the majority of mainstream film fare released around the same time.

I've since gone on to forgive Lydia (but NOT anyone else connected with the production of this film) for teasing us with the idea that the star of TOO CLOSE FOR COMFORT might be doing a nude scene in a "monster" movie.

Man, were we duped; but those were the chances you took in a suburban grindhouse.

I was hell bent on getting an interview with Lydia Cornell. We had some correspondence online, but unfortunately her schedule was so busy and she just didn't have the time. However, she mentioned she had once spoken about Blood Tide on a NJ radio show, and after some Internet searching, I tracked it down and was given the blessing by both Lydia and her interviewer, DJ David "Ghosty" Wills, to use their discussion in this book. As far as I know this is the only time Lydia Cornell has spoken publicly at this length about her involvement with this film, and I'm forever grateful to her and Mr. Wills for allowing this to be a part of Suburban Grindhouse.

A chat with Lydia Cornell

THIS INTERVIEW ORIGINALLY AIRED 11/5/2011 ON WFDU 89.1 FM (NJ), HOSTED BY DAVID "GHOSTY" WILLS

 AVID WILLS (DW): You're part of this film called BLOOD TIDE. When I mention it to people, I ask them if they ever saw this movie with James Earl Jones, where Lydia Cornell gets ripped to pieces? And everybody knows what I'm talking about.
LYDIA CORNELL (LC): You're kidding?

DW: Everybody has seen this movie!
LC: No way?! Well, it has a cult reputation for being one of the worst movies ever made...one of the worst horror films ever made.

DW: First of all, let me be in the defense of this movie: You play this sort of helper/girlfriend?

LC: The struggling helper of James Earl Jones. A beach bum.

DW: I recently watched the film again on DVD, and I'm sure it'll be on Blu-ray soon.
LC: (laughs)

DW: So you get ripped to shreds by this creature, but what was it like working with James Earl Jones in this crazy, crazy capacity?
LC: Amazing! This film was so

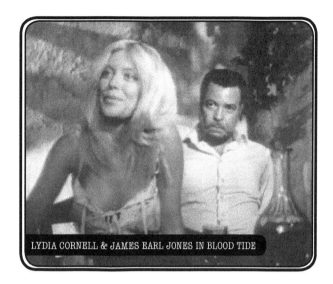

LYDIA CORNELL & JAMES EARL JONES IN BLOOD TIDE

amazing and silly. I was flown to the Greek isles right after I was hired for the TV series TOO CLOSE FOR COMFORT. I was in L.A. maybe three months, landed a TV series right away, then I was flown to the Greek isles and then there was an actor's strike, so we were stuck there. It prolonged my time in Greece. I was there for 9 weeks, living on this byzantine island. We had an old yacht, and there was nothing on this island but one restaurant and a bunch of donkeys, and they would take us up to the top of this old monastery, and I lived in a byzantine library.

The hardest part filming BLOOD TIDE was the drowning scene, because that day they told me to keep my eyes opened while salt water was going in and out of my eyeballs with the sun shining on my face.

We took about forty takes of that, and I had to look with my eyes open in salt water. It was crazy. And then they wanted me to drown as if I was topless, but I could not do any topless scenes. I would never do nudity. I had this big thing that I'd never do nudity, in case my children one day...

DW: Mmm Hmmm.
LC: I was doing this all-American family TV series starting in the fall, so I figured the ABC network wouldn't let me do it, anyway. So I tricked the camera people. We tried everything: the wardrobe lady had me kneel behind a rock, as there were no dressing rooms outside by the beach. So I was bending down behind the

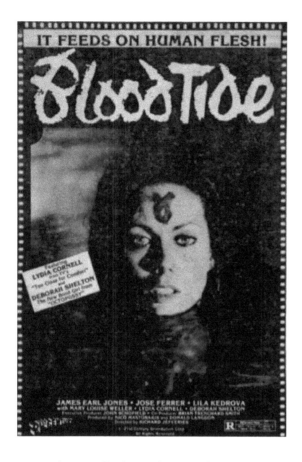

rock and she was putting zinc oxide all over me. And then bandages, and she figured zinc oxide would be perfect because there was an underwater camera following me while I was drowning, and I was all white, so they could never use the footage. But, the first day of shooting they didn't have the zinc oxide, and I had to go to the director of photography's cave...he lived in a cave.

So while they were eating, I snuck into his cave and stole the film. I put it in my dressing room. My cave, back at the monastery! They didn't know I took it. I actually said to the director that I couldn't let them have the footage. They had naked footage of me! Swimming nude! I told him my manager would kill me, that I didn't sign a contract saying I could do this. So they had to reshoot all the takes with me wearing zinc oxide.

DW: I'm surprised at the covert cloak and dagger world of Lydia Cornell.
LC: (laughs) It was such a blast. We were living in a tiny village with just nuns and donkeys!

DW: James Earl Jones' character is so mean to you. Was he nice on the set?
LC: He was playing a drunken Othello type who had lost everything in America and came to this island. We were supposed to be boyfriend and girlfriend and we had a big kissing scene, and they cut it out. They said audiences wouldn't accept a bi-racial love affair, and I said, "Why?"

DW: We had Star Trek twenty years before this, so why not?

LC: Yeah. We were going through the Reagan era. But I loved it. Jones was a blast to work with. He was this iconic figure even back then.

DW: It was very strange because when I first saw Blood Tide I was a kid, and I was just like, "That's the voice of Darth Vader!" And, "That's the girl from Too Close for Comfort!" What the heck am I watching?
LC: (laughs)

DW: And now she just got killed! She was doing aerobics on the beach and the next thing you know, she's ripped to shreds!
LC: (laughs) First of all no one knew the plot, we couldn't figure out what the movie meant. We couldn't figure out what it was about. To this day we have no idea what it means.

DW: And I've seen it now twice. I still have no idea what it means, but I love it though.
LC: I love it too. The opening music was beautiful.

DW: Right, it's very atmospheric.
LC: And by the way, we had a scene where we were all on a speed boat together. Twenty-five crew members were on the boat with us four or five actors. The sound crew was from Acapulco. The camera crew was from Greece. The actors were American and the producers were British and Greek. And no one could communicate. It was like the Tower of Babel! So at one point the well known Mexican sound man who had just assisted on Farrah Fawcett's movie SUNBURN, got sea sick. He lost his entire set of false teeth overboard and the rest of the summer he had to eat masako with a straw! (laughs)

DW: No wonder this movie wound up as some sort of surrealist masterpiece.
LC: (laughs) Thank you!

DW: And it's very famous now.
LC: Oh I love you saying that!

DW: Everybody I talk to says, "Oh, I've seen that movie."
LC: (laughs) That is weird!

Suburban Grindhouse Memories No 12

A KARATE FILM FOR THOSE WITH ATTENTION DEFICIT DISORDER

Whenever you see a poster like the one for 1981's FIRECRACKER, you know you're in for more than a Bruce Lee-type flick. In the case of this U.S.-Philippines-co-produced exploitationer, audiences were treated to way more than they had probably expected. I know I sure was!

FIRECRACKER tells the story of seasoned karate instructor Suzie Carter (played by Jillian Kesner, an alleged champion Olympic kick-boxer, although I've yet to find any documentation on that) who travels to a city in the Philippines in search of her sister who had been there investigating a drug-trafficking ring. Suzie quickly locates one of the drug mob's right-hand men (he in turn actually falls in love with her!) and he brings her to a bunch of underground martial arts matches (I mean, what better way to impress a lady?) that take place in a night club (let's hear it for the Philippines!). Of course, these fights are run by this guy as a front for his day job: international drug distribution.

Did I mention Suzie just happens to be an amazing martial artist?

When Suzie eventually finds out this scum murdered her sister, she gets a death match with him which she wins by jamming two mini-poles into his eyeballs (there's some wild scenes of Fu-Violence spread throughout this seldom seen gem).

With its standard martial arts/revenge plot, the producers must've figured they'd better give the audience something different for their money. And by conning the lovely Jillian Kesner into this role, they accomplished their goal by having most of her fights taking place either naked or scantily clad; the sequence where she takes on two thugs while topless had the (mostly) teenaged audience I saw this with cheering with their mouths hanging down to the popcorn-butter-stained floor.

Director Cirio H. Santiago (at the time a favorite among underground action-film enthusiasts) wisely grabs the audience's attention from the get-go as Suzie's first fight takes place less than two minutes after the film begins. Aside from the aforementioned topless fight scene, Suzie's unforgettable final brawl (where she slowly loses pieces of her clothes until she's down to her panties) is filmed in pure exploitational glee—the audience was screaming and cheering her on the whole

time as if we were at a live boxing match (something home viewers who rented this a couple years later in the oversized VHS box missed out on).

With a gruesome electric saw blade-to-the-head scene, a sex scene that borders on late night Cinemaxism, absolutely lifeless acting, so-so martial arts choreography, FIRECRACKER was and still is (IF you can find it—a DVD was never officially released) a great alternative to the endless tide of kung fu/revenge movies.

In researching some names for this article, I was sad to discover actress Jillian Kesner had lost her life due to a staph infection while suffering from leukemia in December of 2007. Aside from FIRECRACKER and a few other martial arts films (most notably 1982's RAW FORCE, which I will cover in a future column), Kesner had an interesting acting career, appearing in many TV shows (including a spot as Fonzie's girlfriend on HAPPY DAYS and roles on THE ROCKFORD FILES and THREE'S COMPANY).

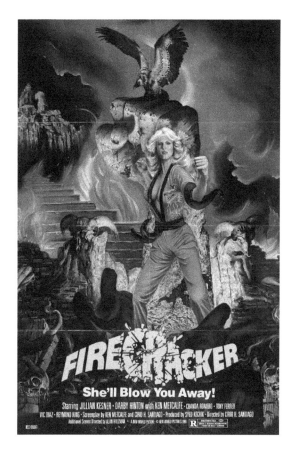

Fonzie's chick or not, Jillian's topless kick-ass karate fights left an impression on this (at the time) 13-year-old film fanatic's celluloid psyche that even RAIDERS OF THE LOST ARK (the BIG film everyone was seeing that year) failed to do.

Gotta run; I'm late for my weekly psychiatric evaluation…

UPDATE: FIRECRACKER was finally released on DVD as part of a martial arts triple-feature package, but sadly the highlight of the film (the aforementioned clothes-losing fight sequence) is edited. And how I forgot to mention the scene where Jillian grabs a snake (dumped toward her by the legendary Vic Diaz) shows that enough scantily clad fight scenes can clog anyone's memory.

Suburban Grindhouse Memories No 13

DON'T GO IN THE WOODS... OR THE THEATER!

Hot on the heels of HALLOWEEN (1978) and FRIDAY THE 13th (1980), one of the worst of the worst reared its ugly head during the dawn of the slasher film craze. DON'T GO IN THE WOODS … ALONE! hit American theaters in 1981, and sucked in by the cool-looking poster ad, I once again convinced a few of my buddies to attend a matinee with me the second day of this film's release.

I was lucky to still have (said) friends by the time this 82-minute test of horror fans' patience finished unreeling.

Staten Island's Fox Twin Cinema (known for its late 70s midnight movie screenings) was the venue for this completely plotless flick dealing with a Daniel Boone-looking slasher hacking up hikers in the Utah mountains. Actor Tom Drury plays the maniacal mountain man in unconvincing fashion (he had also starred in a late 60s DANIEL BOONE TV show … talk about stretching one's abilities).

A bunch of typical teens, a newlywed couple, an artist and her young daughter, and a wheelchair-bound cripple (who looks eerily like the wheelchair-bound Franklin from the original TEXAS CHAIN SAW MASSACRE) become victims to Boone's homemade machete-tied-to-a-stick weapon (at least those who don't get pushed off of cliffs).

Despite the poor cripple getting his head hacked off (after climbing a mountain in his wheelchair!) and another sucker having his arm ripped out, no amount of ketchup-looking gore could've saved this one: the crowd I was with continually booed and even verbally insulted the theater manager for booking the film, and one older guy a few rows in front of me began to sing some old DANIEL BOONE theme song whenever the killer came on screen.

Screenwriter Garth Eliassen (who thankfully only penned one other film) doesn't even bother to explain WHY this lunatic is living all alone in the woods, chopping people up, and in a vain attempt to give this film some resemblance of a STORY, an overweight redneck sheriff is seen looking into the missing persons despite us never seeing anyone report these missing persons (I mean, WHY

give the sound crew any extra work? We're supposed to KNOW this is what sheriffs do, right?).

With phony gore scenes that are about as shocking as watching Kermit the frog get slapped by Miss Piggy, DON'T GO IN THE WOODS...ALONE! was surprisingly one of the first features to make the UK's infamous early 80s "Video Nasties" list. I'm convinced the British film board put way too much brandy in their afternoon tea and judged films based on their poster art.

I'm assuming this film was made to cash in on the far superior JUST BEFORE DAWN, another maniacs-in-the-wilderness HILLS HAVE EYES-type flick released just a few months before WOODS; and considering the initial filming for WOODS only took 10 days, it's not hard to believe.

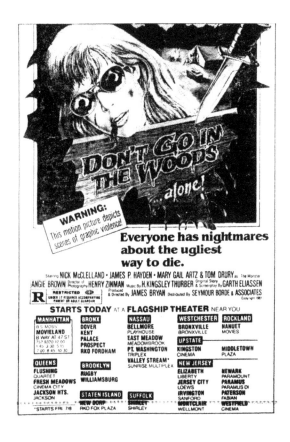

I'm still trying to understand how this film has gained a cult audience. An online search will reveal many claiming this to be a "so-bad-it's-good" classic, but my friends and I still stand firm that it's a GENUINE "so-bad-it's-bad." The nut-jobs over at CODE RED DVD even released a deluxe collector's edition DVD a couple of years ago, so if you hate yourself you might want to get a copy and check it out. I won't.

DON'T GO IN THE WOODS ... ALONE! came to VHS and DVD without the "ALONE!" in the title; why it EVER had ALONE! in the title is anyone's guess as most of the victims entered the woods as couples. I almost feel bad for my Australian friends who saw this in 1983 when it was released down under as THE FOREST 2, despite it having NOTHING to do with the equally-as-bad 1982 film THE FOREST (a.k.a. TERROR IN THE FOREST). Got that?

Twenty-nine years after apologizing to my friends for dragging them to see this, I again offer my condolences ... although this time I'm not treating for lunch.

THE EPITOME OF 70s SLEAZE

his week's classic is a film I actually saw first on VHS as part of a double feature series titled "Harry Novak's Frightful Flicks." Novak was an exploitation film pioneer during the 60s and 70s, producing and releasing countless "nudie cutie" films, cheap horror and sci-fi outings, and the following gem that just may be the world's first "cop/buddy movie."

A SCREAM IN THE STREETS (1973)—while fun to watch on VHS—was even more fun when seen in a theater alongside the DEATH WISH-esque VIGILANTE (which was directed by William "MANIAC" Lustig). I don't know if a more entertaining movie night was had by me during the year of 1983, when this twisted double bill pulled into the Fox Twin Theater in my hometown.

Knowing there was a good chance NO ONE else in attendance had seen A SCREAM IN THE STREETS, I put my feet up on the back row and anxiously waited for the crowd's reaction to this softcore sex film that Novak cleverly disguised as a slasher/police drama.

From it's opening (nearly) credit-free sequence of a transvestite slashing up some poor young girl, to its closing shot of the same tranny slashing up someone else, this crudely directed "police drama" had most patrons either drooling over the extended peeping tom scenes, cringing over a brutal massage parlor beating or laughing whenever detectives Ed and Bob came on screen, each with the acting ability of a parking meter.

Ed and Bob cruise around downtown L.A., looking for perps (and pervs). One poor girl who works at a massage parlor has to deal with some old freak, who—not satisfied with using his hands to spank—ends up chasing her around the joint with his belt, swinging at her (and occasionally connecting) in a scene so absurd most of the theater didn't know what to make of it. I found out a few years later (thanks to some horror fanzine) that A SCREAM IN THE STREETS' massage parlor sequence was actually a peek into a "roughie" film, i.e. late 60s/early 70s sex films that used S&M and/or light bondage or hitting as a replacement for hardcore sex scenes. Whatever the case, this was one of the

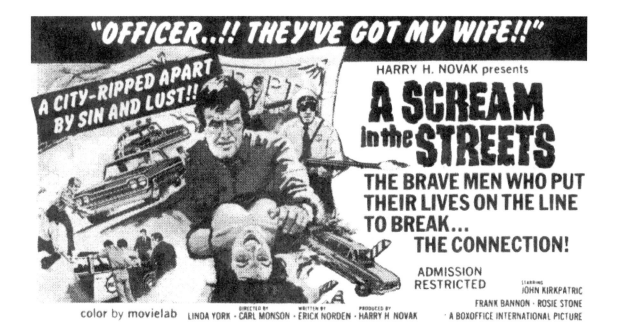

more obscure things I've ever seen in a suburban cinema, and I'm sure everyone at this screening would agree.

Next, we're treated to a peeping tom spying on two housewives who decide to turn their afternoon tea party into an experimental lesbian session. Wouldn't you know our hero detectives happen to spot this creep hiding in the bushes, but he escapes before they can bring him in. A few more peeping tom scenes fill up the rest of the time in-between completely lifeless dialogue and some of the more hideous fashions ever committed to celluloid.

Our transvestite slasher (who rapes and kills girls for no apparent reason) is played with an emotionless smirk by Con Covert, an actor who starred in countless 70s softcore films (including 1974's THE PLAYMATES IN DEEP VISION 3-D!) before landing a supporting role in the 1984 cult classic REPO MAN. His face is partially covered by a bad wig and Sunday church hat to help hide his horrendous facial expressions.

A few people left the theater, either offended by the belt-sequence or off to get a large Coke to help caffeinate them through the rest of the film, which, while truly slow at times, does have that certain charm fans of bad cinema have come to love.

While detectives Ed and Bob may or may not be the first "cop/buddy" team, A SCREAM IN THE STREETS is arguably one of the trashiest low-budget features to not only get a theatrical release (in 1973), but to be brought back 10 years later as a back-up for Lustig's semi-successful street justice actioner. Director Carl Monson (who directed the pseudo-cult epic PLEASE DON'T EAT MY MOTHER, also in 1973), evidently not satisfied with the transvestite or the peeping tom, also manages to squeeze some goofy-looking cokehead into the mix, and even throws in semi-underground star John Tull as a reefer-smoking hippie.

With more nudity than a nudist camp, worse acting than PLAN 9 FROM OUTER SPACE (1958), choreography-free fight sequences, sloppy-aftermath gore "F/X" and one of the lamest slashers ever to hit the screen, A SCREAM IN THE STREETS is a cop/buddy movie that also features two of the lamest cops ever to be paired (but thankfully the tranny kills one during the suspense free finale).

For belt fetishists and trash-film completists only. (If you MUST see this, Something Weird Video released a deluxe DVD edition a few years ago ... even I have yet to revisit it).

UPDATE: I couldn't take it anymore and found a copy of the out of print Something Weird DVD from ebay in 2013. It's as gloriously horrible as I remembered.

THE LITTLE SCARE THAT COULD

O n an unusually hot August afternoon in 1981, my 7th grade buddies and I managed to get into HELL NIGHT, a new R-rated horror film starring Linda Blair (oh how we LOVED the Amboy Twin Theater). Anyone can see Linda Blair being the star of a horror film (she was in two previous possession films you might have seen). But Vincent Van Patten, the son of EIGHT IS ENOUGH star Dick Van Patten, too? I had my doubts about this one going in: What kind of a horror film would cast the son of Dick Van Patten? Then again, he did have a role in ROCK N ROLL HIGH SCHOOL (1979) and a few years later starred in the seldom seen ROOSTER: SPURS OF DEATH (1983).

Needless to say, HELL NIGHT works big time.

The story's nothing fancy. Four fraternity pledges must spend the night in Garth Manor, a place where the owner had murdered his wife and three deformed kids a dozen years earlier. Of course, rumor has it that a member of the family survived, and still haunts the joint.

I must admit I rolled my eyes as soon as this plot was set up early on during pledge night. Even in 1981, this basic premise was getting played out. But then something amazing— and rare—began to happen.

People in the audience began to scream. Remember, in 1981, most people were beginning to look for

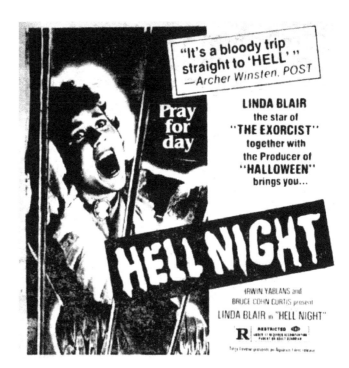

"It's a bloody trip straight to 'HELL'."
—Archer Winsten, POST

LINDA BLAIR
the star of
"THE EXORCIST"
together with
the Producer of
"HALLOWEEN"
brings you...

Pray for day

HELL NIGHT

IRWIN YABLANS and BRUCE COHN CURTIS present
LINDA BLAIR in "HELL NIGHT"
R RESTRICTED

gruesome gore scenes (myself being a major culprit). Imagine my surprise when I began to sweat a little, both out of tension and happiness that a horror film was ACTUALLY SCARY for a change. While there are a couple of gruesome kills, the gore is shown quickly, as not to distract from what really makes the film work: its fantastic atmosphere, as well as a few college kids you actually care about (that in itself is a minor celluloid miracle).

What also works are the killers (OOPS—spoiler alert!). Two of the three deformed sons Mr. Garth allegedly murdered have survived, and are now protecting their turf from the partying pledges. They both look quite creepy, even though we don't get a good look at them until the ending (and one very brief earlier shot). It's also not clear until late in the film that there are two killers, which caused one of several audible gasps from the crowd when revealed.

While Linda Blair's acting in this one is nothing to brag about, she does a decent job considering the mundane plot, and the way she manages to deep-six one of the killers is fantastic.

I saw HELL NIGHT for the second time a week after this initial screening, and the crowd (which was almost as crowded as opening weekend) jumped out of their seats and screamed a few times. Seriously...how many horror films—especially a generic one like this—managed to create genuine scares? The answer? NONE that I can think of. Likewise, there aren't many films that work on a grindhouse level with (practically) no nudity or extreme gore the way this little gem does.

HELL NIGHT is no masterpiece. But it does what a horror film's supposed to do. It'll give you the willies (and considering you won't be seeing this in a theater anytime soon, make sure to watch the DVD by yourself, in an empty house, preferably at midnight for maximum effect).

I actually let this one play in the background each year on Halloween as I hand candy out to the kiddies...it's a great flick to watch alongside holiday standards such as NIGHT OF THE LIVING DEAD and HALLOWEEN. No, it's not as scary as either, but it works in a way that still surprises me every time I see it.

Suburban Grindhouse Memories No 16

NIGHT OF THE HELL OF THE LIVING DEAD

 n a frosty winter night in 1984, NIGHT OF THE ZOMBIES opened in the NY metropolitan area. Besides the title, the thing that caught my attention on its newspaper ad was the director's name: Vincent Dawn. I mean, NIGHT OF THE ZOMBIES directed by Vincent DAWN? (Remember, at this time there was no Internet to Google the name and discover this was an alias for Italian Fulci-wannabe Bruno Mattei). With DAWN OF THE DEAD (1979) fresh in our young minds from a 1983 re-release, my crew and

I hit the Rae Twin Cinema (another long-defunct suburban grindhouse here on lovely Staten Island) and we were surprised to find the place was packed: SOLD OUT, in fact.

The opening sequence had the theater in hysterics: A leak at a chemical plant somewhere in Papua, New Guinea, turns a mouse into a flesh-eating monster. The newly carnivorous critter manages to eat its way inside one of the plant worker's oversized, CRAZIES-like white hazmat suit, turning him into a zombie and quickly starting a snowball-effect of living dead.

But the Romero-ness didn't end there. What happened next ALMOST made me leave the theater: we're introduced to a four-man team, sent in to contain the zombie outbreak. Each one is dressed in S.W.A.T.

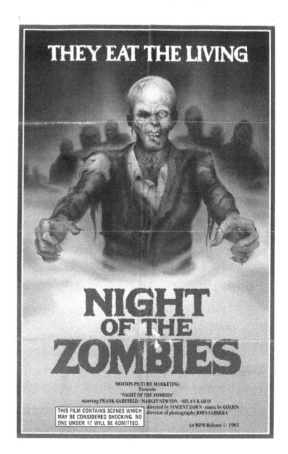

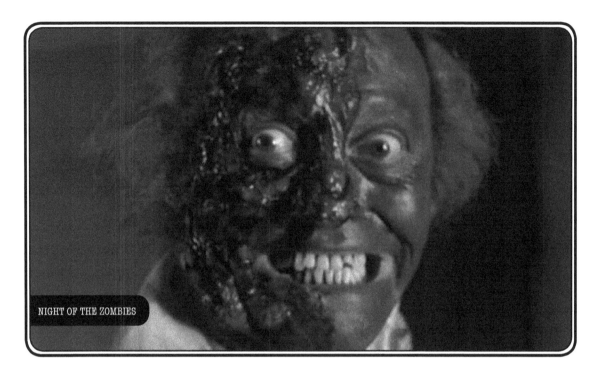

NIGHT OF THE ZOMBIES

attire, making a theater full of (mostly) DAWN fans groan out loud.

And then the film does something seldom seen outside of a National Geographic special. Apparently added to fill up a respectable running time, there are countless scenes of our squad walking through the New Guinea jungle, looking to their right and left for the undead. But the editor(s) of this masterpiece took the opportunity to stick in stock footage of animals in their natural habitats; birds, hippos, lizards, cattle...every time these poor, exploited creatures showed up I nearly wet myself laughing, wondering if we had paid to see a zombie film or a lost episode of WILD KINGDOM.

But despite all the silly stock footage and blunt DAWN-rip offness, NIGHT OF THE ZOMBIES features plenty of headshots and gore, which is good considering their isn't much of a story going on here, so the film at least gives fans of the undead some grue to keep their interest.

Yet to add insult to injury, the producers also swiped Goblin's soundtrack from DAWN OF THE DEAD and felt at liberty to use it...no idea if anyone was ever sued. And in an attempt to truly make a Romero-esque picture, the underlying theme (about trying to feed overpopulated countries) is so obscured by the poor

overdubbing and silly stock footage, Mattei's (OOPS—I mean Vincent Dawn's) attempt at some social commentary is utterly lost in the shuffle.

I'm pretty sure it was at this screening when I realized just how popular DAWN OF THE DEAD was, and how much horror fans loved and respected it. Constant yells of "What a rip off!" and "I want my money back!" (and even one "Sue these bastards!") continually filled the theater to my giggling friends and my own delight.

Besides the celluloid thievery, my biggest complaint as a zombie fan was how most of the zombies looked; while a few were genuinely eerie, most were just people covered in mud and grime: I'm thinking the effects crew must've saved on latex to buy some New Guinea home-grown and had the zombie extras pelt each other with mud pies. Either way, most of the undead looked painfully silly.

Despite being told the only way to kill these zombies is to shoot them in the head, COUNTLESS ROUNDS of ammo are still wasted putting holes in the recently risen's torsos. Apparently rip-off SWAT teams in New Guinea don't take directions as well as those stationed in Pittsburgh.

Originally titled VIRUS in Italy, then NIGHT OF THE ZOMBIES for its U.S. release, the film is more commonly known worldwide on DVD as HELL OF THE LIVING DEAD.

If you're in the mood to see George Romero and Lucio Fulci get ripped off (the ending is a "nod" to Fulci's ZOMBIE from 1979), then by all means see this flick. If you're in the mood to hear a theater full of DAWN fans go ape, try to get a screening of this in your local theater. At least Bruno Mattei sort of redeemed himself in 1989 when he finished ZOMBIE 3 (1990), after Fulci reportedly gave up on it after some script disputes. But that's another story.

If you see this, just remember to watch out for the mice...

SOMETIMES YOU JUST HAD TO GO TO THE CITY...

egardless of whether you're a horror, sci-fi, or fantasy film fan, a slick newspaper ad that ran in several local papers managed to get anyone with a love for B-cinema out of the 'burbs for one gloriously cheese-filled fall evening back in 1987. The double bill played in Times Square at the Cine 42, thanks to a distributor known as Urban Classics (they also released these titles to video shortly after their week-only theatrical run). Was it worth the bumpy train ride, dodging peddlers, hookers and drug dealers? Yes ... and no.

The first feature, SLAVEGIRLS FROM BEYOND INFINITY, turned out to be a loin-cloth-bikini version of THE MOST DANGEROUS GAME (1932). Two cute "slave girls" escape from a slave ship in a cheap-looking space shuttle and crash land on a planet where a nut named Zed throws them into the jungle and hunts them with his goofy-looking robot. Unless you're a teenage boy (I was at the time), chances are you'll scan through this with the fast forward (although we didn't have that option in the theater). If not for scream queen legend Brinke Stevens, and beautiful newcomers Elizabeth Kaitan (or Cayton) and Cindy Beal, the film would have been a total wash. There's one scene that did stick with me: our two hunted femmes find themselves at a ravine that's bridged by a fallen tree. At the time I thought, "Man, this reminds me of KING KONG." Sure enough, I read an interview with director Ken Dixon a year or so later where he said Kong did indeed inspire this sequence. I'm also assuming most of the budget went into this decent visual.

So, if you want to see cute girls running around on an alien planet (that doesn't look much different from any national state park) in bikinis as robots chase them with continual lame dialogue, SLAVEGIRLS is the film for you. The NY crowd I saw this with mocked the acting for most of the running time. And despite the babes, I was eager to get on to the second feature. (Did I mention Elizabeth Cayton returned a year later in the wonderfully-titled ASSAULT OF THE KILLER BIMBOS? Surprise time: it was worse than SLAVEGIRLS!)

Moving on: Just two years after making a name for herself (and her shapely buttocks) in RETURN OF THE LIVING DEAD (1985), Scream Queen Linnea Quigley

had already began her downward spiral with CREEPOZOIDS, a tedious ALIEN rip off that features one of the dumbest-looking monster babies ever committed to celluloid.

Shortly after the film started, I remember everyone in the theater laughing because the film took place in the distant future of 1998(!).

After the world has been nuked (yawwwn), a group of survivors find an underground government research facility, where scientists were trying to find a way for humans to survive without food (yes, this script had Oscar written all over it). The crowd laughed like hyenas at the attacking giant rats (not as cool-looking as those in THE FOOD OF THE GODS [1976]), and of course shouted praise for Linnea's arse during the too-long shower/sex scene. YES—even the

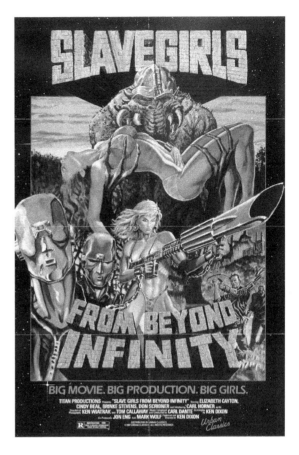

shower/sex scene wore out its welcome in this darkly-filmed non-epic from director David DeCoteau, previously responsible for gems such as DREAMANIAC (1986) and NIGHTMARE SISTERS (1987). (Researching DeCoteau, I have discovered he's been actively directing ever since, his latest being a FOOD OF THE GODS remake slated for 2011. Heaven help us if he recycles CREEPOZOIDS' rats for it).

Like all classic-era Times Square double features, the time spent outside the theater, along with the audience hi-jinks and continual insults at the screen, is what made films like these so enjoyable: I don't know how well I (or anyone else) would do with them on home video, so even if you're a sci-fi/trash film completist, approach both of these titles with extreme caution.

And a double-shot of espresso if you plan on making it to the end.

UPDATE: As of this writing, the FOOD OF THE GODS remake has not happened.

HOW COULD DECAPITATION BE SO MUNDANE?

981: My seventh grade buddies and I were hungry for gore. With DAWN OF THE DEAD, FRIDAY THE 13TH PARTS 1 & 2, a re-release of THE TEXAS CHAIN SAW MASSACRE and several early copycats already under our belts, we looked forward to the Friday papers and what new horror flick we'd discover in their weekend sections. A half-page ad for a double feature of STUDENT BODIES and NIGHT SCHOOL got our juices flowing: STUDENT BODIES turned out to be a slasher film spoof, which was odd considering NIGHT SCHOOL is a serious attempt at a slasher film.

This was 80s future-star Rachel (AGAINST ALL ODDS) Ward's debut film (at the time we just knew her as "that hot brunette that did the shower scene in NIGHT SCHOOL"—which is still rumored to have been the work of a body double).

After a daycare worker is decapitated in a playground on a carousel, a detective arrives and finds her head in a nearby bucket of water. They discover this woman worked at the daycare center during the day and went to a local college at night. The detective meets up with his partner at a hospital and they realize another female student has been missing from the same college...this one had also been decapitated and her head found in a pond.

Two decapitations. Two heads found under water. Our detectives have their work cut out for them. Even at this early stage of the film, cries of "Where's the blood?" came from a younger audience who were there to see the sauce. So far there wasn't much.

The detectives visit the dead girls' college and speak to one of their professors. We find out the flirty anthropology professor is dating Rachel Ward's character, and before long another student is beheaded at an aquarium (the shot of her head floating to the bottom was quite effective, earning cheers from a blood-thirsty crowd that was just about to start booing).

Another victim's head is found at a diner in a bowl of stew, another woman's in a toilet and the girl who finds THAT is quickly decapitated, all by a mysterious

killer in a black leather cycle jacket and black cycle helmet.

It turns out Rachel Ward's the killer—the first time a female slasher has been seen on film since the first FRIDAY THE 13th—and when she gets busted, she spews some nonsense about decapitating people in a way similar to one of the tribes her professor/lover has been teaching his students about. Why did she do this? I wish I could remember. All I know is NIGHT SCHOOL is one of those "on the fence" slasher films; you don't know if you should like the decent suspense and semi-attempt to tell an intelligent story or boo it for its lack of gore (I mean, a film about decapitation with almost no blood? Huh?). While it was a bit different (in 1981) to have a slasher film where the victims weren't brain-dead teens having stoned sex, much of it feels like a routine thriller, broken up by some neatly-place severed heads and Rachel Ward's shower scene (which, again, is still subject to validity).

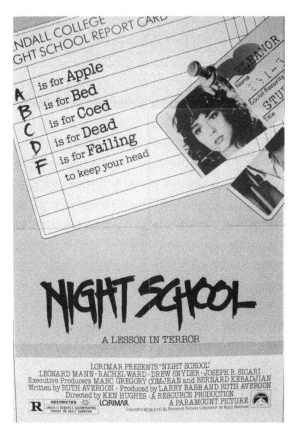

Each time the two detectives spoke, the audience broke out into laughter, not so much from their mediocre acting, but from their ridiculous assumptions (I'd really like to see this one again now that I think about it!).

While not a Gaillo film, it does resemble one, as it's more of a murder mystery than the horror film the catchy-theater poster promised. And if director Ken Hughes' name sounds familiar, it's because he directed another crazy film back in 1968, CHITTY CHITTY BANG BANG! (I kid you not). Oh, how the great ones fall. Not surprisingly, NIGHT SCHOOL was his last directorial effort.

While no masterpiece, NIGHT SCHOOL is a decent, interesting early slasher effort that could have been a lot worse. And for a suburban grindhouse crowd to be won over after an iffy start, you have to give it a little credit.

Suburban Grindhouse Memories No 19

WHERE'S THE MONSTER?

1980's PROM NIGHT quickly gained a respectable following among horror fans. Two years later, we were thrilled to see another film from director Paul Lynch (as far as I know, no relation to David). A quick and creepy TV ad for HUMONGOUS (1982) had my juices flowing for a few weeks before its release, not to mention a great poster campaign. Opening night at the Fox Twin Cinema was quite hot (being mid-June) and the crowd was eager to get into the air-conditioned theater. Little did we know we'd soon be eager to get back out …

Sometime in the 1940s, a wealthy woman is raped after teasing some poor schmuck, but thanks to her malnourished guard dog, manages to survive the attack (she even kills her rapist with a brick-to-the-head). The woman eventually gives birth to a deformed son (because, as we all know, rapes always create monster children, at least in the movies) and decides to raise him on an isolated island.

Flash forward to the present: a bunch of teens partying on a nearby island decide to head home but crash on another island before reaching the mainland (guess which island they get stranded on?) The rest of this stinker's seemingly endless running time features our "survivors" getting picked off by the oversized deformed rape monster, mostly in some very poorly lit sequences. In fact, every time a kill scene occurred, everything became darker and the crowd booed louder and louder and with more frustration; it was nearly impossible to tell what was happening. Why director Paul Lynch chose to do this is anyone's guess, but it didn't earn him any new fans as a filmmaker (at least no one I know). Some online reviews of this film claim this was the result of a bad, early VHS transfers, but as someone who sat through this the night it was released in a theater, I can say they're incorrect.

One of the more memorable scenes features one of the girls dressing like the monster's mother, trying to trick him (you may remember this same tactic was attempted a year earlier in FRIDAY THE 13TH PART 2).

This brought yells of "RIP OFF!" from the crowd, which caused my friends and me to laugh, and join in on the commentary. The only thing we couldn't insult was the acting, which was well done for this type of film (except for one of the girls who had quite an irritating accent).

While the monster/slasher is only seen in shadows and ever-so-briefly, our stranded crew eventually discover a diary kept by the thing's mother which sheds some light on why "Humongous" is the way he is. I'm guessing Lynch either a) wanted the audience to use their imaginations to picture something more gruesome than FX could show, or b) their budget just didn't have enough for the effects (or blood, for that matter, as very little is shown).

With several better slasher films released in '81 and '82, it's easy to see why HUMONGOUS came and went within a week and was all but forgotten among genre fans (and while it found a micro-following upon its 80s VHS release, an official DVD has yet to surface).

This one's a real chore to get through (despite a grim opening and

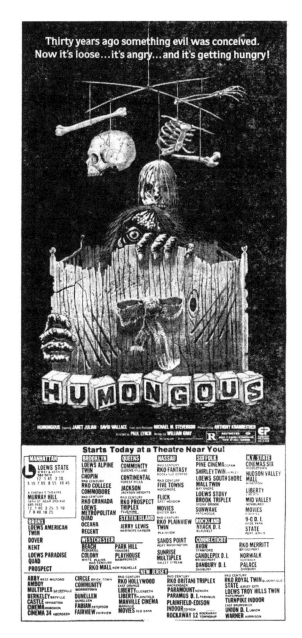

decent 15 minutes). Plus, how can anyone recommend a horror film in which the most memorable scene is a topless girl laying on top of some guy to keep him warm?

NEXT!

Suburban Grindhouse Memories No 20

AN EYE-OPENING SECOND FEATURE

How or why Barbara Bach was conned to star in the unwatchably bad 1980 slasher film, THE UNSEEN, is anyone's guess. It's one of the few films I've ever walked out of (and if I walk out on a film, there's simply NO hope for it!). Thankfully, the first of this double feature (which stormed NYC theaters in 1981) was a wicked little sexploitation film from 1968, re-titled in the 1970s by the always reliable Harry Novak, and yet again unleashed on an unsuspecting public just in time for my seventh grade eyes to feast upon.

BEHIND LOCKED DOORS earned audible groans from the audience upon its early scenes of two girls dancing around at a hippie "rave" party held at an isolated barn house. We all knew this was some recycled left-over acid trip from the Woodstock era, but before anyone could complain any louder one of our girls is struggling away from an attempted rape. Whoa … where did that come from? She's rescued by a slightly overweight guy who looks eerily like Henry Kissinger, but little does she (or her girlfriend) know that her would-be hero has also siphoned all the gas from their car!

Stranded in the middle of nowhere, Ann and Terry search for a gas station when they eventually find a house that's even more isolated than the party barn. Surprise, surprise: it's the home of Ann's rescuer, who they discover is named Dr. Bradley. He lives here with his sister, Ida, who likes to spy on people before breaking out her whip.

Most of the audience had no idea what to do with this set up. My friends and I laughed at the continual, silly softcore sex scenes, and a couple of us yelled out in geek-glee when Dr. Bradley's handyman came walking out (cult film freaks will recognize him from 1974's SHRIEK OF THE MUTLIATED). Although he doesn't do anything as depraved as the doctor or his sister, it is hinted that he's a necrophiliac. Just seeing this whack-job from one of my favorite trash films made my day. (The three stars of BEHIND LOCKED DOORS, Eve Reeves, Joyce Danner, and Daniel Garth have only starred in this one film … and if you watch it you'll see that acting wasn't a good career choice for any of them).

The second half of BEHIND LOCKED DOORS takes a spooky turn. Ann and Terry are offered a room for the night, but discover (too late) that it locks from the outside. Now captives, they panic, wondering what this freak and his sister have planned for them. If nothing else, BEHIND LOCKED DOORS stands above countless other exploitation films of the time due to its growing sense of doom; while there's plenty of nudity and simulated sex scenes (plus off-screen violence), I doubt anyone who paid to see this was expecting more than a T&A show. Despite the horrendous acting, there's some real tension, enough to quiet down my fellow suburban film-goers who thought they might be getting duped

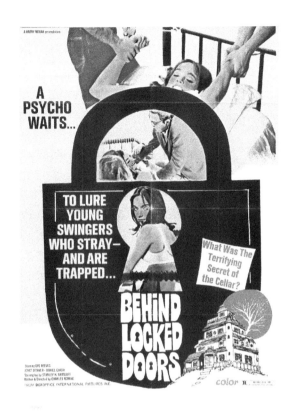

(although when Dr. Bradley began to rub oil on his slightly plump, pale torso in preparation of his "love experiments," the place howled in both laughter and disgust. I still crack-up whenever I think of the crowd's reaction).

In one eerie sequence, our girls discover a basement full of corpses posed as statues (if memory serves me, they were actually bloodied mannequins). Between this, the rape scenes, and the doctor's sister, I continue to wonder if I SPIT ON YOUR GRAVE (1978), TOURIST TRAP (1979) and MOTEL HELL (1980) didn't each borrow a little bit from this seldom seen 60s shocker.

With a semi-happy ending (and the discovery that "Dr." Bradley is actually a demented mortician), BEHIND LOCKED DOORS was a fine way to kill an afternoon at my local cinema, and at least made us feel we got our money's worth when we left about 25 minutes into the main feature (seriously: THE UNSEEN should remain unseen!). I saw this for a second time in the late 80s on VHS, and there's a double feature DVD available from the fine folks at Something Weird Video (although the other feature—thankfully—isn't THE UNSEEN).

Suburban Grindhouse Memories No 21

WHEN SLEEPOVERS (AND SLASHER FILMS) WERE FUN

While 1982 was still fairly early into the slasher film explosion, who would've thought a routine, by-the-numbers, T&A-filled, gory, psycho-escapes-from-the-nuthouse flick (produced and directed by a woman, no less) would turn out to be one of the slicker, more entertaining films of its kind? Surely not me when I ventured to Staten Island's now long-defunct Fox Twin Cinema for an early showing of SLUMBER PARTY MASSACRE one Saturday afternoon, accompanied by two buddies (one who we had to drag along).

A cute high school girl named Trish decides to invite her friends over for a slumber party (most of them members of the girls basketball team). Before you can say BOO! we see a middle-aged man stalking her around the school grounds. When he kills a telephone repair woman in the back of her van (while our party-planning teens converse close by, unaware), he discovers an extra-long drill (which he uses to knock off the rest of the cast). Seriously, this thing is about 10-times longer than that little Tonka toy used in DRILLER KILLER (director Abel Ferrara's way-overrated 1979 slasher outing). While there's a lot of action, kill scenes, and scantily clad teenage girls running around the rest of the film, this early sequence managed to quiet down the audience (mostly young teenage males whistling at the onscreen females) due to its well-done camera angle: we see the woman being killed through the rear window of the van in the background, between two talking high school students. For this type of film it's a brilliant piece of horror that managed to get the crowd to take the rest of the film more seriously. Everyone knew this wasn't going to be just another HALLOWEEN-wannabe to openly mock.

The THEN future scream queen legend Brinke Stevens plays one of the girls who gets killed before the party even starts, although I didn't know who she was until seeing this for a second time sometime in the late 80s on VHS.

The one thing we all noticed about halfway into this was the killer, named Russ Thorn, never hides his face behind a mask or under a pillow case, unlike

the more famous cinema slashers. He walks around (at night, anyway) proudly holding onto his oversized drill (possibly compensating for something??), not worried about who might see him. To me, that's a TRUE psycho! I got a kick out of this guy, who for some reason reminded me of BLOOD FEAST's killer, Fuad Ramses (for those who don't know, BLOOD FEAST is considered the first gore film—it's from 1963—and one of the earliest slasher films).

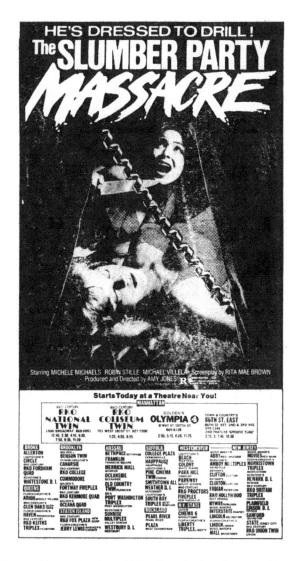

The best thing about SLUMBER PARTY MASSACRE is the final 20-25 minutes: after a night of stalking and slashing the outside grounds (my favorite being when the girls answer the door to find the pizza delivery boy with his eyes drilled out), Russ Thorn finally manages to break into the house, and chaos ensues. He chases the partying pretties all over the joint, drilling those who trip or aren't faster than a middle-aged man (funny, being most of these girls allegedly played basketball). While it's true some of the acting during this finale isn't exactly top-notch, it works because it's done seriously and is actually suspenseful. After a lot of false-scare scenes (something that has become beyond played out in horror films), the real ones come fast and furious, and we truly wonder who (if anyone) will survive.

HUGE props must go to producer/director Amy Jones, who released this film among a tsunami of male-made slashers … and she not only managed to hold her own, but did a better job than most of what was around at the time. It was

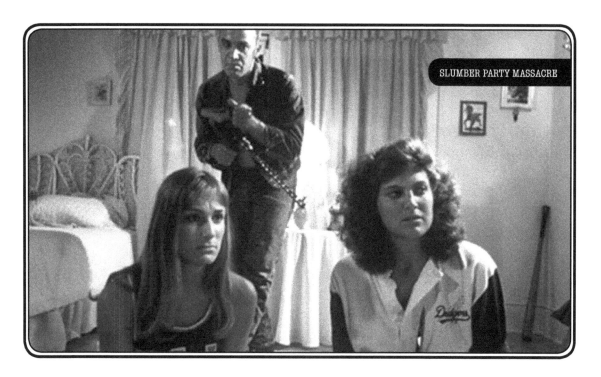

SLUMBER PARTY MASSACRE

also refreshing to see the female cast not acting like ditz-bombs, and some of them taking on heroic roles.

But all that aside, SLUMBER PARTY MASSACRE was (and still is) a rip-roaring fun time, and even had a midnight run at Manhattan's Waverly Twin Theater for several months in 1983, becoming the first slasher film to gain that type of a cult following (at least that I know of). While I must admit to really liking the 1987 sequel (titled—you guessed it—SLUMBER PARTY MASSACRE 2—also directed by a woman), the original quickly became one of my favorite slasher films, and one of the most fun times I've had at a suburban grindhouse.

You just can't enjoy these films the same way unless you're in a theater full of excited, like-minded fans.

(Note: Avoid SLUMBER PARTY MASSACRE 3 [1990] at all costs)

Suburban Grindhouse Memories No 22

WHO KNEW SASQUATCH WAS SO MAD?!

While listed as being made in 1980, the gory NIGHT OF THE DEMON looks to be a few years older. I caught this on a double bill (around 1983) with the lame killer-rat film OF UNKNOWN ORIGIN, and while I can hardly remember ORIGIN, NIGHT OF THE DEMON turned out to be a very well done monster-on-the-loose flick.

Faithful readers of this column have heard me mention the Amboy Twin Theatre, one of Staten Island's finest venues for underage patrons to be admitted to an R-rated film. OF UNKNOWN ORIGIN was a mainstream release, and had a solid TV ad campaign. But during its second week of release, several theaters in

the NY/NJ area decided to add a second feature to it … and I'm glad they did. I'm still convinced whoever was responsible for this didn't watch either film; while they're both "monster" movies, DEMON's penis-amputating Sasquatch was just slightly more hardcore than ORIGIN's annoying rat. And thanks to the money-hungry suburbanites at the Amboy Twin, my sophomore eyes got to see the hairy carnage on the big screen.

An anthropology professor (why do all Bigfoot/Yeti films have an anthropology professor?) convinces a bunch of his students to go looking for the source of a rash of recent murders (for a professor, the guy's a real moron) as the culprit is reported to be a Sasquatch-like creature. That's basically the entire story … but what makes NIGHT OF THE

DEMON so much fun are the kill scenes. The professor tells his posse (around a campfire) the stories he's heard of Sasquatch-related killings, the best being some poor biker who pulls off the road to take a leak. As he whizzes into a bush, he gets his Johnson yanked off by a strong, hairy arm. With the exception of the infamous decapitated-head-goes-down-on-woman sequence from ReANIMATOR (1985), I can't recall a crowd going more crazy for a scene … and this was one of the earliest kills in the film.

In an attempt to add a little to the story, our search party finds an old woman who lives isolated in the woods and discover she had a baby with the Sasquatch (oh yes folks, one of the finest moments in American cinema in my opinion). While we only see the offspring's head in a quick close-up, he looked an awful lot like one of the title creatures from WAR OF THE GARGANTUAS (1966).

DEMON's body count puts most slasher films to shame. In one Oscar worthy sequence, a couple shagging in a van fall victim to the irritated Bigfoot (why he's so pissed is never clearly explained). There's proof that Sasquatch is almost as inventive as SAW's Jigsaw: two female tour guides—walking around with pocket knives—are picked up by the hairy demon who then smashes them together, causing them to stab each other until they're both a bloody mess. There's also an arm amputation, bodies impaled on glass, rocks, and in one of the more memorable scenes, Sasquatch rips a guy's intestines out and uses them to whip and strangle a room full of coeds.

THIS is entertainment, folks.

Like any genuine trash film, NIGHT OF THE DEMON is plagued by sub-par acting, inept dialogue, and so many technical errors my friends and I had a hard time keeping up with them. There are also plenty of boobs flopping around the forest, so perhaps, like your standard human slasher, Sasquatch just doesn't go for sex on his turf.

Despite the low budget and everything else it has going against it, this film still manages to work. It entertains more than any other Bigfoot/Yeti film this side of SHRIEK OF THE MUTILATED (1972). Considering this was the only film directed by James C. Wasson, it's safe to say he put everything he had into it, so at least give him a big E for effort.

If the sheriff looks familiar to you, you may be one of the 6 other people who saw him as a detective in the nearly impossible-to-watch MEATCLEAVER MASSACRE (1977). No? I didn't think so…

MODERN MEMORIES: "BACK TO THE GRIND"

t's that time again, faithful readers—time for me to cover a new film. And considering the subject matter of this 2010 documentary (that made its New York City debut this past weekend) I'm sure you'll agree it fits perfectly with this column's bi-weekly theme.

AMERICAN GRINDHOUSE is an ambitious (although nowhere near comprehensive) history of exploitation films. To my surprise, the majority of the film focuses on pre-60s cinema, going all the way back to Thomas Edison and how the earliest of films often featured themes and scenes that were precursors to the sleaze that came decades later. While younger audiences might groan at this, I

found most of it interesting, and for those who haven't read much on the subject, there are many things to discover. Director Elijah Drenner does a fine job of highlighting the seedy side of early American cinema, from the silent era through the explosion of "nudie" films that came on the heels of World War II. There's actually so much pre-60s material in the first 60–70 percent of AMERICAN GRINDHOUSE that I'm looking forward to a second viewing just to hear what I missed (there's plenty of laughs and "I can't believe they showed that in the 20s/30s/40s!" throughout).

When we get to the 60s (specifically, the gore films of Herschell Gordon Lewis and the "Nudie Cuties" of Russ Meyer) the film seems to "speed up." There are many onscreen interviews with 60s and 70s exploitation film icons such as Lewis,

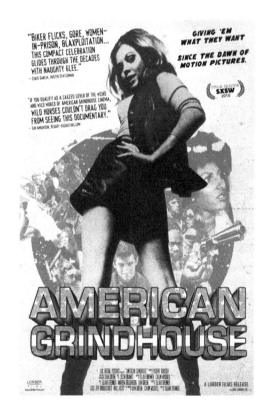

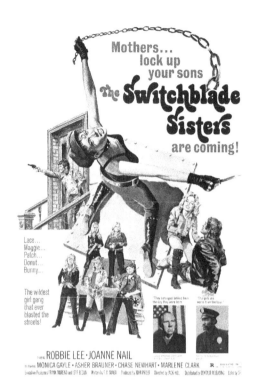

Mothers...
lock up
your sons
The **Switchblade Sisters** are coming!

Lace...
Maggie...
Patch...
Donut...
Bunny...

The wildest girl gang that ever blasted the streets!

ROBBIE LEE · JOANNE NAIL
MONICA GAYLE · ASHER BRAUNER · CHASE NEWHART · MARLENE CLARK R

Ted V. Mikels, and Jack Hill, yet the film seems as if it struggles to stay within its brief 80-minute running time by rushing through most of its final quarter. Had there been the same amount of time given to the post-60s films as with the pre-, AMERICAN GRINDHOUSE could've easily been a 2-hour (or longer) epic.

Yet, as it stands, it's still incredibly entertaining (if these films interest you).

For the fan boys: there are multiple talking head interviews, and thankfully most of them are funny and you might actually learn something about the plight of the low-budget filmmaker. The most entertaining interview is easily Don Edmonds (director of two Ilsa films, most notably ILSA: SHE WOLF OF THE SS [1975]). He reluctantly took the directing job after reading the screenplay, then basically figured he may as well do it as outrageously as possible. Herschell Gordon Lewis doesn't say too much that his fans haven't already heard, but he makes one statement that even I—as a major Lewis fan—had to laugh at. He claims the tongue-ripping scene in BLOOD FEAST (1963) changed the direction of American cinema. Perhaps the 'ol Wizard of Gore's getting a bit silly in his golden years? Any horror fan knows that credit goes to the shower scene in PSYCHO (1960). There's a great comparison of Hitchcock's classic and Lewis's BLOOD FEAST, as well as a look at PSYCHO's grindhouse-style marketing campaign. Ted V. Mikels gives a funny synopsis of his classic THE CORPSE GRINDERS (1971) and Jack Hill speaks of his two women-in-prison classics, THE BIG DOLL HOUSE (1971) and THE BIG BIRD CAGE (1972), but I was disappointed there wasn't even a mention of SPIDER BABY (1968) or a personal favorite of mine, SWITCHBLADE SISTERS (1975). There's a LOT of talk with director John (KENTUCKY FRIED MOVIE) Landis, so if you're a fan of his you're in for a major treat. William (MANIAC) Lustig gives some of the best memories of New York girndhouses, as well as the rise of the hardcore porno film. Blaxploitation is briefly covered, with short (but sweet)

interviews with Fred Williamson and Bob Minor. There's many other appearances, including Joe (GREMLINS) Dante, David (LAST HOUSE ON THE LEFT) Hess, Judith (THE BIG DOLL HOUSE) Brown, Larry (IT'S ALIVE) Cohen, Fred (HOLLYWOOD CHAINSAW HOOKERS) Olen Ray, James (THE TORMENTORS) Gordon White, and Jonathan (NIGHT CALL NURSES) Kaplan. Despite all these famous (and infamous) exploitation personalities, the audience gave the biggest laugh and applause to the relatively new film critic Kim Morgan (she'll be on a revamped "AT THE MOVIES" TV series this year) when discussing sex on film.

There was some talk in the lobby afterwards on how many more films could've/should've been covered. My biggest gripe is how the 80s are all but forgotten (the film DOES mention a few post 70s films, including—shocker here—Tarantino's GRINDHOUSE [2007]). 42nd Street in NYC was home to many grindhouses up until the mid-late 80s (which is where I saw countless slasher, zombie, and action films during my teenage years). The whole 80s slasher/gore re-kindling was ignored (despite being a MAJOR part of the latter-day grindhouse scene), and the small amount spoken of women's prison films was surprising, especially how popular they became in the 80s (mainly due to the mainstream Linda Blair film CHAINED HEAT). I also found it odd to see a segment on blaxploitation films with no mention of Rudy (DOLEMITE) Ray Moore.

Again, AMERICAN GRINDHOUSE is a fine primer for those interested in where the sleazier side of cinema came from. While I learned a couple of things—especially about the older films—most of what's on display here should be common knowledge to trash film aficionados. And yet as a fan of this stuff, I sat through these 80 fun-filled minutes with a (mostly) satisfied grin, hoping director Elijah Drenner will give us a sequel (or at least a ridiculously extended "director's cut" DVD).

A chat with American Grindhouse director

ELIJAH DRENNER

 UBURBAN GRINDHOUSE (SG): What initially attracted you to the whole grindhouse thing?
Elijah Drenner (ED): My interest was in the movies and filmmakers, before they began being identified as "grindhouse". For me, these

ELIJAH DRENNER

were movies that I would read about, years before seeing them. So my interest was in the film history and hearing about these movies by the filmmakers who made them.

SG: How long did it take to compile the footage used in AMERICAN GRINDHOUSE?
ED: We shot off and on for about 2 years.

SG: Were there any grindhouse or grindhouse-like theaters were you grew up? If so, any fond memories you can share?
ED: None at all. I grew up in the midwest where we had drive-ins. But again, the movies I was interested in were hard to find. One had to seek them out and know what to look for. So I scowered our local Ma and Pa Video Stores, often asking if I could buy some of their VHS tapes of movies that were not rented regularly. I got a lot of great stuff that way.

SG: As of this writing it has been over four years since AMERICAN GRINDHOUSE was released. How has the response been?
ED: Good. At least, I think its been good. People seem to keep finding it and discovering the films and filmmakers — which is, I guess, why we made it.

SG: 2014 saw the release of your documentary THAT DICK MILLER GUY. Do you have any more feature-length documentaries in the works?
ED: I'm always kicking around ideas, but TDMG was a massive endurance test. So I'm enjoying the time off. But yes, I do hope to get another feature-length film-related documentary going again soon.

HUMANOID FROM THE DEEP WOODS

 982's creature feature THE BEAST WITHIN was a genius of movie marketing. By taking a typical 50's monster movie plot, adding updated 70's/early 80s monster-rape mayhem (ala XTRO and HUMANOIDS FROM THE DEEP), and packaging it with one of the best TV ad campaigns seen since the golden days of exploitation cinema, this effective, low-budget shocker gave theater goers everything they were promised … except for a coherent plot.

For about a month before THE BEAST WITHIN's Feb. 15th, 1982 opening weekend (YIKES! that's almost 30 years ago!), MGM ran a relentless television ad campaign that featured a slow zoom-out of the theater poster with a man's voice saying something like, "The producers of this film DARE you to sit through the last 30 minutes of THE BEAST WITHIN without covering your eyes, screaming, or running from your seat! They DARE you!" Ka-CHING! That was the sound of every horror fans around the United States being reeled in, and of course yours truly was in attendance opening night at the (of course, now defunct) Rae Twin Cinema, a slim but lengthy duplex that was located adjacent to an OTB. The excitement waiting in line to see this was kind of amazing for a low-budget horror film: people bopped around (whether due to the cold or from being psyched by the TV ad, is anyone's guess) as old men cut through the line to lay cash down next door on the ponies.

I stared at THE BEAST WITHIN's poster, which reminded me of a few favorites from the 70s, such as CREATURE FROM BLACK LAKE (1976) and THE LEGEND OF BOGGY CREEK (1972). I wasn't too surprised when the film began and I discovered it took place in Mississippi: despite the TV commercial having no scenes from the film, the poster just gave it that vibe. (Okay, who am I kidding? The pre-coverage in Fangoria magazine had spilled a few beans).

Part of the genius of DARING an audience to make it through the last 30 minutes of a film is the producers now had the freedom to give us a crappy, boring first 60. But thankfully—and despite a slow scene or two—THE BEAST

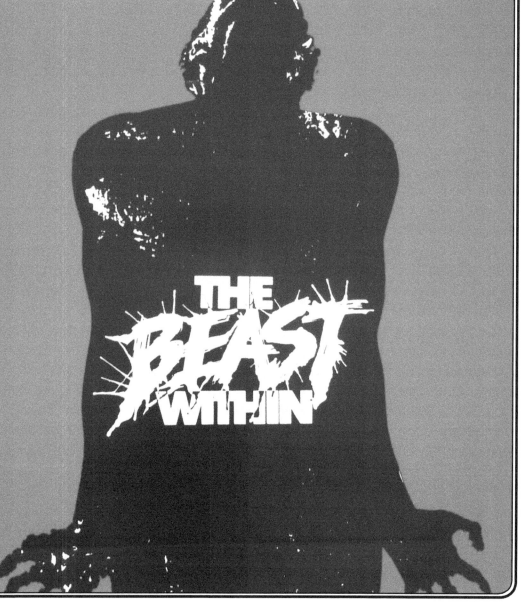

WITHIN turned out to be an effective little monster movie, beginning in the 1950s when some poor newlywed woman is raped on a dirt road by a bug-eyed creature, and of course the rest of the film dealing with her son who is the creature's offspring. While his parents didn't understand this yet, the audience pretty much had it figured out from the get-go.

It doesn't take long for 17 year-old Michael (played nicely by Paul Clemens, who starred in a few other genre outings) to start showing signs that something wasn't right in his life. He begins having violent outbursts, local townspeople are found dead, all leading up to one fantastic metamorphosis-sequence courtesy of underrated FX whiz Thomas Burman, who worked on the great 1977 version of THE ISLAND OF DR. MOREAU, 1978's INVASION OF THE BODY SNATCHERS, 1979's mutant-bear epic, PROPHECY, and, more famously, had a hand in THE GOONIES (1985). Here, I dare say he even gave the Oscar-winning werewolf-transformation sequence in AN AMERICAN WEREWOLF IN LONDON a run for its money.

THE BEAST WITHIN turns out to be some kind of cicada-insect creature, and while it's not even remotely explained why or how this thing exists, I always found this missing information added to the film's overall creepiness (I remember at the time a lot of people left the theater complaining about it). The plot is infested (full pun intended) with this and other plot holes, but people who come to a monster movie with a gimmick marketing campaign really shouldn't be looking for logic. They should come looking for fun—and the last 30 minutes of this delivers the goods: The BEAST is on the loose in a small town as a few rednecks take refuge in a police station (my favorite scene has one older man—who decides it'd be safer to lock himself in the jail's small holding pen—has his head ripped off when the BEAST slams his insectoid-hands through the only non-barred side of the cage and pops his noggin' like a dandelion!). All sorts of carnage ensues, including (SPOILER ALERT!!) Michael/BEAST impregnating some poor lass to keep the bug-line going, shortly before his mother blows his head off via shotgun for a dark and satisfying finale.

I'm not sure how well this one holds up on cable or DVD (I've only seen it once that opening night, way back when), but for a bunch of high school freshman, it worked like a charm and spewed us out of the theater with wicked grins on our popcorn-buttered faces. I think I'll re-watch this the next time it airs on the IFC channel, which it does quite often...

MODERN MEMORIES: THE GODFATHER FINALLY GETS HIS DUE

fter recently viewing the documentary AMERICAN GRINDHOUSE, where exploitation director H.G. Lewis has a brief (but memorable) appearance, my appetite was set for more from the "Wizard of Gore." Directors Jimmy Maslon and Frank Henenlotter do a phenomenal job of satisfying that appetite with HERSCHELL GORDON LEWIS: THE GODFATHER OF GORE, a 106-minute look at the life and career of a man who is both worshipped and loathed in horror film circles.

There's a lot of time spent on Herschell's pre-gore films, which were mainly nudie movies. Herschell's old partner, David Friedman (who passed away February of 2011) shares some hysterical stories of what they went through when they got into the nudie film market, and confesses they were coming in on the heels of what Russ Meyer was doing at the same time. But where Meyer

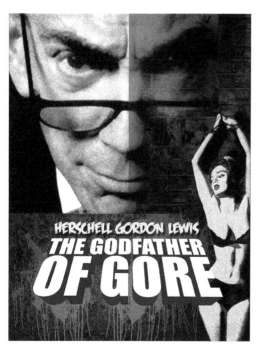

shot his women in an innocent, almost artistic way, Lewis and Friedman always featured their women in ways that could more easily be taken as something more than a tame peep-show (and hence a precursor to their coming extreme horror films). And the duo's explanations of how nudies (as well as all independent films) were distributed back in the early 60s will give modern filmmakers a whole new appreciation for what Lewis had to go through to sell his product.

For those fascinated with the evolution of the "splatter" film, it's simply amazing how Lewis came up with BLOOD FEAST (1963). He and Friedman had wondered to themselves, "What is something that

NO ONE else is doing right now?" (in the world of exploitation films). They had been in Florida staying at a hotel with an Egyptian theme, and before long they started writing/shooting BLOOD FEAST on the fly. Fans of the film will be glued to the screen when star Mal Arnold (who plays the film's killer, Fuad Ramses) is interviewed (there's even footage of some early nudie films he had done for Lewis), and when Lewis speaks of the difficulties they had working with Playboy Playmate Connie Mason, who had zero acting abilities and refused to do a nude scene despite being a Playboy centerfold. There's also much about actor William Kerwin, who plays BLOOD FEAST's main detective (and starred in many other Lewis films) and was also Lewis' "do everything else" guy on several projects. Kerwin died in 1989, and his presence as a commentator would surely have added to this film.

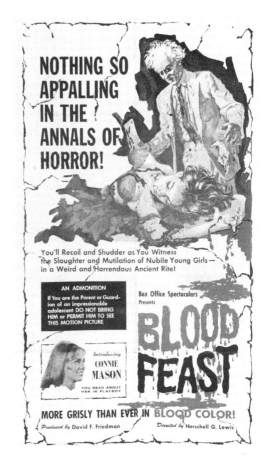

The success of BLOOD FEAST (despite horrendous reviews—some critics are interviewed) made Lewis and Friedman a lot of money, and set them on a course they never thought would catch on.

If you're a fan of Lewis' second gore film, 2000 MANIACS (1964), you're in for a treat. Directors Maslon and Henenlotter cut footage from the original film's opening sequence with new footage of Lewis and Friedman revisiting the small Florida town where they shot MANIACS, making it look like the original cast is welcoming them back to town. They visit the hotel and some rooms where the film takes place, and there are interviews with some of the cast (including an adult Vincent Santo, who played young Jimmy in the film). Lewis says 2000 MANIACS is his personal favorite film, the one he wishes he'd be remembered for, although he knows BLOOD FEAST will forever hold that

title. There are also some great stories of what went on with some of the gore effects, and a near-fatal accident Lewis almost had while filming the infamous boulder-drop sequence.

One of the funniest interviews comes from director Frank Henenlotter. He claims one of his favorite scenes in any movie—ever—is in Lewis' COLOR ME BLOOD RED (1965). And when you see the scene he's speaking about, you'll laugh as hard as the audience I saw this with. Henelotter's commentary is always interesting, as are memories shared by director John Waters (who shows off his rare novelizations of two Lewis films) and the legendary Joe Bob Briggs. Former Playboy photographer Bunny Yeager shares some great stories and explains why she refused Lewis' offer to star as Connie Mason's mother in BLOOD FEAST.

Being a huge fan of Lewis' 1970 epic THE WIZARD OF GORE, I was happy to see plenty of interview time with its star, Ray Sager. Every time he imitates Herschell the crowd cracked up, and his story of a blooper he caused on the set of Lewis' JUST FOR THE HELL OF IT (1968) is priceless.

Every one of Lewis's gore films get coverage (there's even a lot of time spent on A TASTE OF BLOOD (1967), Lewis's attempt at a modern Dracula film), and gorehounds will be happy to know they show all the blood and guts in all their karo-syrupy glory. An audience favorite seemed to be stories told about THE GRUESOME TWOSOME (1967), as well as the dual nipple-slicing scene from THE GORE GORE GIRLS (1972).

While I would've liked to have heard a bit about some of the director's more obscure titles (such as 1969's LINDA AND ABILENE), Lewis does spend some time explaining what caused him to "shoot" a kiddie feature in 1967 titled THE MAGICAL LAND OF MOTHER GOOSE (and it's a doozie!). There's also no

mention of BLOOD FEAST 2 (2002) or THE UH-OH SHOW (2009), two recent films directed by Lewis (which I found odd), although they do go a bit into his post-film career as a money-marketing expert.

There's also a genuine treat IN the film itself: Henenlotter and Maslon managed to get footage of a film Lewis never finished titled AN EYE FOR AN EYE, and pieced it together as a mini-movie (which stars BLOOD FEAST alumni William Kerwin). It's a supernatural-type thriller and actually seemed to be of higher quality than most other Lewis films.

I'm not sure how interesting THE GODFATHER OF GORE will be to the average horror film fan; surely the history of BLOOD FEAST and Lewis's early gore films should have respect from any genre fan, but it's no secret that the majority of horror fans find Lewis' work too bad to watch and too cheap to even mention. But love it or hate it, BLOOD FEAST started something (and yes, I know a film from Japan released in 1960 has recently been claiming the title as the world's first gore film—but I'm willing to bet it's not a quarter as entertaining— or gory—as Lewis' epic … and it didn't inspire the slasher films to come in the 70s and 80s).

Packed with more gore and nudity than any documentary I can think of, THE GODFATHER OF GORE is almost like watching a "Greatest Hits" list of Lewis films, so I'm hoping newcomers will be enticed to go back and check out these precursors to FRIDAY THE 13th (1980) and HALLOWEEN (1978), and the haters may see what a great guy (if not the greatest director) Herschell Gordon Lewis was (and still is).

Even though I've been a fan of Lewis since reading about him in the fourth issue of FANGORIA magazine way back when, have read three books about him, and have met and spoken with him and David Friedman, I still learned some things about him in this wonderfully entertaining and educational tribute that any horror fan interested in the roots of modern horror cinema would be crazy to miss.

(The film is dedicated to the late Daniel Krogh, who filmed a few of Herschell's later films and co-wrote the first book about him titled THE AMAZING HERSCHELL GORDON LEWIS AND HIS WORLD OF EXPLOITATION FILMS [1983 Fantaco]).

Suburban Grindhouse Memories No 26

WHEN SLASHERS BECAME ABSURD

"You Don't Have To Go To Texas For a Chainsaw Massacre!"

With a poster blurb like that (not to mention the artwork), what horror fan wouldn't be lured into the theater in less than a second? And in 1982, my gang of high school freshman gorehounds and I hit the (you guessed it—now defunct) Rae Twin Cinema (where waiting in line to get in was often scarier than the film you were waiting to see: an adjacent OTB was often the scene of fights, ticked-off, bottle-tossing losers and drug deals gone awry).

You've heard of a "so-bad-it's-good" movie? Well, PIECES is a "so-bad-it's-mind-boggling-awesome!" masterpiece.

Some poor 8-year-old's mother finds his puzzle of a naked woman (and his stash of porn magazines hidden in his toy chest), but instead of throwing them out, the nag burns them right in front of the poor, young perv. Furious, the kid decides his mother has earned herself an axe in the head and wastes no time making his dream a reality. To say the audience went wild with laughter and gasps is an understatement.

In following the traditional slasher film pattern, the movie then flash forwards forty years (to 1983), where there has been a string of murders on a college campus. Some psycho has been chain-sawing female victims, taking different parts from each one and leaving a string of amputees. Christopher George (you've seen him in Fulci's CITY OF THE WALKING DEAD (1980), as well as 1981's GRADUATION DAY), Frank Brana, and Christopher's wife, Linda Day George, all play detectives and head an all-star trash film cast, including Paul Smith of MIDNIGHT EXPRESS (1978) and CRIMEWAVE (1985), and Jess Franco alumni Jack Taylor. The nearly-inept screenplay was co-written by Dick Randall, who was responsible for a bunch of EMANUELLE and kung fu films.

Oh yes, there's also a host of cute college girls who get chainsawed and sliced & diced with more nudity than your average genre outing. PIECES—as

another poster blurb states—is "Exactly What You think It Is!" The film never hid the fact that it was simply an excuse to show excessive gore, and as a young gorehound, I was in my glory here, especially when the camera didn't cut away during one kill scene where we actually see a chainsaw cut through a victim's mid-section. While I didn't find this sequence too entertaining during a recent DVD viewing, it sent me into a state of gorehound glee when viewed at this 1982 opening night screening. With the exception of 1970's THE WIZARD OF GORE (which I wouldn't see until a few years after this, thanks to VHS), no other horror film (including the original version of THE TEXAS CHAIN SAW MASSACRE) actually showed the audience something this graphic before.

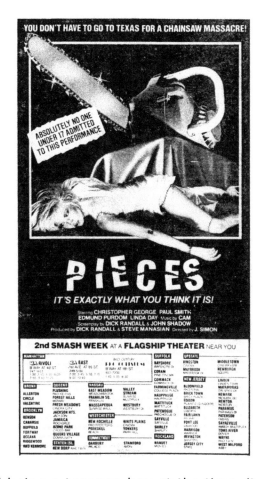

To be honest, PIECES is an awful, pointless mess of a movie, existing only to exploit gore and nudity: (i.e. it's a teenage-boy's-night-out type of film—and being a teenage boy at the time, it was right up my alley!).

So while modern viewers can forget about any kind of story here, they can still thrill to Linda Day George—after she is too late to save a victim—scream the word "Bastard!" about five times in a row, in what could easily qualify for the worst piece of dialogue and acting ever committed to celluloid. They can also have fun trying to figure out how the killer is able to sneak a 2-foot long chainsaw onto a tiny elevator simply by hiding it behind his back, right in front of his next victim (despite its ridiculousness, the scene is actually quite claustrophobic and cringe-worthy).

And next to the gore and nudity, the creators of PIECES also thought it'd be good to feature a bizarre foot fetish scene, a wacky karate instructor, a

HIS DEVASTATING TOOL MADE WOMEN SCREAM!

Chainsaw Devil

HE'S A REAL BASTARD!

Starring CHRISTOPHER GEORGE PAUL SMITH
EDMUND PURDOM LINDA DAY Music by CAM
Screenplay by DICK RANDALL & JOHN SHADOW
Produced by DICK RANDALL & STEVE MANASIAN Directed by J. SIMON
A BEYOND HORROR DESIGN RELEASE

killer who dresses like he's in a serious Gaillo film and some scared girl peeing her pants. (I should mention here that Italian exploitation/porn film icon Joe D'Amato was one of the three screenwriters … if his name's unfamiliar, Google him—but don't say I didn't warn you).

Spoiler Alert! This Spanish-shot film (that tries to fool audiences into thinking this is all happening somewhere in America) has one of the most ridiculous endings next to THE MUTILATOR (1985). It seems our killer (GASP!) happens to be the boy who had his porno puzzle burned 40 years earlier (making him one of the oldest slashers in horror film history), and has been busy building a human body puzzle from his freshly-cut victims (so those of you who thought MAY (2002) was original, sur-prise!) This half-baked film then concludes with the freshly-stitched female Frankenstein coming to life and ripping some poor guy's manhood off. Yowch...

They just don't make 'em like PIECES anymore.

For grindhouse fiends, that's sad news. For serious cinephiles, that's a blessing. Either way, PIECES is one slasher film that no one who sees it ever forgets. And that's saying something.

TWO MACHETES ARE BETTER THAN ONE

 n a brisk Friday afternoon in early 1982, an ad for a film titled JUST BEFORE DAWN caught my eye in the local newspaper. But what caused major interest in me was who the director was: Jeff Lieberman, who had directed the killer-worm epic, SQUIRM (1976), which I must've seen twenty-five times on TV during my childhood (and years later I finally found a DVD of his seldom seen 1978 acid-slasher epic, BLUE SUNSHINE). I was geeked-out happy when I arrived at the (now defunct!) Fox Twin Cinema to see this new film by the director of who helped me waste so many hours of my youth in front of the boob tube.

The legendary George Kennedy stars as a park ranger who warns a group of five future-victims not to go camping in the direction they're headed (yes, I hear you yawning, but remember this was 1982 and every other horror film released during this time had the same plot). As they get closer to the mountain they plan to camp on, they're warned a second time by a crazed old man that there's demons running around the hills (yet another staple of 80s slasher films). One of the campers is there to look over some property he has inherited, so the warnings mean nothing to him (can you say "mis-take?").

When their RV can go no further, our victims—err—campers decide to hike the rest of the way up the mountain (I don't know about you, but if I inherited land this remote I'd just give it to the locals). Before long our friends start getting picked off one by one, and unlike many slasher films of the time, Lieberman's direction works: once camp is set, there's (nearly) non-stop suspense and a sense of impending doom that has seldom been seen in a B-movie outside of the original TEXAS CHAIN SAW MASSACRE (1974). Like HELL NIGHT (1981), DAWN relies more on scares than gore, and it works quite well.

Perhaps the best thing about JUST BEFORE DAWN are the killers: they're backwoods, inbred-psycho hillbilly twin brothers (!), each one oversized and truly menacing (one of them giggles each time he kills, yet unlike the wise-cracking post-Freddy slashers to come, his evil laugh actually adds to the

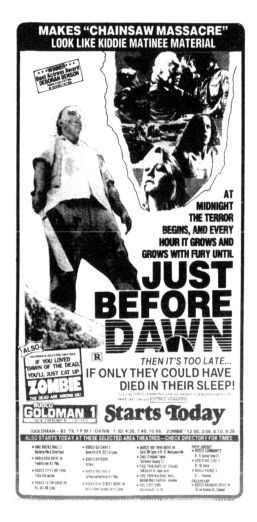

tension). And let's face it: the reason we go to see slasher films are for the kill/gore scenes, and while DAWN isn't overly graphic, it's still as brutal as they come: there's a machete to the groin, one poor guy gets a fist shoved down his throat (part of a truly unique ending kill-technique), and one sequence where a female camper tries to hide atop a tree as one of the killers chops it down.

Despite taking half its running time for the goodness to begin, JUST BEFORE DAWN then kicks into high gear and never lets up. Lieberman doesn't let his budget hinder the cinematography, which fans of the film agree looks much more professional than most slasher films (although much of the acting is nothing to write home about).

Like a cross between DELIVERANCE (1972) and THE HILLS HAVE EYES (1977), JUST BEFORE DAWN is a gem of a backwoods horror flick that's much more entertaining than the recent WRONG TURN films. Many of the night scenes are shot a bit TOO dark for my taste, but it's worth squinting through for the great pay off ending (that oddly horror fans have been split on since the films' release).

As much of a "survival" film as a horror film, JUST BEFORE DAWN was a real treat, even during these early years of the slasher film uprising. There are a couple of DVD editions available today, one from the always reliable folks at Shriek Show.

It must've been a blast seeing it in a redneck theater...

UPDATE: I saw a screening of this with director Lieberman in attendance in 2012 in Metuchen, NJ. He still claims this was never meant to be a slasher film.

Suburban Grindhouse Memories No 28

SOMETHING FISHY'S GOING ON HERE...

In the middle of 1987, THE KINDRED was released with minimal advertising yet managed to pack Staten Island's (now defunct) Rae Twin Cinema to the gills (full pun intended). No one knew what to make of this film (even Fangoria magazine had little to say about it before its release), but it turned out to be a nifty little mad scientist/ monster movie that was quite welcome after years of abundant slasher and zombie films.

An elderly scientist named Amanda (played by Kim PLANET OF THE APES Hunter) wakes up after spending three years in a coma. She orders her son John to go back to her seaside home and destroy her life's worth of experiments and paperwork—and anything else she may have left behind. John grabs his girlfriend and a few of his mother's admirers and heads to her house, where they slowly discover genetic experiments and notes that claim John has a brother named Anthony who he didn't know about.

Despite the decent set up and general serious tone of the film, the audience laughed out loud when it was revealed Amanda had been trying to find a way to make people breathe underwater, convinced the Earth would one day be nothing but a giant sea. Okay, so maybe that IS a bit silly, but what goes on during the rest of THE KINDRED's running time is creepy, at times scary, and always entertaining. First of all, we discover John's "brother" is actually a squid-like creature Amanda had created using John's cell tissue. It lives under the house in a deep cavern, and at times manages to stretch its tentacles into parts of the house. While everyone tries to figure out how to kill this monstrosity, one of Amanda's colleagues wants to keep it, hence adding to the growing tension (and for a low budget film, the tension is quite well done). Thinking back, it's amazing just how serious the tone of this one is, even with a brief scene where a woman is attacked by a creature hiding in a watermelon in the back seat of her car (but trust me, it's not half as goofy as it sounds).

By far the standout sequence that anyone who has seen this film remembers

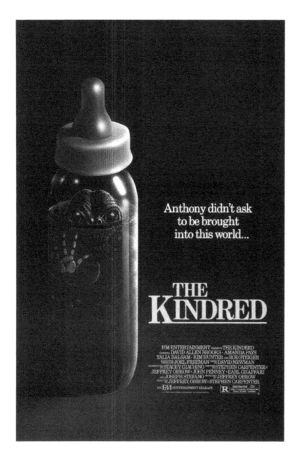

is when attractive co-star Amanda Pays transforms into a fish. One second she's talking to a few people and the next—BLURP!—her nose melds into her face and her cheeks and ribcage slices into gills; hats off to the FX crew who pulled this one off (I saw this again a few years ago on late night cable and the effect still works fantastic—TAKE THAT you CGI bozos!).

Props also go to the legendary Rod Steiger, who appears briefly as Amanda's superior—but MAN does he hand in a great performance as a whacked out scientist (Rod starred a year later in another fine, underrated horror film, AMERICAN GOTHIC, with Munster Yvonne DeCarlo—and yes, I'll eventually be getting to that one, too).

A lot of horror fans (at the time) complained about THE KINDRED's lack of gore; but I had no complaints, enjoying the various genetic-abominations running around the screen in all their latex-age glory. Plus, when squid-boy Anthony gets electrocuted during the finale (oops—post-spoiler alert!), he melts down with more slime, glop, and gloop than the ending of THE DEVIL'S RAIN (1975) and STREET TRASH (1987) combined (okay, maybe not THAT much, but enough to shut up the several schmucks in the theater who kept yelling for gore scenes).

THE KINDRED is no masterpiece and I doubt it's on any monster-film fan's top 10 list. But considering the budget this must have been shot on, and the fact the film moves along at a nice pace and I've never heard anyone say they didn't like it, THE KINDRED more than held its own among the endless 1980's sea of Jason rip-offs and DAWN OF THE DEAD wannabees.

It's definitely worth checking out.

rooklyn's "reRun Gastropub Theater" was the setting on Wednesday, June 1st, 2012 for a screening of the 1976 blaxploitation classic, BLACK SHAMPOO. The reRun Theater is a fun little indie cinema, located in the back of a trendy restaurant. Its stadium-styled seating is made up of 60 seats ripped from mini vans (!), and a full bar with snacks are located right alongside them. A 12-foot screen features digitally projected, locally made films as well as independent features from around the world (so, if you're ever in NYC I strongly suggest a visit). Back in January, I had the pleasure of viewing Alejandro Jodorowsky's SANTA SANGRE (1989) here, and the picture and sound were phenomenal.

The BLACK SHAMPOO screening was actually part of author Mike White's book tour (his collection of pieces from his long-running fanzine, "Cashiers du Cinemart," has been compiled in a hefty volume titled IMPOSSIBLY FUNKY [2010 Bear Manor Media]—and although I'm only halfway through it I can HIGHLY recommend it to any serious film geek). Mike has a large section dedicated to the film BLACK SHAMPOO (his all-time favorite movie), featuring commentary and interviews with a few of the films' stars, as well as director Greydon Clark (who is responsible for countless 70s/80s exploitation classics, such as SATAN'S CHEERLEADERS (1977), WITHOUT WARNING (1980) and the infamous arcade sex comedy, JOY STICKS (1983)). While Mike did a brief intro for the film and a reading/book signing afterwards, it was the film that was the highlight of the evening.

This was my first screening of BLACK SHAMPOO, and as a life-long fan of the blaxploitation genre, I can safely say you'll be hard pressed to find a more entertaining, funny, violent and downright FUNKY film. While the first 20 minutes play out like a really bad 70s porn film (complete with some of the coolest music ever to grace this type of feature), BLACK SHAMPOO soon turns into a hybrid love/gangster/revenge story complete with everything we psychotronic film fans love: stereotypical black men and women and

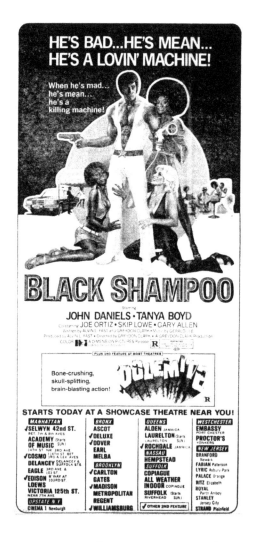

stereotypical gay hairdressers that would probably cause a protest were they done this way today; a party sequence that's so out of place it almost gives the film a surreal edge; insane violence that includes chainsaw mayhem, pool cue mayhem and a mob-orchestrated curling-iron anal rape shakedown (you read that correctly); deplorable acting; and so much more, it's hard to remember half of what went down after just one viewing.

The film centers around Mr. Jonathan, the owner of "Mr. Jonathan's" hair salon on the Sunset Strip. His reputation as the ultimate ladies man has caused an endless line of women to book appointments for his "services." And while he's in the private back room "shampooing" his clients, the front of the place features women having their hair done by Mr. Jonathan's staff, which includes Artie and Richard, two gay hairdressers who are done so over the top you can't help but laugh every second they're on the screen (fans of "classic dialogue" would do well to keep a pad and pen on hand during the entire film).

Mr. Jonathan gets so much action he actually begins to find shagging a real chore (even when two seemingly underage rich white girls seduce him during a house call only to get their butts whipped by their mom's belt for stealing her appointment [in a sequence that brings the "roughie" films of the early 70s to mind]. The mother then goes on to shag Mr. Jonathan as the two girls watch from the pool!).

After all this opening softcore madness, BLACK SHAMPOO gets down to business. It seems the new black secretary at the salon has actually run away from her white mob "boyfriend," who has kept her in his mansion as a

modern-day sex slave. When Mr. Jonathan catches wind of this, he takes his new receptionist, Brenda, out on a date and the two quickly fall in love. When the mob finds out Brenda's whereabouts, they come down to the salon and trash the place (after kicking Artie's poor little white ass in one of the most unconvincing "fight" scenes ever filmed). Brenda's ex-boyfriend turns out to be underworld kingpin Mr. Wilson (an amazingly non-stereotypical name for a gangster), who is now on a mission to get Brenda back. He employs three of the goofiest goons ever to grace a trash film (Maddux, appropriately nick-named "Schumck;" an unnamed, tall black guy who looks like he played for the Knicks in the mid-70s; and a hysterical chauffer who has a few scene-stealing lines and actions).

Feeling guilty over the beating Artie took (which left him in a neck brace) and the trashing of the salon, Brenda goes back to the mob's mansion. Mr. Jonathan—by way of a mob "invite"—takes a trip to the mansion so Mr. Wilson can explain that Brenda's now back where she belongs—and Brenda seems happy about it. Confused and pissed off, Mr. Jonathan heads out to his cabin in the woods to get his head together—and Brenda eventually meets him there with Mr. Wilson's top secret book of money laundering information. Before long, the mob catches wind of this, and we're all set for a bloody-good showdown in the woods.

BLACK SHAMPOO is unlike any blaxploitation film out there, mainly due to the character of Mr. Jonathan. He's not a cop or pimp ala SHAFT (1971) and DOLEMITE (1975), just a heterosexual hairdresser who happens to be quite handy with a chainsaw and pool cue. And while his onscreen persona is actually quite boring (John Daniels has the acting skills of a parking meter), for some strange reason the audience revels in his booty-shaggin, belly-slashing schtick.

I mean, come on folks: what other film features a chainsaw-wielding black hairdresser dishing it out to the mob after laying pipe on half of Hollywood? Mr. Jonathan just may be the COOLEST blaxploitation character of all time (I'll let you all know if this holds up to repeated viewings as good as DOLEMITE, the granddaddy of all blaxploitation films). Also, major kudos for a sonically-funky soundtrack that will stay in your head long after the film concludes.

I also recommend watching BLACK SHAMPOO with an audience of like-minded fans: while I'm sure I would have loved this had I watched it alone on DVD, I'm not sure how many non-fans of this subgenre will be won over by it.

But I still say give it a shot. Until next time, I'm off to the salon …

Suburban Grindhouse Memories No 30

A PARABLE IN THE HOOD!

 ohn Sayles is a man of many talents. He was the screenwriter for the original PIRAHNA (1978), ALLIGATOR (1980) and BATTLE BEYOND THE STARS (1980). He also had bit parts as an actor in these films, and is (probably) best known among horror fans as the screenwriter for THE HOWLING (1981). This one-man movie machine has also written film soundtracks, has edited and done various crew work on countless films and directed 17 films. But I believe one little gem he directed in 1984 is his masterpiece … and the audience I saw THE BROTHER FROM ANOTHER PLANET with on opening night would agree.

In the lily-white neighborhoods where the few suburban grindhouses I often mention in this column once stood, you hardly saw patrons who were not of a Caucasian background. These theaters were usually packed with white middle-class guidos (yes, the same types you see on shows like THE JERSEY SHORE), many who would leave screenings before certain films even reached their halfway point. Thankfully—on occasion—I'd meet up with a few people who were serious about film. Imagine my surprise when an African-American couple sat down in front of me at the (now defunct) Amboy Twin Cinema, arguably the first black couple ever to set foot in a theater on that side of Staten Island. And when they heard my friend and me discussing director John Sayles before the film began, they both turned around and joined in our conversation. It was amazing—here were two people the rest of the theater were looking at, daring them to stare back, and I was having a fantastic film chat with them as the trailers began to unreel (we even spoke for about an hour afterwards out front). Guidos and racists be damned! This was one of the most beautiful experiences I ever had in a movie theater—and to make matters better, the film we were about to see couldn't have been more ideal on this particular evening.

THE BROTHER FROM ANOTHER PLANET reminded me of Nicolas Roeg's THE MAN WHO FELL TO EARTH (1976), only nowhere near as strange. A mute black man with strange-looking feet (played by Joe Morton, who delivers a truly fantastic

performance here) crash lands in Harlem in a small space ship. Even though he's black and in Harlem, it quickly becomes apparent this guy isn't on his home turf. Most of the film deals with The Brother adjusting to his new surroundings, and despite the fact he's from another planet, there's so much dark humor here you quickly forget this is technically a sci-fi movie. Although The Brother is not able to talk, we learn he has escaped his home planet where he was a slave. Two "men in black" type guys (both white—one played by Sayles) trail him to Earth, but The Brother makes so many friends (in unique ways) that those who are

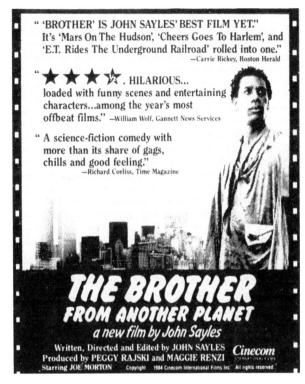

affected by him help keep him safe from his would-be captors.

Sayles shot this on a miniscule budget, but the story makes up for any lack of special effects (one of The Brother's powers is the ability to remove one of his eyes and use it as a "video camera" of sorts, as well as an E.T.-like touch that is able to fix all kinds of equipment). While Sayles gets his points on illegal immigration and slavery across, the quirky characters The Brother meets help the film's underlying messages go down smooth and not preachy. This is one of those films that's hard to describe: while it has gained a cult audience over the years, and it does have its own vibe, it's not as dark or depressing as most cult films tend to be ... and I remember leaving the theater refreshed and in an unusually good mood. Best of all, my two new friends were glad they made the trek to this *white* theater to see the film, and they couldn't stop laughing when I told them how many times I had been the only white guy at a Times Square horror or sci-fi flick...

THE BROTHER FROM ANOTHER PLANET was one of those rare gems that I've never forgotten and which continues to impress most who view it today. Definitely seek it out.

Suburban Grindhouse Memories No 31

ANOTHER TRIP INTO THE CITY...

he summer of 1987 was a great time to be me (or at least my age). I was only out of high school for a year, working the night shift at a local supermarket as I awaited my current city job to call, and playing drums in three different punk bands. And while there was somewhat of a lull on the suburban grindhouse scene, an ad for a 1950s throwback film caught my attention in the film pages of the Village Voice. I rounded up a couple of buddies and we trekked to the Waverly Twin Cinema in New York City (today the home of the IFC Center, which continues to show new and classic midnight movies).

In front of the theater, one of the film's producers (at least that's what he claimed to be) was handing out flyers for the film's soundtrack (which is quite good, by the way) and telling everyone, "Come on in! This one's a Coke classic!" (meaning "You'd enjoy it more if you were on cocaine!"). I don't know if he convinced any passers-by to come in OR if he was selling blow on the side, but we took our seats and were surprised to see such a large crowd at this relatively unknown film's midnight premiere.

While I LOVED The Fleshtones' opening title song, one thing annoyed me then and throughout the rest of the film: you could actually hear the sound of the projector OVER the sound of the film, and we were sitting around the center aisle toward the rear. But this distraction aside, the film still turned out to be an enjoyable—if uneven—horror comedy.

A group of high school buddies (who looked way older than high school buddies and resembled the cast of the Archie comics) accidentally kill a local drug dealer after trying to get some weed for their prom dates, and dump his body into a river. Being a 50s-tribute film, the river is (guess what?) full of toxic waste, and causes the dealer (wonderfully named "Mussolini" and played by Steve McCoy) to come back as a crazed, green-faced zombie bent on revenge. Mussolini kills the group's "leader," high school baseball star Dan (Michael Rubin). His friends decide to dump him in the same river as Mussolini, figuring he'll come back as

a "good zombie" to protect them from the undead dealer.

What ensues is at times hysterical, at times really stupid, and still at other times quite gory, although the "special effects" are below amateur level, some looking like the effects crew didn't even give half a try. Mussolini rips one poor guy's face off (in the only decent-looking effect), going on about "You want weed? HERE'S some weed for ya!" or something like that; there's a silly "romance" sequence where Dan reveals to his girlfriend that he's now back as a zombie; and in the finale (SPOILER ALERT!), Dan tosses Mussolini's decapitated head for a 3-point shot at the prom in the school's gymnasium, then proceeds to chop it in half with a machete in one of the goofiest-looking gore scenes of all time.

The scene that floored the audience, however, had nothing to do with zombies or gore. A policeman (played by an elderly Steve Reidy in his ONLY film appearance) questions the boys at a "police station" that I'm assuming was one of the film crew member's backyard shed. Reidy's police uniform also looks like it was purchased at the Salvation Army on a bad day, and his constant, un-threatening questions such as "What were you guys doin' down at the pier?" had the crowd in stitches. It's a masterpiece of bad acting that would've made Ed Wood jealous.

I WAS A TEENAGE ZOMBIE was a fun

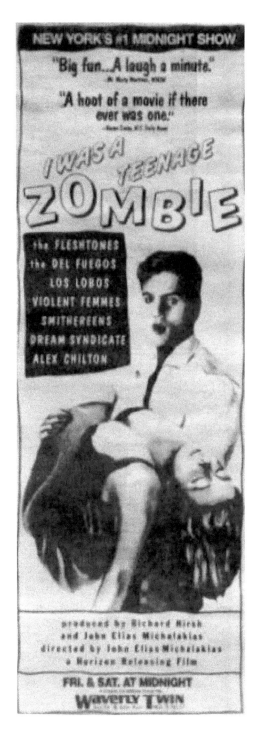

I WAS A TEENAGE ZOMBIE

film to see at a midnight show in NYC. I'm not sure how many enjoyed this when it came to video, and I even saw a VHS of this placed in the "classic monsters" section of an old video store I belonged to, presumably by an under-informed employee. I can still remember the sound of the projector's click-click-clicking over the scenes I've just described, and the voice of the live film peddler out front was as entertaining as the film.

Trash film fans: SLIME CITY (1988) and SLIME CITY MASSACRE (2010) star Robert Sabin stars as one of the high school buds, and keep your eyes peeled for an unaccredited cameo by director/author Gregory Lamberson, who plays a young pot-head. The film also boasts an impressive soundtrack for a low-budget production, and includes artists such as Los Lobos, The Smithereens, Alex Chilton, The Waitresses and the Violent Femmes. The aforementioned title track from The Fleshtones is easily the best, though.

Now excuse me while I go jump in the river...

Suburban Grindhouse Memories No 32

THE UNBORN ALIEN AVENGER!

FANGORIA magazine had been running articles (and graphic stills) about an ALIEN-like gore-fest titled INSEMINOID. Week after week, we gorehounds of the early 80s anticipated this potential gem's release, and had all but given up when a film titled HORROR PLANET was unleashed in late 1982. It turns out INSEMINOID had been re-titled (and as much as I LOVE the original title, perhaps HORROR PLANET was a bit more marketable?). Either way, the (now defunct) Fox Twin Cinema was packed to the gills on opening night, with horny teenagers and underage patrons waiting for their long-awaited dose of otherworldly splatter.

It turns out the only similarity between this and ALIEN (1979) was in the alien impregnating someone. In this case, a group of scientists are exploring the underworld of one of Jupiter's moons (Why? I still have no idea—just go with it), when they happen to unleash a strange creature who forcefully does the intergalactic mambo with one of the prettier female scientists (hey—even monsters go for the hotties!). Her pregnancy accelerates at an unearthly pace and her fellow explorers (in no certain terms) begin to look at her and her coming child as lab rats. Unfortunately for these cosmonauts, whatever's growing inside her is requiring human blood. What follows is pure exploitation genius: Our pregnant heroine (Sandy, played

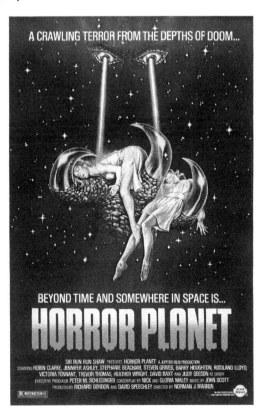

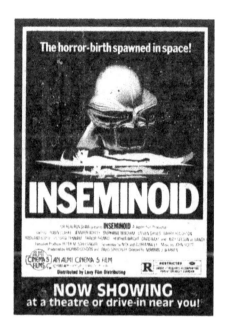

The horror-birth spawned in space!

INSEMINOID

NOW SHOWING
at a theatre or drive-in near you!

by Judy Geeson—trust me, you've seen her in tons of TV shows) begins to protect herself and her unborn by slaughtering the rest of the cast, turning HORROR PLANET into one of the first intergalactic slasher movies I can think of. And MAN does the sauce flow...

If you can overlook the horrendous acting and dialogue (if memory serves me, nearly every line was openly mocked at the screening I attended), HORROR PLANET is a decently made British flick with tons of brain-dead splatter fun in store for your viewing (or is that 'spewing?') pleasure: one guy's stomach is blown apart with a laser gun as some poor woman is sliced to shreds with a pair of scissors, and another is eaten alive, in a genuinely savage scene of space-age cannibalism. When Sandy finally gives birth, it turns out she was carrying twin humanoid creatures that come out of the womb with more goop and vomit-inducing green glop than even Linda Blair could've handled. I haven't seen the film since this fine evening around November of 1982, so I don't know how much I'd enjoy this today ... but at the time I was in splatter/sleaze heaven. And apparently so was the crowd. This is the first time I can remember the audience cheering during the kill sequences—a few years before this became the norm at FRIDAY THE 13th sequels (I believe FRIDAY THE 13TH PART 4 started this ritual—which—in my opinion—began to cheapen the feel and affect of most horror films).

If you're a sci-fi fan, you'll probably laugh at the primitive special effects, especially the base of command center (which looks like it was constructed on a really cheap set—or in someone's basement) and as mentioned, this is more of a gore film than a serious ALIEN wannabe.

HORROR PLANET is worth a DVD viewing (I believe it was finally released under the INSEMINOID title), if, for nothing else, to show you how much fun and in-your-face these early gore-epics could be.

One thing's for sure: you won't have half as much fun with any other low-budget space monster film released since (and there's simply NO WAY this would receive an R-rating today).

HORMONES AND WHOREMOANS...

eptember 1981: after having enjoyed screenings of FRIDAY THE 13TH PART 2 and a re-release of THE TEXAS CHAIN SAW MASSACRE (1974) only a few weeks earlier, it was time to take a break from the gore and scares. Along comes a sex comedy titled LUNCH WAGON GIRLS, with its enticing poster and newspaper ad (enticing for a bunch of thirteen year-old boys, anyway) nearly DARING us to try and get in without adult accompaniment. And thanks to Staten Island's Amboy Twin Cinema (who let ANYONE in, so long as they had CA$H), my buddies and I waltzed right in and were set for who-knew-what (remember this was a full year before the sex comedy craze that came after PORKY'S and FAST TIMES AT RIDGEMONT HIGH were released). If not for the Amboy Twin Cinema (that has long since been replaced by a Perkins Restaurant), I wouldn't have seen half the films I write about in this bi-weekly column. Man do I miss that place!

Two girls (played by Pamela Jean Bryant and Roseann Katon, both with impressive exploitation film credits) are roommates who also happen to be auto mechanics (!). They're sick and tired of their sleazy boss spying on them as they dress for work (because, as you know, all-female mechanics get undressed AT the garage), and when they confront him about their crappy salary and a host of other issues, the guy flips out and fires them. Aggravated, our two lovely ladies stop for lunch at a local lunch wagon (owned by Dick Van Patten, who goes unaccredited here although there's two other Van Pattens with higher billing) and, after a talk about their future, manage to buy the lunch wagon off of Van Patten and start their own business. Realizing neither one of them can cook, they get their friend Diedre (played by Amazonian blonde Candy Moore, the woman who modeled for the cover of the classic album CANDY-O by THE CARS) then set up shop by a local construction site, where the girls start to get hit on by the workers and their business starts to take off. Deidre is the funniest of the group: she has a thing for short, dorky guys, and manages to control them like a dominatrix in the sack...

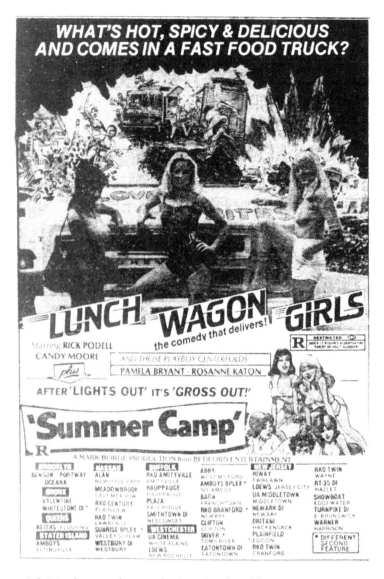

While the boobage wasn't as high as our young perverted minds were hoping for (nor the laughs for that matter), we were treated to a surprise—another unaccredited appearance by a band called TERRI AND THE ROUGH RIDERS. One of the two songs they perform was quite catchy, and a few weeks after seeing the film I found a 12" single with said song ('Mental Hopscotch') by a band called MISSING PERSONS, and sure enough, it was the same band. I'm assuming MOST of LUNCH WAGON's budget went to paying this up-and-coming new wave act. The band was made up of three members and two actors, one who our girl Diedre ends up dating in the film.

Despite the rockin' tunes and cute cast (who call their lunch wagon "Love Bites"), the film doesn't work too well as a comedy, and after a recent re-viewing, it doesn't even hold up good as a teenage T&A feature, either. And yet for some reason I still can't figure out, it's quite entertaining. The screenwriter tried to deliver a bit of a story: a rival lunch wagon sets up shop near the same construction site, and of course it turns out to be a front for a bunch of jewel

thieves. Even with the added gangster goofballs, LUNCH WAGON GIRLS only offers an occasional chuckle and an even rarer flash of flesh. With everything it has going against it, the film is still worth it for the horrendous spandex outfits every female character seems to walk around in (which drew howls from the crowd, even in 1981), the great soundtrack, and it's overall positive vibe: here's a trio of girls with (seemingly) no future, making the best out of life by serving sandwiches at a construction site! If that doesn't make you feel better about your own mundane existence I don't know what will...

The déjà-vu I felt while watching this the first time in 1981 must've been due to the aforementioned female cast, who had previously starred in exploitation and horror epics such as H.O.T.S. (1979), DON'T ANSWER THE PHONE (1980), THE SWINGING CHEERLEADERS (1974), and even DEATH RACE 2000 (1975). In researching this article, I discovered the beautiful Pamela Jean Bryant had just passed away in 2010, which added a sad undertone to my recent viewing.

If you want to taste a pre-PORKY'S sex comedy that's easy on the comedy and the sex but big on horrible fashion and kick-ass music, give LUNCH WAGON GIRLS a try. (The film was also seen on late night cable TV under the shorter title LUNCH WAGON, and was released in Germany as HAMBURGER GIRLS).

Suddenly I'm in the mood for ham and Swiss on rye...

"SHE MATES... THEN SHE TERMINATES!"

*J*une 1989. I see an ad in the NY Daily News for what promises to be a real wild one. I venture out of the safety of my suburban neighborhood (alone) and hit the still-sleazy pre-Guiliani Times Square for what would be one of my final visits to the famed area before it was cleansed a few years later. Getting off the train around 36th Street, I see a HUGE billboard poster for LADY TERMINATOR, and attempted to peel it off. No luck. I was offered weed and other substances at least five times during my 8-block trek uptown to the theater. One guy claimed to have switchblades. I kept walking, keeping my eyes straight ahead, hoping I made it to the theater in one piece.

MAN, do I miss the old NYC.

LADY TERMINATOR played solo at the Criterion Center on 44th Street, a rarity for a Times Square feature at that time. I attended an afternoon showing, and the place had at least a dozen people in attendance ... yet I was thrilled about 10 minutes into the film when screams and comments were flying as loudly as any midnight screening of ROCKY HORROR could hope for.

Check out the plot of this Indonesian import: An anthropology student named Tania Wilson (played by the beautiful Barbara Ann Constable in her ONLY credited role) becomes possessed by some ancient queen—while exploring her underwater lair. In a surreal/dream-like sequence, Tania finds herself swimming one second then tied to a huge bed the next. An eel-like creature wiggles up the sheets and into her vagina, causing her to become possessed. She soon emerges on shore (stark naked) and interrupts a lame drinking party where she wastes a couple of losers. After taking one of their leather jackets (this follows THE TERMINATOR (1984) quite closely at this point), she begins an all-out attack that'd make Hurricane Irene green with envy. While it's never clear why this ancient sea witch is bent on revenge, the audience (and I) really didn't care. Tania (aka the LADY TERMINATOR) goes TOTALLY BALISTIC, creating a body count 10 miles high via machine guns and a couple of brutal sex scenes (Remember

the tag line: "She mates...then she TERMINATES!" One blurb that lives up to its promise).

Why this woman is turned into a cyborg-type revenge creature by an ANCIENT sea witch is anyone's guess, but that's not even a quarter of a quarter of the flaws in this insanely ridiculous action romp. And when Tania starts her killing spree, you'll either overlook these flaws, ride with it and have the greatest time of your trash film life, or shut the DVD off and continue to be a dullard (this film is

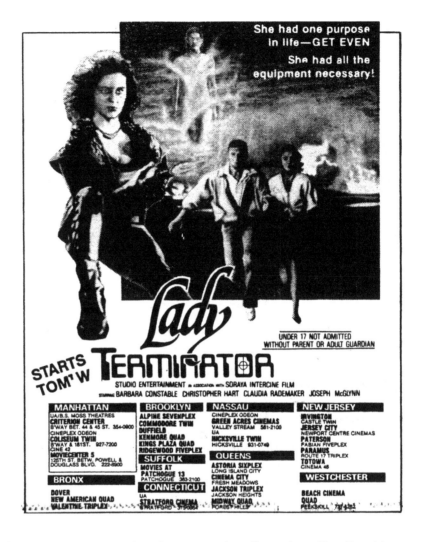

actually playing in NYC at a rare screening in a couple of weeks—I'm freaking out that I can't attend— hence the inspiration for this week's column).

What put the crowd into a screaming frenzy were several repeated scenes, especially one of Tania spraying a group of military men with machine gun fire: that had to be shown at least five times. I'm guessing this saved the film crew from having to shoot from different angles? Either way, this is the type of thing that makes "so-bad-they're-good" movies memorable.

I'm a big fan of the original TERMINATOR. BUT, I can sit through LADY TERMINATOR a thousand more times without being bored, as it contains more

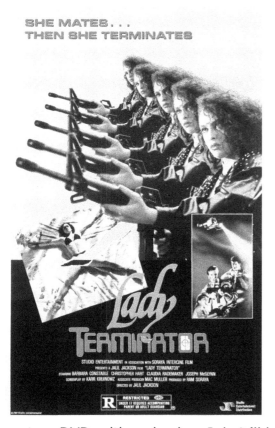

SHE MATES . . .
THEN SHE TERMINATES

Lady TERMINATOR

STUDIO ENTERTAINMENT IN ASSOCIATION WITH SORAYA INTERCINE FILM
PRESENTS A JALIL JACKSON FILM "LADY TERMINATOR"
STARRING BARBARA CONSTABLE CHRISTOPHER HART CLAUDIA RADEMAKER JOSEPH McGLYNN
SCREENPLAY BY KARR KRUNOWZ ASSOCIATE PRODUCER MAC MULLER PRODUCED BY RAM SORAYA
DIRECTED BY JALIL JACKSON

car chases, explosions, gore, violence, nudity and sheer insanity than a dozen low budget rip-offs combined. (It should be noted that star Barbara Ann Constable is also credited as doing the make-up for the film, too).

The most amazing aspect of LADY TERMINATOR is its ability to entertain to the CORE, despite a plot that's all over the place (or not even there, depending on who you talk to), dialogue that's beyond inept, and question after question after question and confusion on top of confusion. SOMEHOW this pile of Indonesian trash WORKS. It's a true miracle of low-budget filmmaking that I've been contemplating for the past twenty-two years, made worse by my second viewing via a VHS screening in the early 90s.

I think I'm finally ready to seek this out on DVD…although when I do it'll be hard not to toss it in the DVD player for weekly viewings.

LADY TERMINATOR was one of the greatest exploitation films I've ever had the pleasure of seeing on the big screen with my fellow Noo Yawk trash hounds at the near-end of the GENUINE grindhouse era.

I think I'm gonna go cry now…

UPDATE: since writing this article I found a copy of Mondo Macabro's incredible DVD release, and saw a 35mm screening in Brooklyn at the Nitehawk Cinema in 2013. The film holds up very well…

KUNG FU CHEERLEADERS JUST SAY NO!

1981 was not only a good time for slasher flicks ... it seemed every week there was some kind of DEATH WISH rip off or kung fu movie being released (at least here in New York City). Enter LOVELY BUT DEADLY, a film with an amazing exploitation poster and to my delight, a PG-rating (I was only thirteen at the time, and Staten Island's (now defunct) Fox Twin Theater wasn't crazy about letting underage kids into R-rated films). So, knowing I'd be able to get in without offering some older teenagers popcorn if they bought my ticket (for whatever reason I attended this one solo) I headed to a Saturday afternoon showing.

The trashy goodness begins with an oddly-filmed beach party and a 007-sounding rock soundtrack during the opening credits, then we're introduced to beautiful star Lucinda Dooling, who previously had a tiny role in the 1979 comedy classic 1941, then later appeared on a few TV shows, most notably on a 1983 episode of THREE'S COMPANY. In LOVELY BUT DEADLY, she plays Mary Ann Lovette, but her friends (and enemies) call her Lovely (get it? Get it??). The aforementioned opening beach party is the type that only seems to happen in low-budget films. One guy (who had been smoking more weed than Cheech & Chong in all of their films combined) finds his way to the ocean and ends up drowning. It turns out the dude is Lovely's brother, and she decides to make every drug dealer in her high school pay.

The first murder is the best in the film. Lovely accepts an offer to hang out at some video stud's apartment (which looks more like a local cable TV station after being ransacked) and she learns his nickname is Captain Magic, a dealer who even has his own special brand of pot on the market (known as 'Elephant'). Using her sexy left-over 70s red jumpsuit to seduce him, Lovely manages to pin the Captain's hands behind his back as she dumps his entire stock of dope down his throat. Come on folks: PG-rated cinema doesn't get more exciting than this!

The film then slows a bit as Lovely befriends some dorky dude who she takes home to meet her parents and aunt. The audience began yelling things such as

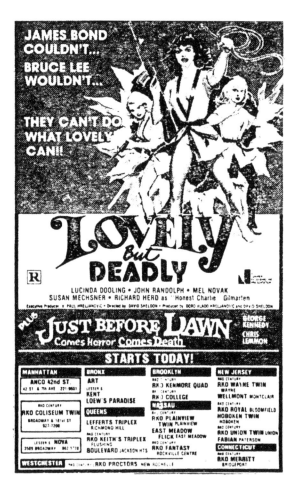

"What the F...?" when this guy drives Lovely's parents to the airport only a few minutes after meeting them. We're never told why. And this isn't the only head-scratching, out of place sequence in the film.

The next thing you know Lovely is sucking face with some guy in a rock band for what seems like twenty minutes (of course making out means they're now boyfriend and girlfriend). Then the film abruptly cuts to two guys coming into Lovely's high school: apparently word somehow got out that there's an anti-drug vigilante at large. She manages to take care of them in one of the most unconvincing fight sequences I've ever had the pleasure of sitting through in a cinema (added laughs come from another one of Lovely's dorky male friends who takes a beating from the two thugs before she straightens them out).

The HANDS DOWN best sequence involves a cheerleader who goes after Lovely for hitting on her drug-dealer boyfriend. As soon as the cat fight begins, the cheerleader's buddies show up to help pummel Lovely. BUT, Lovely's friends from karate class happen to arrive in the nick of time for an all-out, horrendously choreographed locker room throw-down that had the mainly male crowd at the Fox Twin shouting in teenage delight (and surprisingly there's a quick flash of boobies that somehow made it past the 1981 MPAA censor board). I remember this because I am a guy.

As if this wasn't enough, Lovely is later invited to a massive party at the cheerleader's boyfriend's pad, where she makes out with him before stealing some of his stash THEN having another fight with the cheerleader,

this time using food as their weapons (keep in mind ANIMAL HOUSE (1978) was still fresh in every movie producer's mind). Before long an old drug dealer named Honest Charley shows up and eventually invites Lovely to visit his mansion. MISTAKE! Charley finds out Lovely has been killing all his drug dealers and he keeps her captive by a boat yard (why he doesn't just whack her is anyone's guess).

In one unforgettable sequence, Honest Charley has his two goons murder the cheerleader's boyfriend, thinking he was trying to take over his drug business. They stuff him into a cardboard refrigerator box and cook him to death by inserting a steam hose through a hole in the side. Why this film didn't win an Oscar for Best Screenplay is a tragedy of the highest sorts.

In the spectacular mess of an ending, Lovely escapes when one of Charley's goons tries to do the horizontal mambo with her. She steals a boat that quickly runs out of gas but for some reason the guys chasing her collide and die. An epic dock-battle ensues as soon as Lovely makes it back to land. She faces Charley and his gang of thugs with her posse of kung fu high school girls (who again show up in the nick of time). While I'm making this sound much more epic than it actually looks on screen, you have to give director David Sheldon credit for not letting the film's budget influence his ambition.

The crowd groaned during the post-conclusion when Lovely learns her musician boyfriend had been supporting the school drug dealers to help get his band established. I couldn't help but laugh out loud.

Along the ride there are appearances from a who's who of cult movie and TV personalities, including SEINFELD's Richard Herd, John Randolph from SERPICO (1973), Pamela Jean Bryant from H.O.T.S. (1979), Irwin Keyes from THE WARRIORS (1979), Mary Beth McDonough from MORTUARY (1983) and Wendell Wright from THE HOWLING (1981), just to name a few.

Some have called LOVELY BUT DEADLY a remake of the 1973 Pam Grier classic COFFY, and although it's similar it's nowhere near as good. But if you like cheesy fight sequences, hysterical dialogue, and cute babes kicking the crud out of each other, you may just enjoy this forgotten action offering.

I know I did.

Suburban Grindhouse Memories No 36

YOU'LL PUKE YOUR GUTS OUT!

uring the spring of 1983, it didn't take much to get us horror fans into the theater. It was even easier when a film came out UNRATED and was directed by some Italian guy only a handful of us had heard about. Remember, this was still the age of no Internet. The only sources of horror news came through FANGORIA magazine and, for a select chosen few, a small network of crudely-made underground horror film fanzines.

I had missed Lucio Fulci's ZOMBIE (1979) when it hit American shores during the summer of 1980, and was tired of hearing people rave over how wonderfully disgusting it was. But three years later, here was another one from the same director with an equally as creepy ad campaign. To say I was psyched was putting it mildly (I later found out GATES had been released in 1980 in Italy, a year after ZOMBIE premiered there.).

Thankfully, THE GATES OF HELL opened at the (now defunct) Amboy Twin Cinemas, the easiest theater in all of NY's five boroughs to get into if you were underage. And despite being UNRATED, the Amboy Twin still allowed me and my gang of pimple-faced freshman gore geeks to march right in on opening night.

Let's back-track one more time: Everything about this film gave the theater itself an uneasy aura: from its startling title (that I still prefer over its official DVD release as CITY OF THE LIVING DEAD, as well as over twenty other international titles) to its threatening blurb at the bottom of its poster ("This film contains scenes which may be considered shocking. No one under 17 admitted."). A brief NYC television ad even featured a Catholic priest slipping a noose around his neck as a luminous voice said "The gates of HELL are about to be opened!" In other words, there was no bootleg VHS copies available, no Pay-Per View previews on cable TV … just good, old school advertising and a short & sweet trailer I've been trying to track down since the night I saw it on late night television. If memory serves right, even FANGORIA didn't run pictures until AFTER the film had been in theaters.

GATES OF HELL

While, at the time, none of us saw Fulci as the gore-god he would soon become known as, it was evident the guy wasn't playing with even half a deck: I can't recall any other film featuring a zombie apocalypse caused by a priest hanging himself. Well, maybe it wasn't an apocalypse per se, as all the action took place in a small town.

The strong point of GATES is its constant sense of dread. As soon as the suicidal priest does his business, supernatural-type zombies began to appear all over the small town of Dunwich, ripping out unsuspecting people's brains, shown in gooey, graphic detail that would become any gorehound's glory. And just WHY this dead priest caused the dead to rise is anyone's guess (if you've never seen a Lucio Fulci film, logic is rarely—if ever—something to bother looking for). But the audience and myself really didn't CARE why, as we were having too much fun watching zombies rip out brains, and others become possessed: one poor woman begins to cry blood before puking her guts up (literally) in what seemed like a five-minute sequence. While I actually laughed as this happened, due to the ultra-fake looking teeth during the close-up, most of the audience screamed and gasped, causing me to laugh harder. But any laughs had during

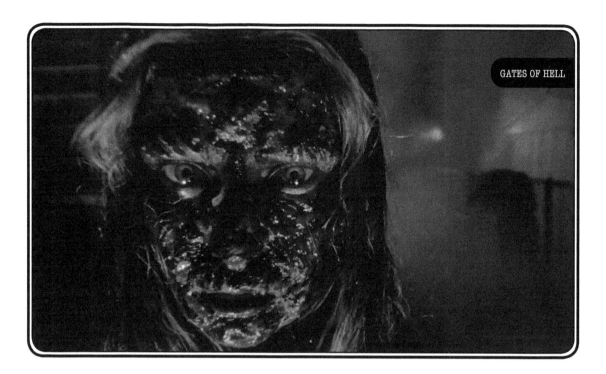

this cheap-looking effect were made up for in BUCKETS over the film's most infamous sequence.

The mentally challenged Bob (played by the soon-to-be Euro-cult film icon Giovanni Lombardo Radice) is thrown onto a table by his father. On the table is a stationary power drill, which Bob's head is slowly—ever so slowly—pushed onto. The camera doesn't cut away. The theater freaked out. I was glad when I eventually found out Giovanni was making another film as I was CONVINCED they had killed the poor guy for this scene! If you haven't seen it, it's arguably one of the most gruesome, realistic special effects ever devised for a film. Hats off to FX artist Gino de Rossi for pulling off one of the greatest gore sequences I ever had the pleasure of witnessing in a theater.

Now, despite all the fun we were having, and despite the non-existent plot (and DO NOT even get me started on the ridiculous, completely pointless ending), what TRULY bothered me about the film was its star, Christopher George, who plays a New York City reporter who, for some reason, is in New England covering the priest suicide story. While it's true George has starred in numerous horror and exploitation films (most notably 1982's PIECES and 1980's

THE EXTERMINATOR), I've just always had a hard time buying him in any role. Thankfully, the lovely Catriona MacColl co-stars as a psychic who helps him discover what happened the night the priest hung himself at a local cemetery.

THE GATES OF HELL, with its slow-moving first half and horrendous acting, is truly an acquired taste. But once things get underway—and if you're willing to ignore the fact there's not much story—you just might enjoy this gross, over the top splatter-fest from the legendary Lucio Fulci. Despite people attempting to explain the ending to me over the years, trust me IT MAKES NO SENSE!

With all his flaws, I truly miss Fulci and his few films I was lucky enough to see during the Golden Age of the Splatter Film.

THE GATES OF HELL was one of his better efforts.

UPDATE: On November 2nd, 2017, I saw a 35mm screening at the Nitehawk Cinema in Brooklyn, and the film has held up very well, even creepier and with better atmosphere than I recalled.

Suburban Grindhouse Memories No 37

THE DANGERS OF ADVANCED SECURITY

arch 1986: While I'm assuming most fellow members of the class of 1986 were busy scouting colleges and making plans for their post-high school graduation, I was transfixed on an advertisement I spotted one Friday in the New York Daily News's weekend section. CHOPPING MALL: "Where shopping costs you an arm and a leg." Priceless. Perfect. How come no one had thought of this earlier? Who knows? Either way I made my way to the (now defunct) Rae Twin Cinema on opening night despite the frigid temperature, not knowing what to expect.

Judging from the brief TV ad, it looked like a typical slasher film set in a mall. But CHOPPING MALL turned out to be a sci-fi-tinged outing, although it basically follows a slasher film pattern.

A bunch of teenagers (who don't look like teenagers) decide to hide in a shopping mall. Their plan is to party once everyone has gone home for the night. What they don't realize is the place has recently installed a state-of-the-art computerized security system, which not only locks the place down tighter than Fort Knox, but also unleashes three 1950s-looking robots, armed with high-tech laser weapons (because, you know, all malls need laser-spitting robots to protect the priceless merchandise).

Among our group of partiers are Barbara Crampton (who, at the time, the audience referred to as "HEY! It's that hot chick from REANIMATOR!"), who provides one of the mandatory topless scenes, main star Kelli Maroney (who had roles in NIGHT OF THE COMET (1984) and FAST TIMES AT RIDGEMONT HIGH (1982), before battling these robots and becoming a TV star) and Tony O'Dell, who had starred a year earlier in the wonderfully inept and insane EVILS OF THE NIGHT (1985).

Wouldn't you know the same night our partiers get things going, a nasty thunderstorm sends lightning into the mall's roof antenna, causing the high-tech security system to malfunction? And, besides our teens not being able to get in or out, the three laser-spitting robots are now running amuck, their first victim

a night janitor played by cameo king Dick Miller. He gets zapped in some of the most horrible-looking "electric" effects since the psychic-battle at the finale of Ted V. Mikels's BLOOD ORGY OF THE SHE DEVILS (1972). Come to think of it, most of the teens are killed by the robots electrocuting them.

So what about those laser beams?

In the film's most memorable scene (next to Barbara Crampton showing off her post-REANIMATOR ta-tas) one poor lass (played by the cute Suzee Slater, who also had a role in LAS VEGAS SERIAL KILLER the same year as this masterpiece) has her head blown to smithereens by a killbot (the film was titled KILLBOTS in pre-

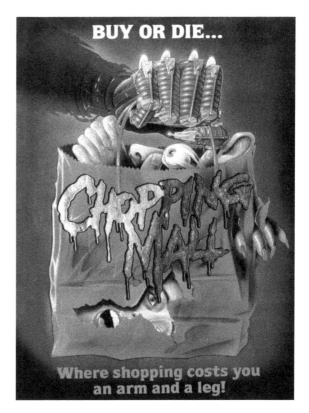

production, and expensive theater posters with this title can be found at sleazier horror conventions or on eBay). The effect is quite effective, causing everyone in the theater to scream. I was a bit taken aback, too, as no one thought these little rolling 'bots had this much aggression in them (not that electrocuting or pushing people off the second level into a hot pretzel stand is anything mellow). This glorious four seconds of celluloid was as gruesome as the head explosions in both DAWN OF THE DEAD (1979) and SCANNERS (1981). Kudos to special effects artist Anthony Showe—who—despite not being a common name among genre fans—has a respectable list of credits under his belt, including 1982's CONAN rip off, SORCERESS, 1985's slasher classic THE MUTILATOR, and horror comedy effort SATURDAY THE 14TH STRIKES BACK (1988). I challenge you to find ANYONE who has seen this film and ask them what they remember about it. It won't be Crampton's rack or the silly-looking killbots. It'll be this gooey, disgusting, explosive display of cranial destruction.

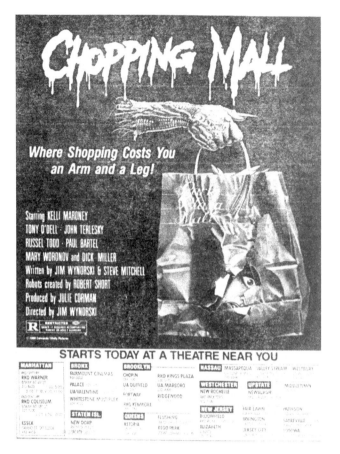

CHOPPING MALL

Where Shopping Costs You an Arm and a Leg!

Starring KELLI MARONEY
TONY O'DELL · JOHN TERLESKY
RUSSEL TODD · PAUL BARTEL
MARY WORONOV and DICK MILLER
Written by JIM WYNORSKI & STEVE MITCHELL
Robots created by ROBERT SHORT
Produced by JULIE CORMAN
Directed by JIM WYNORSKI

R RESTRICTED

STARTS TODAY AT A THEATRE NEAR YOU

MANHATTAN	BRONX	BROOKLYN		NASSAU MASSAPEQUA VALLEY STREAM WESTBURY
RKO WARNER	FAIRMOUNT CINEMAS	CHOPIN	RKO KINGS PLAZA	
	PALACE	UA DUFIELD	UA MARBORO	WESTCHESTER UPSTATE MIDDLETOWN
RKO COLISEUM	WHITESTONE MULTIPLEX	FORTWAY	RIDGEWOOD	NEW ROCHELLE NEWBURGH
		RKO KENMORE		
	STATEN ISL.	QUEENS	FLUSHING	NEW JERSEY FAIR LAWN PATERSON
ESSEX	NEW DORP	ASTORIA	REGO PARK	BLOOMFIELD IRVINGTON SAYREVILLE
				ELIZABETH JERSEY CITY TOTOWA

The audience got a real charge (full pun intended) out of our heroes, when they realize what's happening and start looking for things to protect themselves with. When one guy comes walking out with an M-16, I nearly fell out of my chair in hysterics. While I don't recall any shopping malls in my area selling any type of guns (let alone a military-issued assault rifle), I think the film would have had a TAD more credibility had he armed himself with a cheese grater, or a shiatsu massager, or I don't know … ANYTHING you'd find more easily in a mall than an M-16!

But what else can you expect when you plunk down your cash to see something titled CHOPPING MALL? It's goofy, it's a borderline slasher satire, and it has a few interesting kill scenes. AND it has Dick Miller.

What more does a grindhouse fan need?

SO BAD IT'S... NOT GOOD OR BAD... JUST... HMMMMM

eaders of this fine column have heard me mention Staten Island's (now defunct) Fox Twin Cinema. The more my suburban memory is refreshed, the more I realize just how many amazing double features were shown there during the early 80s—1982 being out of control.

And in 1982, the Fox Twin introduced me to the wacky world of low-budget film maker Don Dohler. Among Don's nearly-unwatchable achievements are the painfully bad THE ALIEN FACTOR (1978) and NIGHTBEAST (1982), both which feature unconvincing monsters and acting that'd make H.G. Lewis blush. But in 1980, Don ALMOST got it right, and the result has been debated by underground horror fans since its release.

FIEND (1980) was re-released in 1982 with the gruesome DON'T GO IN THE HOUSE (another film originally released in 1980), in one seriously uneven double-bill. After two years of seeing stills from FIEND in horror magazines and fanzines, I was thrilled to finally catch it. DON'T GO IN THE HOUSE was first, and a more brutal R-rated film would never be released (how this one hit American theaters unrated is anyone's guess). Its depraved scenes of some lunatic killing women in his fire-proof basement with a flamethrower had the theater screaming out loud, and the film managed to work even despite its PSYCHO-inspired conclusion.

After a brief intermission, FIEND hit the screen, and within the first five minutes I can recall at least 6 people walking out … not due to anything disturbing, but due to a "special effect" so cheesy, it's amazing any of us stayed for the rest. But I'm glad I did. Kind of.

Some red "spirit" is seen floating around a dark graveyard in the aforementioned special effect. It enters a grave and reanimates some 70s-looking guy, complete with big mustache and ugly sports jacket. Just WHY this happens is never explained, but we now have the title creature who—instead of eating flesh or drinking blood— decides to buy a large house in Maryland where he opens a music school!

(BRIEF PAUSE FOR MY MENTAL STABILITY: It's my interest in plots like these

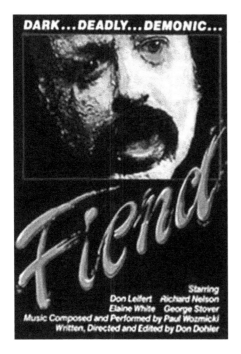

DARK...DEADLY...DEMONIC...

Fiend

Starring
Don Leifert Richard Nelson
Elaine White George Stover
Music Composed and Performed by Paul Wozmicki
Written, Directed and Edited by Don Dohler

that have caused me to age at an unusual rate and lose friends. Now back to the review.)

The Fiend takes the name Eric Longfellow, and spends a lot of time wandering around the front yard of his new home where his neighbors stare at him with odd expressions. It should be noted that Longfellow, played by Don Dohler regular Don Leifert, does a fine job here and gives off a truly eerie vibe.

We're eventually clued in as to just why Longfellow is a FIEND and not a ZOMBIE: if he doesn't take other people's "life forces" on a regular basis, he starts to grow old. When fully charged, Longfellow looks to be about 35-40 years old. But as he ages, the cheap special effects attempt to make him look like he's in his 80s. The unique angle of the FIEND is how this freshly-risen creature kills his victims: by strangulation! When the FIEND chokes some poor soul, his body glows the same shade of ghastly red that reanimated him in the first place. And while this could've been a real laugh-riot (especially with the below-grade-Z effects), there's a certain sense of dread and some decent atmosphere that makes these sequences work.

A couple of nosey neighbors begin to suspect there's something weird about their new neighbor, and decide to investigate. (The one thing I laughed at was the absence of students or any actual music playing in Longfellow's home academy ... perhaps this is what caused suspicion in his neighbors?).

FIEND is a seriously flawed film, but worth a look if only for Leifert's fine performance as the soulless title monster, and some unusually solid atmosphere for a low budget picture. But as fans of B-horror know, there are stretches of boredom here that will challenge even the most jaded of trash film junkies. But if you can get through these areas, FIEND isn't too bad a time (and it didn't help seeing this after DON'T GO IN THE HOUSE, a superior film on every level).

(NOTE: In researching this film, I discovered FIEND star Don Liefert had passed away just recently in 2010. Hopefully his rest won't be interrupted by a tacky-looking, malevolent spirit...)

1981: While RAIDERS OF THE LOST ARK was on its way to becoming a classic, those of us who knelt at the altar of stop-motion animation were thrilled when CLASH OF THE TITANS hit U.S. screens to showcase the talents of the great Ray Harryhausen. Packed with countless monsters (and a mechanical owl!), this fun re-telling of the Greek myths brought the fun of classic creature-features back to the screen, along with a sword and sorcery theme. I couldn't get enough of how cool Medusa looked (let alone when she loses her head to Perseus's sword, which featured a nice batch of red sauce seldom seen in a PG-rated movie) and I went back to see it three times.

And then one Friday afternoon in 1982 or '83, I spotted an ad in my local newspaper. COOL! Maybe this monster/sorcery thing was slowly catching on, and I'd be able to get my fix more often in a theater and not just between the pages of Marvel's CONAN comics.

WRONG!

An older friend of mine managed to con his old man to drive us into New Jersey (GASP!) to see this, as it played everywhere in the tri-state area except for Staten Island. I think it was twenty minutes into the film when I realized my buddy wouldn't be letting me pick the movies anymore, and I was worried they'd leave me in the Garden State.

WAR OF THE WIZARDS turned out to be anything BUT a CLASH OF THE TITANS rip off. It wasn't until I recently attempted to find it on the Internet (where it's not even listed on imdb.com) that I discovered it's actually a circa 1978 Hong Kong/Taiwanese film originally titled THE PHOENIX. I KNEW something had to be up upon my initial (and only) viewing, when more screen time was dedicated to hokey martial arts action than monsters and sorcery. But like a true trooper, I convinced my buddy and his dad to stay, and to this day haven't heard the end of it.

The story (from what I could remember through the horrendous overdubbing) dealt with a fisherman who finds a bowl with magical powers at the bottom of a lake. He becomes wealthy and begins to live the good life—until a couple of wizards and martial-artists discover he has this legendary artifact. Two women manage to

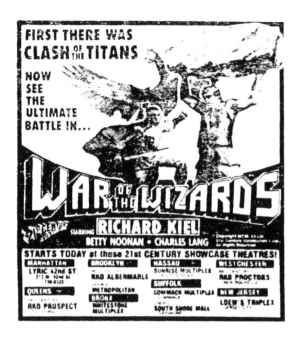

defeat all those attempting to get this magic bowl, and they both decide to marry the fisherman. Like a true idiot, he begins to show off his wives (and his wealth) in public, causing more attacks on his life (including some really, really, REALLY bad-looking laser-beam effects from a magical religious cult).

The highlight of the film was the religious zealots attacking the wedding of our fisherman and his brides, when a cheesy-looking phoenix rescues the fisherman and takes him to a high mountain, where he's trained to battle the animal spirits who control his wives, an extremely-sad-looking rock monster, and best of all, a hit-man of sorts played by non other than Richard Kiel (yes—THAT Richard Kiel, a.k.a. the metal-mouthed assassin "JAWS" from the James Bond films). I'm assuming film producers in Hong Kong were so taken aback by Kiel's performance in THE SPY WHO LOVED ME (1977) they just couldn't wait to get him into one of their mythical kung fu flicks (makes sense to me). In keeping with his metal-persona, Kiel attacks our hero with a pair of steel gloves (so at least he didn't have to bite through thick cable wire or Roger Moore's neck this time around) but proves to be little match for the scrawny fisherman.

With horrendous special effects all around (especially when the fisherman rides to the aforementioned mountaintop on the neck of the phoenix, which looked more like a gigantic peacock), unconvincing fight sequences, and a storyline that makes even less sense than what I just attempted to explain, WAR OF THE WIZARDS is a horrible film in WHATEVER title one may see it under.

I managed to find ONE review of this film on the entire World Wide Web, making it the most obscure title I've covered for this column so far. I have no idea if a VHS or DVD was released (I'm assuming it has in Hong Kong, most likely under a third or fourth title), but suffice it to say my solo theatrical viewing was more than enough.

SUPPORT YOUR LOCAL VETERANS!

esides an overabundance of slasher films, the early 80s was also a hotbed of DAWN OF THE DEAD and ZOMBIE rip-offs, and if you lived in the right places, these (mainly) Euro-schlock offerings seemed to be released every week.

Although zombie-mania is mainstream today, in 1982 it was still cool to be a zombie geek. And upon seeing an ad in my local newspaper for something called CANNIBALS IN THE STREETS, my geekdom hit an all-time high. Here was a film I hadn't read a thing about in any horror magazine or fanzine, and it starred John Saxon, an actor I had been a fan of since his stint as a robot opposite Lee Majors on the TV show THE SIX MILLION DOLLAR MAN (1974-76 episodes).

Thankfully one of my buddies' older brothers smuggled us into the Fox Twin Theatre, another defunct twin here on Staten Island that's now the site of a multiplex. For a Saturday afternoon, CANNIBALS IN THE STREETS was packed, but by the halfway point the theater had all but emptied. The fools should have stuck out the slow middle...

I should point out—before I go any further—that I eventually discovered this film was a HEAVILY edited version of a 1980 Italian production released in Europe as CANNIBAL APOCALYPSE, and eventually released on VHS in America, still edited, as INVASION OF THE FLESH HUNTERS (got all that?). As far as I know, this is the first Italian cannibal film to be shot almost entirely in Atlanta. I forced myself to watch (okay—SCAN) through Image Entertainment's uncut DVD version (under the title CANNIBAL APOCALYPSE) back around 2002, and am happy to report that the "uncut" version didn't enhance or change my opinion of the film. In fact, anyone seeking a gory cannibal/zombie outing can do themselves a favor and look elsewhere.

BUT: the film still has its moments.

Saxon locates a couple of P.O.W.'s in Vietnam. To survive, the men resorted to cannibalism, and as Saxon tries to help one soldier out of a prisoner pit,

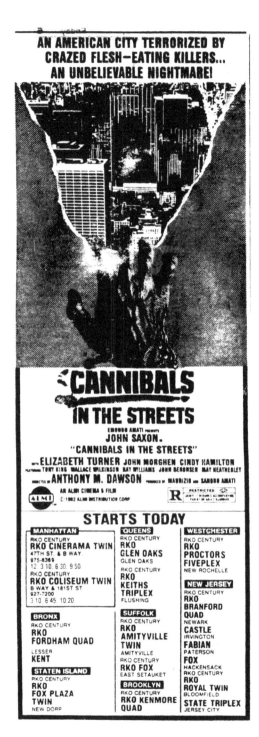

he has a nice chunk taken out of his arm! The theater DID go nuts over this opening sequence, which quickly ended and brought us back to modern-day Atlanta. Giovanni Lombardo Radice (who would soon get a power drill through his head in Fulci's THE GATES OF HELL (1983)) plays one of Saxon's 'Nam buddies—and for some reason they're both living in Atlanta. When Saxon refuses to go out with him for a drink (apparently he's still haunted by being bitten in 'Nam), Radice heads to a local movie theater where instead of focusing on the feature, he watches some pervert lick his girlfriend's body. Radice has a flashback and decides to bite the poor girl's neck, which causes the place to panic. He's chased by a bunch of crazed theater patrons, and a sorry-looking biker gang, into a thrift shop, where he's eventually apprehended and sent to the hospital for observation. DURING this fiasco, John Saxon is at home with a babysitter, who keeps giving him flashbacks every time she flirts by showing a little leg. Knowing his wife is being unfaithful, Saxon gives in and goes down on her without literally eating anything, temporarily sating his cannibalistic urges with some playful nibbling.

At this point in the film, it became clear CANNIBALS IN THE STREETS wasn't a zombie film, and while it moves well up to this point, the mid-section becomes quite tedious. Patron after patron began

to leave the theater, but my friends and I were confident something titled CANNIBALS IN THE STREETS simply HAD to have a pay off.

It does and it doesn't.

The action slowly picks back up when Radice and the other rescued P.O.W. escape from a hospital along with a nurse they've bitten. They run into the aforementioned biker gang right outside the hospital and a mini-brawl breaks out. The trio goes on to infect unlucky citizens with their cannibal virus, and eventually meet up with their former captain, John Saxon.

The rest of the film turns into a violent action flick, complete with a nifty chase sequence through Atlanta's sewers and a flamethrower battle at the finale. The gore scenes cut out of this theatrical release (provided by ZOMBIE (1979) and THE BEYOND (1981)-alumni Gianetto De Rossi), which I finally saw on the DVD, include a gruesome close-up of Radice's stomach after he gets a hole blown in it, a doctor having his tongue bitten off, and some sloppy mechanic having his leg sliced up like cold cuts at a deli.

I have no idea if director Antonio Margheriti was trying to make some kind of non-subtle point regarding the returning Vietnam vet as being the "real" monster, or if he just set out to make some cash by combining APOCALYPSE NOW and DAWN OF THE DEAD (both 1979). What I came away with was a satisfying exploitation experience, despite the (then) lack of gore, which was made up for with uncomfortable sex scenes, plenty of action (despite the slow middle), and some of the worst left-over disco music ever to appear in a cannibal film (and THAT'S saying something). I've read that John Saxon has publicly denounced the film, and co-star Radice has said Saxon seemed "out there" while the film was being shot. Either way, CANNIBALS IN THE STREETS is must viewing for Saxon completists and lovers of so-bad-they're-good grindhouse classics. All others, stick to RAMBO...

"LIZARD TAIL JERKY!"

y the middle of my senior year of high school, I was 100% addicted to gore films and spent much time trading bootleg VHS tapes (via snail mail) through my old fanzine, STINK. The sicker the title one acquired on the underground market, the better chance you had of trading it for something crazier. Yet despite being controlled by the sleazier side of sinema for close to 10 years, a silly little science fiction farce was about to remind me that light-hearted fare could still be as entertaining as any Euro gut-munching cannibal caper or women-in-prison epic. Or necrophiliac outing…

A couple of my friends were DJs at a local college radio station. I'd often do movie reviews on their shows, and spent most of my time in the studio going through the new albums. One that caught my eye was a soundtrack for a film titled TERRORVISION, a film that wouldn't be released for another three months. The main track, titled Terrorvision, performed by The Fibonaccis (whoever they were), is an addictive DEVO meets B-52s new wave jam that holds up great to repeated listens. So, with the main track imbedded in my mind, TERRORVISION finally came to my town on a freezing cold winter day in February, 1986, to a nearly sold-out opening night. Of ALL the films I've reviewed for this column, the theatre where this unspooled refuses to come to memory, but chances are it was the Lane Theatre, one of Staten Island's last single screen cinemas.

Produced by Charles Band's Empire Pictures, TERRORVISION is chock full of cheesy acting, lame special effects, and a story that's barely there, yet for some reason, the humor works. A suburban couple (played by PHANTOM OF THE PARADISE's Gerrit Graham and cult icon Mary Woronov) discover that a strange creature keeps popping up on their television. Figuring it must be some kind of interference, they think little of it until the creature eventually POPS OFF the set and literally comes into their home. Of course, the creature enters the home when the swinger parents are out, and the kids fail to train their strange new pet. It then tries to eat each member of the family (which includes a nerdy kid who hangs out all day long with his crackpot survivalist grandfather and a teenage

heavy metal sister with her rock-star wannabe boyfriend) as well as any friends or whoever just may happen to be stopping over for a visit. The alien is able to "reproduce" the heads of those he's eaten and mimic their voices in order to hide from police and an intergalactic alien cop (yeah, this one gets goofier by the minute).

It turns out the creature's home planet has discovered a way to turn its trash into antimatter and dispose of in space. This particular alien is an eating machine, resulting in its planet getting rid of him TRASH style! It's REALLY bad luck that this family had their satellite installed just as this batch of space junk was passing Earth!

While much of the humor is just plain silly, I found (even on recent viewing) most of it holds up, especially the aforementioned grandfather who lives on "lizard tail jerky." He keeps a pet lizard on him at all times, and yanks its tail off when he needs a snack. He assures his grandson the tails grow back as the two of them hunt the creature that has invaded their home. Although rated R, the only thing that

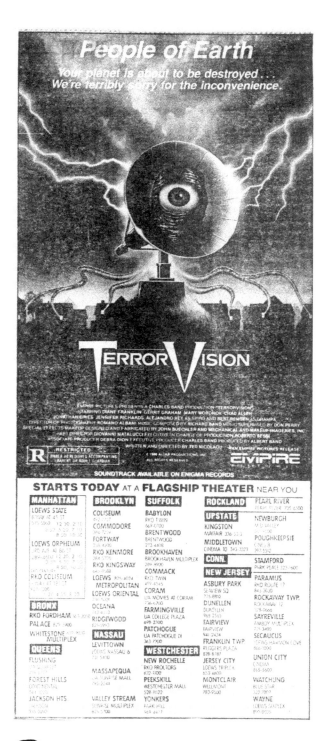

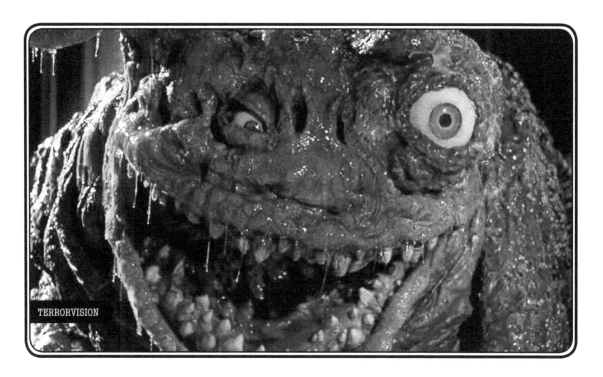

TERRORVISION

MIGHT have landed it this rating is the sleazy erotic artwork hanging around the house (remember, the parents are swingers!), much of it quite funny looking.

The highlight (for me, anyway) is a late night horror film TV-hostess named Medusa (complete with a head full of snakes) who makes non-stop sexual puns, some pretty graphic for an otherwise exploitation-less film. Just WHY she's in the film is anyone's guess, but she provides some fine eye candy nonetheless.

What surprised me (and the audience) most is the ending (SPOILER ALERT!): Our grotesque alien (who dribbles non-stop BUCKETS of goo and slime) eventually eats the entire family and takes off for world domination in a taxi cab! Who would've thought such a tame sci-fi comedy would end on such a dark (although in its context, funny) note?

With lots of laughs and a nifty soundtrack, this might not be as funny as SPACEBALLS (1987) or as exploitative as GALACTIC GIGOLO (also 1987), but as it was released before either, it deserves a little respect and hopefully one day a proper DVD release. It's good, slimy, goofy fun.

(This was also one of the earliest films I can remember coming to home video less than a month after its theatrical release).

CONAN... WITHOUT CLASS!

I spent most of the time during the second half of my sophomore year in high school daydreaming about movies. While horror preoccupied 90% of my mind, other exploitation films took about 8%, and the final 2% was dedicated to all things CONAN. From the early Marvel comics to the 1982 Ah-Nuld film version, I was always a big fan of the sword & sorcery genre. And while the success of CONAN THE BARBARIAN (1982) spawned several rip-offs, none were as memorable as the 1984 schlock-fest DEATHSTALKER, which happened to be released as I trudged through the tenth grade.

Picture—if you will—a group of fifteen year-old male teenagers managing to get into an R-rated action film with no problem. Now picture—if you will—that same group of ecstatic fifteen year-old teenagers giggling with glee as the sword & sorcery epic unreeling before them turned out to feature some of the worst acting, fakest-looking creatures, and massive amounts of jiggling boobs this side of a PORKY'S film. Even one-time sex symbol Barbi Benton appears as a princess, although she was better off taking another cruise on THE LOVE BOAT than accepting whatever peanuts she was offered for her forgettable role here.

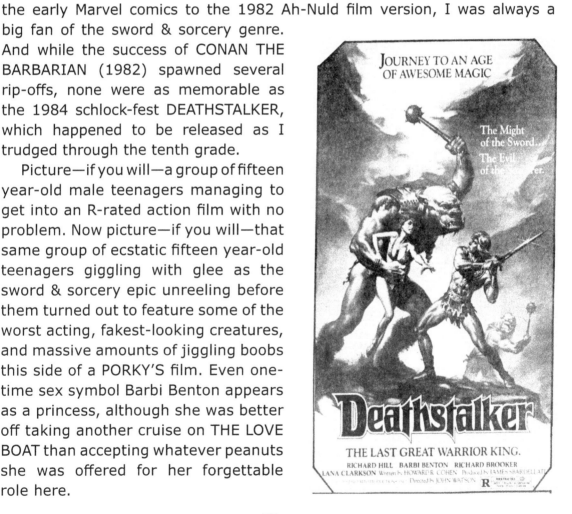

JOURNEY TO AN AGE OF AWESOME MAGIC

The Might of the Sword... The Evil of the...

Deathstalker

THE LAST GREAT WARRIOR KING.

RICHARD HILL BARBI BENTON RICHARD BROOKER
LANA CLARKSON Written by HOWARD R. COHEN Produced by JAMES SBARDELLATI
Directed by JOHN WATSON **R**

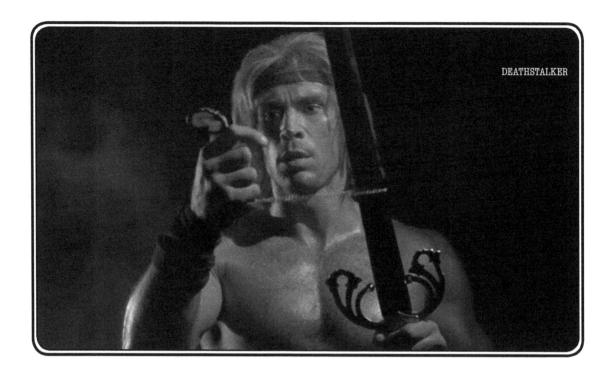

DEATHSTALKER

Besides the gratuitous boobs and brutal fight sequences, what truly made DEATHSTALKER such a joy to watch was the title character himself. Deathstalker was played by stuntman/actor Rick Hill, and is far less noble a warrior than Conan: he's a conscience-less murderer and rapist, taking any woman who even looks at him as he walks by with his bulging biceps. And in what tries to pass for a plot, a king asks Deathstalker to try and redeem himself by rescuing his kidnapped princess daughter from a tattoo-headed tyrant. Like any social misfit, Deathstalker basically tells the king where to go, then proceeds to eat (yes, EAT) half of the king's poor dog! At this point, you either buckled your seatbelt and prepared to enjoy the trash that followed, or you left the theater and spared your brain any further damage.

I stayed.

There was mumbling around the theater wondering just why this king asked a known, savage rapist to rescue his daughter, and why he even cared if the guy redeemed himself. But such are the mysteries of rip off, grindhouse cinema.

In one scene that drove the audience wild, a brawl goes down where one burly man (with his gigantic mallet) smashes his opponent into a bloody pancake.

Popcorn flew around the (now defunct) Fox Twin Theatre in appreciation, and at one point I started to hope some of the older guys in attendance didn't get any ideas after the film, out in the parking lot.

Between more bouncing boobs and heads getting lobbed off, there was talk of Deathstalker also having to find three objects that were allegedly part of the world's creation (I remember one being a sword, which he finds, but can't recall what the other two were … and you probably wouldn't, either). Deathstalker eventually rescues the princess (who actually looks like an old sea hag) and takes the sword of creation from the clutches of Munkar, the aforementioned tattoo-headed tyrant (and MAN did his head-tattoo look fake!). Just WHY Deathstalker went ahead and did what the king asked—after saying he wasn't interested—remains a mystery.

The remainder of DEATHSTALKER features our anti-hero joining a tournament where warriors battle other warriors to the death—sort of like a sword & sorcery tribute to the Bruce Lee classic ENTER THE DRAGON (1973). Here the blood flows deeper than your standard slasher film, as arms, legs, and heads fly, bodies are impaled; all the while Munkar looks on with a smirk, thinking everyone who stands in his way will eventually kill themselves off, leaving him to rule the world. MUHAHAHAHAHAHAHAHAHAHA!

But as fate would have it, Deathstalker manages to kill the final opponent, a goofy-looking pig-faced warrior beast, and eventually destroys Munkar and the mystical objects of creation.

Unlike CONAN THE BARBARIAN, or better rip-offs such as THE BEASTMASTER (1982), DEATHSTALKER's sloppy script and countless plot holes will cause even the most jaded fan of grindhouse cinema to shake their head in disbelief. But, if you're looking for a real GUY/party flick, full of hot babes, endless bloodshed, and acting so bad you can't help but yell back at the screen (even if you're watching it at home), DEATHSTALKER is a prime example of a so-bad-it's-amazing film. Most mind-boggling: this cinematic abortion was followed by three sequels, with Rick Hill returning in the title role for the fourth installment. None were half as good (or bad) as the original.

DAWN OF THE NUCLEAR SLIME...

eleased about 6 months after the unlikely success of THE TOXIC AVENGER, Troma Films' second take on radioactive raunchiness, CLASS OF NUKE 'EM HIGH (1986), is another New York/New Jersey-lensed exploitation epic that Lloyd Kaufman's crackpot film company managed to sort of get right ... at least if B-movies are your thing.

While I wanted to see this in Times Square (being it wasn't in wide-release), I managed to get a ride with a couple of unwilling friends to East Brunswick, NJ to a theater called Movie City, where it was featured for one week only. I conned a couple of my buddies to join me on my quest for Tromaville, and we headed to the Garden State hoping this would at least be half as good as the first TOXIC AVENGER.

Warren and his cute girlfriend, Chrissy, are among the few clean cut students at Tromaville High, which happens to be located right behind a nuclear power plant. The punk students (who look like rejects from a really bad ROAD WARRIOR rip off) grow marijuana right outside the plant, and begin selling radiation-laced pot around the school. One early sequence of government officials checking the power plant for toxic leaks had the audience in stitches; some men fell to the ground stone-cold dead as others kept about their jobs, unaware of what was happening to their colleagues. It's a nice bit of old-fashioned slapstick that worked among the coming gore, slime, and radioactive boobies.

Despite their nerdiness, Warren and Chrissy decide to partake of the toxic weed. As a result, Warren gains incredible strength, and Chrissy becomes incredibly horny...which leads to a wicked spin in the sack with her boyfriend...which leads to a pregnancy. Before long the entire school is having strange side effects, the best being Chrissy's baby who turns out to be a 10-foot tall radioactive monster who eventually helps to wipe out the toxic punk drug dealers.

If you've never seen a Troma film before, CLASS OF NUKE 'EM HIGH is a prime example of the style that gave them notoriety during the splatter film craze of the 1980s. One sequence, where an enraged Warren goes after a

punk who has messed with him one time too many, features a silly (yet effective) special effect where he rams his fist down the guy's throat. The New Joisey crowd ate this scene up, cheers growing louder as Warren's arm eventually goes down further than his elbow with puke-inducing sound effects.

You don't go to see something called CLASS OF NUKE 'EM HIGH for artistic value.

While THE TOXIC AVENGER had a better crafted (if familiar) story, CLASS OF NUKE 'EM HIGH is basically pure chaos: the simple premise is set in motion when a nerdy student freaks out during the opening scene, oozes green slime from his ears, then jumps out the second-floor window. The atomic marijuana is then introduced, along with an endless array of wacky characters. The two directors (Lloyd Kaufman and Richard W. Haines)—for some reason it took two directors to create this!—then let everything go ballistic in a brain-dead, toxic high school gore/ sci-fi romp that (at the time) was

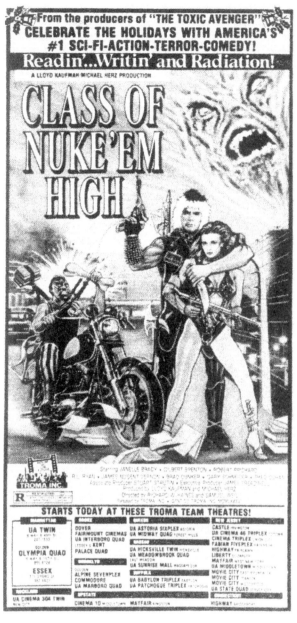

a pure blast for its intended teenage audience. I've seen the film a few times over the years on VHS and DVD, and while there are still some laughs to be had, much of it gets tedious and it doesn't hold up half as well as THE TOXIC AVENGER or Troma's other fluke of a hit, TROMA'S WAR (1988). But I'm betting younger

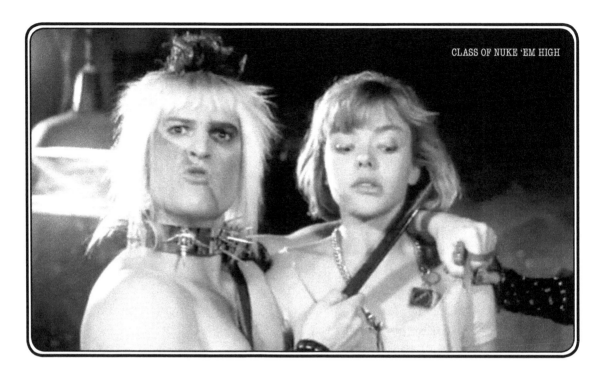

exploitation fans will still get a real charge out of this high-octane trip to Tromaville. The audience at Movie City (as well as my two friends) seemed unimpressed with any of this, and it was my only trip to the place, which has long gone under.

NUKE 'EM HIGH's horrible soundtrack, trademark Troma bad acting, and high school students who look way too old to be high school students has a certain charm that many modern-day made-for-cable/DVD exploitation films just don't have. So throw your biohazard suit on and check this out for a near-lethal dose of old school Troma-rificness. And remember the tagline: READIN' WRITIN' AND RADIATION!

You've been warned.

(This film also spawned two sequels: CLASS OF NUKE 'EM HIGH PART 2: SUBHUMANOID MELTDOWN (1991) and CLASS OF NUKE 'EM HIGH 3: THE GOOD, THE BAD, AND THE SUBHUMANOID (1994). While part two had its moments (especially a gigantic rodent named Tromie the Nuclear Squirrel), you're not missing anything. Part 3 was one of the worst films I've ever seen. You've been warned again!).

BLAIR BEHIND BARS!

I'm finally getting around to looking at a requested subgenre: Women In Prison films, or WIPs, as connoisseurs of the subgenre affectionately refer to them. WIPs were a hot ticket in the 70s and early 80s, and none were as fun, sleazy, and downright mean-spirited as CHAINED HEAT (1983), especially when you consider it played not only in grindhouse theaters, but in respectable multiplexes and duplexes all across the U.S. of A.

What sets CHAINED HEAT apart from others of its ilk is the amazing cast. When I heard Linda (THE EXORCIST) Blair was starring, my 15-year-old rump made no hesitation getting to the (now defunct) Island Twin Theatre, Staten Island's best bet for unusual and midnight film offerings, where the opening night line wrapped around the place like a new STAR WARS film had been released. On top of Blair, cult film legend Sybil Danning was in her prime and delivers one of her most memorable performances here as a tough inmate. CLEOPATRA JONES (1973) herself, Tamara Dobson, plays Danning's African

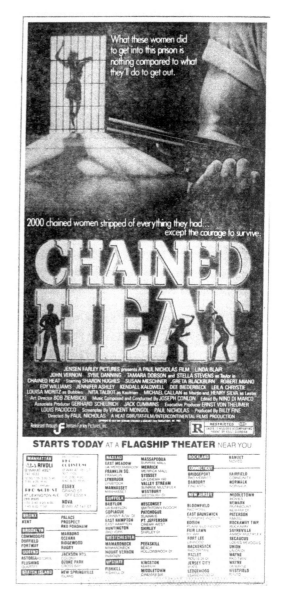

CHAINED HEAT

American rival and is tougher than a bucket of galvanized nails. Topping off the list of cult icons is John (ANIMAL HOUSE [1978]) Vernon as a corrupt warden, and his first in command, TV star Stella Stevens (!). Plus we get sleaze ball king Henry Silva (you saw him in a 1,000 films, including 1980's ALLIGATOR and 1973's BATTLE OF THE GODFATHERS) who runs an escort service comprised of inmates along with Stevens' character.

And those are just at the tip of the iceberg.

Like most WIP films (from 1972's THE BIG BIRD CAGE through to 1982's THE CONCRETE JUNGLE), CHAINED HEAT follows a typical plot of one woman being busted for some unusual crime (this time Blair is arrested for accidentally killing a man). Her sentence is 18 months in one seriously hellish prison, overrun with gangs, rapist security guards, and more corruption than your standard presidential campaign. There's also a racial sub-plot here, as inmates take sides with either the white or black gangs, and there's more pot and crack smoking going on than in three combined Cheech and Chong films.

Before the inevitable prison riot, Blair is chosen to leave the jail at night to be an escort, and of course she, being morally better than the other inmates (not to

mention the highest paid actor in the film), doesn't get down and dirty like the other girls do. In fact she helps one of the weaker ones fight a rough costumer.

There's also a sequence that caused us EXORCIST fans to question if Blair was ever truly exorcised: a lengthy nude shower scene where Sybil Danning forces herself on the former teenage devil-doll; I can't remember ever hearing a theater full of teenaged horn-dogs whistling and screaming "GO FOR IT!" with so much enthusiasm (then again, this WAS less than a year after the blockbuster sequel ROCKY III was released, so pretty much everyone was still yelling "GO FOR IT!" at something or someone). Unrealistic lesbianism has always been a major part of WIP films, and CHAINED HEAT has its share of it (no doubt helping lead to its successful theatrical run: although rated R, this was about as close to an adult film a teenager could get their hands on at the time, both in theaters and a few months later on VHS).

My favorite sequence is when the warden (John Vernon) reveals to a sexy inmate (in his private office) that he makes his own porn films as they're making out in his Jacuzzi. He flicks a button and she realizes they're being filmed by a bulky video camera mounted above the hot tub. For some reason she gets into it, despite the balding, unattractive old goat. This guy gets an A+ for one of the slickest, sleaziest wardens in WIP history.

After the drugs, rape, lesbian sex, straight sex, razor blade murders, knife fights, catfights, and stern speeches by the warden and his right-hand man (or in this case, right-hand woman), the inmates finally decide it's time to turn the tables. They quickly take over the joint, breaking heads and messing the place up, both white and black gangs now working side-by-side against THE MAN. The best sequence features a male prison guard (who had raped most of the inmates) being SLOWLY stabbed in the throat; it was a simple but effective effect that caused audible groans from the crowd.

While WIP films are quite similar and can get tiring, CHAINED HEAT is simply THE one title to see if you feel the need to experience the subgenre. It's not pretty (even the sex scenes are kind-of disgusting), has many technical mistakes (the worst being a sound mic in nearly every other shot), and it's about as violent as an R-rated film gets. In some ways, this is the perfect grindhouse film which I'm STILL amazed had such a mainstream release.

I've yet to watch THE EXORCIST (or any other Linda Blair film) the same way again. Be warned.

Suburban Grindhouse Memories No 45

TV STARS Vs PORN STARS Vs HILLBILLY MECHANICS Vs ALIENS!

 985 was a great year for horror films. We fans were treated to theatrical releases of George Romero's DAY OF THE DEAD, Lamberto Bava's DEMONS, Stuart Gordon's RE-ANIMATOR, and Dan O'Bannon's RETURN OF THE LIVING DEAD … and those were just the tip of the iceberg. It seemed every week a winner was coming down the pike—but, of course, I managed to stumble across a real clunker that caused me to doubt my fellow man's sanity.

While Friday night audiences were wrapped around the block trying to get into sold-out screenings of the second A NIGHTMARE ON ELM STREET film, my buddies and I decided to wait till Monday and instead hit the (now defunct) Amboy Twin Cinema for EVILS OF THE NIGHT, one in a series of exploitation films that reeled idiots like myself in primarily with its poster art. With a rip off of STAR WARS' Millennium Falcon spaceship, a poor girl with spike-like nipples being drained of blood as skeleton hands grab for her, there was just NO WAY I was going to miss this. And when I squinted hard enough that I could read some of the stars (who are all hear simply for a paycheck), I was convinced we had another "so-bad-it's good" epic on our hands.

Well, it truly is a BAD film. If you like bottom-of-the-barrel rip-offs, it doesn't get much more entertaining than this.

Director Mardi Rustam (who had produced several genre titles before this directorial debut) delivers this ode to old school sci-fi films by featuring John Carradine as the main alien who has come to Earth seeking teenage flesh and blood for use in some kind of anti-aging youth serum (or something like that … the plot's all over the place). His assistants are Julie Newmar of TV's BATMAN and Tina Louise of GILLIGAN'S ISLAND fame. Their acting here is as atrocious as the lesser known "teenagers," several of whom were played by popular (at the time) porno stars, such as Amber Lynn, Jerry Butler, and Crystal Breeze, who gets the WORST ACTING IN THIS FILM award for her facial expressions as she's strangled by a hillbilly mechanic as her boyfriend takes her from behind.

Don't ask...

But since you did, the hillbilly mechanics are conned by our alien trio to help them collect fresh corpses. Neville Brand (who is as uninteresting here as he was in Tobe Hooper's overrated EATEN ALIVE (1977)) and Aldo Ray (fresh off another celluloid abortion, 1984's FRANKENSTEIN'S GREAT AUNT TILLIE) play the bumbling overalls-wearing mechanics, who had the crowd shouting insults every time they decided to abduct a teenager by such hi-tech means as frayed rope and pillow cases. I mean, let's get serious here for two seconds: IF a trio of aliens forced me to go out and abduct teenagers, and I was slightly overweight and could hardly run, I'd SURELY demand they give me one of their ray guns or space-age stun phasers. But apparently Carradine and Company come from a planet that's as cheap as their spaceship

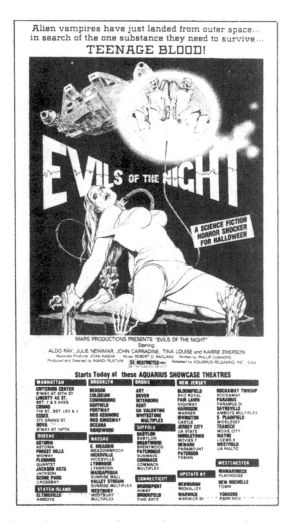

and the run-down hospital where they've chosen to base their intergalactic operation out of.

I never thought I'd say this, but the "blood-draining" techniques used here PALE in comparison to those used in 1972's notorious INVASION OF THE BLOOD FARMERS, and trust me if you haven't seen either film, this IS saying something!

But good 'ol Mardi Rustam (who would mercifully direct only two more films) had an ace up his sleeve: he KNEW the sci-fi here was lame. He KNEW the horror in his stink-fest was non-existent. So he figured he'd grab some porn stars to do a few nude scenes, and Presto! EVILS OF THE NIGHT became as racy (sex-wise) as PORKY'S (1982) and a host of other teenage sex comedies

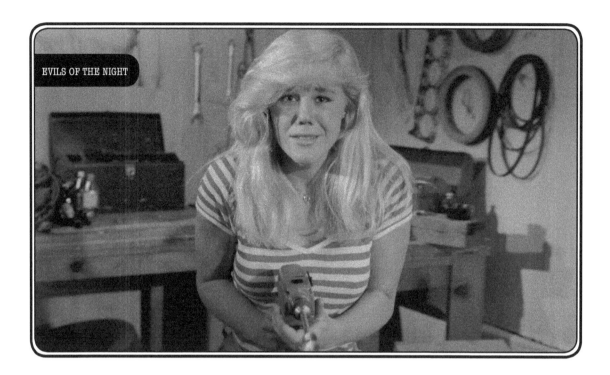

EVILS OF THE NIGHT

that flooded the early 80s market. Word of mouth (at least in my neck of the woods) spoke more of the lesbian beach sequence than it did of aliens draining teenage blood: more people rented this on VHS a few months after its theatrical release due to Crystal Breeze's aforementioned doggie-style sex scene, and Amber Lynn's romp in the boat house segment, than they did for any other reason. Because, there really IS no other reason to see EVILS OF THE NIGHT, unless, of course, you get demented pleasure in seeing former TV and movie stars going down like the Hindenburg in a last ditch effort to save their careers (although John Carradine had already starred in plenty of Z-grade films, so we'll let him slide).

Ironically (OR, was it planned?), Tobe Hooper's LIFEFORCE, a very GOOD film about space vampires, was released a few months before this putrid platter of pus. Perhaps give that one a shot if you haven't.

Unless you're a true masochist for horrendous sci-fi/horror/soft porn films, definitely PASS on this one, should you encounter a DVD or late night cable screening, or be crazy enough to drop some money on the recently released Blu-ray.

his time I'm doing something slightly different. I didn't see this one in a theater (until—finally—a 2013 midnight revival screening), but it's a grindhouse gem. I saw it on VHS when it was re-released by Quentin Tarantino's Rolling Thunder Pictures in August of 1998.

From the jail-breaking dames in 1955's SWAMP WOMEN to "The Man-Eaters" in H.G. Lewis's SHE DEVILS ON WHEELS (1968); from the seldom seen knife-wielding thieves in the 1973 Japanese cult classic, YASAGURE ANEGO DEN: SOKATSU RINCHI to everyone's favorites, "The Lizzies" in 1979's THE WARRIORS, there's nothing cooler than a group of pissed off, rebellious ladies out on the streets marking their own turf and making their own rules.

But when it comes to nearly non-stop action, campy violence, and man-battering domination, you can't get much better than the "Dagger Debs," the all-girl gang from 1975's SWITCHBLADE SISTERS. And unlike the previously mentioned films, The Debs are (for the first half of the film) part of a male gang, the "Silver Daggers." Sick and tired of being treated like second class (gang) citizens, they create their own clique and before long director Jack Hill—the man who also brought us such classics as SPIDER BABY (1968), THE BIG DOLL HOUSE (1971) and two of Pam Grier's best films: COFFY (1973) and FOXY BROWN (1974)—treats the viewer to one of the wildest, craziest, coolest gang films ever made.

Let's get the silliness out of the way: this is first and foremost and exploitation film, chock full of horrible acting and dialogue. The director packed it with plenty of self-mocking sequences. There's obese lesbian prison wardens and high school gang members that look way older than 18; there's chicks fighting over the same goofy-looking guy and a massive shoot-out at a roller skating rink (not to mention an all-black female gang who have a custom-built street tank!). There's dope-dealing and prostitution in the school bathrooms. Yet despite all this, SWITCHBLADE SISTERS is a story of female empowerment. It was released on the tail end of the Vietnam War and shortly after the sexual

revolution, yet still portrays the world as anything but friendly to women. Hence the strength when Lace (played by the cute and oh-so 70s-looking Robbie Lee) decides to break away from the boys and sort of lead her own clique. The film makes an even stronger feminist statement when new member Maggie (played by the even cuter and even more oh-so 70s' looking Joanne Nail) eventually takes over the group (after their men are wiped out during an ambush) and re-names them "The Jezebels," now fully separating them from their male co-bangers. It's not until the last section of the film when the Jezebels join forces with the aforementioned black female gang to take on another rival gang (led by the wonderfully named "Crabs") that we see total female unity, power, and determination. There's bits and pieces of this hinted at beforehand, but in the end (before all hell breaks loose and the Jezebels begin to turn on one another), these ladies are not to be messed with.

Again, SWITCHBLADE SISTERS is a 70s cult film and an exploitation flick if there ever was one. To some who have seen it, they might be thinking I'm giving the pro-woman message a bit too much credit here. But when you look at how female gangs have been depicted in the cinema, few have the charisma, the drive, or the purpose as the Jezebels.

Adding to SWITCHBLADE SISTERS' coolness factor are the fashions. The girls are (mostly) seen in leather and lace, with studded boots, bell bottoms, and funky hats. The black gang sport afros that are the epitome of 70s blaxploitation. There's something to be said for ladies looking this tight and still being able to flick their blades and have gun duels without ever ruining their threads...

I think its Joanne Nail's character, Maggie, who makes SWITCHBLADE SISTERS work. When she joins the Dagger Debs, she's dressed (almost) like the star of a 70s roller-disco porno flick in her tight T-shirt and short-shorts. But when she assumes the role of leader, she drops her sarcastic comments and takes things seriously, not afraid to get things done, even if it means taking a life for the cause. She may not have the toughest-looking face, which only makes her that much deadlier.

If you're one of the unfortunate souls who didn't grow up in or around the 70s, and can overlook the cheesiness and bad acting, SWITCHBLADE SISTERS is an amazingly entertaining film that—thanks to Quentin Taratino's 1998 re-release on VHS and the later DVD—continues to find new fans every year.

HORROR HOTEL THIS ISN'T...

O n a freezing cold Saturday night in January of 1985, I was still reeling from seeing my second Metallica gig at Brooklyn's famous rock club, L'Amour (at the time no one had a clue they'd eventually become the biggest band in the world) and yet an ad I saw in my local paper a day earlier kept gnawing at my brain. SUPERSTITION came out with no TV commercials and, as far as I recall, no mention in any of the horror zines at the time. Most alluring of all, it was released unrated. So I attempted to get my hearing back as I entered the (now defunct) Fox Twin Cinema, one of Staten Island's best venues for exploitation films.

I had to laugh during the opening sequence: two teenagers attempted to pull a prank on a couple who are making out near some abandoned-looking house. They both get deep-sixed by an unseen killer, and I wondered why the film had a supernatural title if this was just another slasher flick.

Well, it isn't a slasher flick per se. As we soon learn, this abandoned house—that's being remodeled to accomodate a minister and his family—had been cursed three hundred years earlier by a witch who used to live there. In flashbacks, we learn the local priest discovered the witch was in league with Satan himself (I believe it's even said she was Satan's daughter), and, as punishment, drowns her in a pond behind the house. Now,

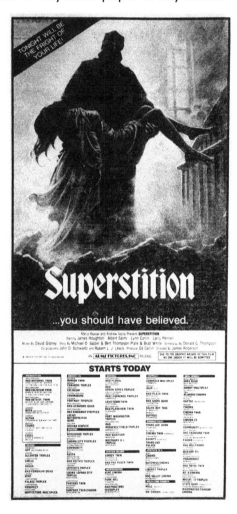

being HORROR HOTEL (1960) is one of my all-time favorite horror films, I was already put off by SUPERSTITION's rip off plot. But what redeems this Canadian production are the kill scenes: I'm guessing even though the killer here is supernatural, the producers thought it would be smart to cater to the (then) popular slasher crowd and off victims in gory and inventive ways. I still don't think this film needed to be unrated, as there were many R-rated films before this that were much more graphic (1980's DON'T GO IN THE BASEMENT and MOTHER'S DAY—both released with an R-rating—make SUPERSTITION look like a kiddie show). Go figure.

So, judging by some groans heard around the theater, it was apparent we weren't in for a deep story. There were several things brought up during the film that are never resolved, but when a working circular saw comes unhinged from its base and flies into a young minister's chest, spinning so fast that it goes through him, as well as the chair he's pinned to, everyone cheered, realizing we'd at least be in for a fun splatter-fest.

While there's plenty of violence in SUPERSTITION, much of it takes place off camera and we see the aftermath. Perhaps this is how the FX crew saved money? Either way, many of the kills are still effective, if not disappointing to a mainly teenaged, blood-hungry-crowd.

My favorite scenes are those of a cute young girl who shows up out of nowhere, dressed in a clean white dress, warning the Reverend about the house. It's never explained who she is, and between the inventive kill scenes not many of us really cared. Some other fun, splattery goodness includes a poor sap being cut in half by a falling window and a head exploding via microwave. Another unlucky lady gets a thick spike to the ol' noggin. Jason Vorhees himself would've been impressed with some of the stuff this old witch comes up with…

In one flashback sequence, there's an exorcism that's quite convincing. For a change, the witch's deep-growl possessed voice doesn't sound too goofy, and for whatever rare reason the scene didn't remind me of THE EXORCIST (1973) and not just because it takes place three hundred years ago.

SUPERSTITION was a decent time at the movies, if not ground-breaking, and all these years later I have yet to revisit it on video. I'm wondering if it holds up as a fun gore-fest? Perhaps it'll show up on cable and I'll see. And if not, I'm happy enough with my one-time viewing, alongside a bunch of cheering, popcorn-throwing suburban grindhouse fanatics. For 80s gorehounds only. All others, see HORROR HOTEL.

THIS FINGER POSSESSED!

While it's a routine, by-the-numbers haunted house/possession film, 1980's BEYOND EVIL holds a special place in my film-going life as it was the FIRST R-rated film I managed to get into on my own! Thanks to my Sicilian genes, I actually had a moustache in the 6th grade that (I like to believe) helped me get into many films I otherwise wouldn't have been able to. The fine folks at the (now defunct) Amboy Twin didn't even blink as I handed them my ticket fee and waltzed to the concession stand for some Saturday afternoon snacks. I can recall about twenty people in attendance, not bad for an early show, and a few of them had no problem letting their opinions be heard as the film unreeled.

BEYOND EVIL opens on an isolated island, where a native couple has just been hitched. They run off into the woods and prepare to do the nasty, when the woman discovers a mansion in the middle of nowhere. Before you can say BOO! a woman's face appears in one of the windows, just as one of the mansion's support columns happens to detach itself from the place and crush the poor bride's arm. The scene is darkly shot and in the theater was hard to see (I have no idea if the VHS or DVD editions cleared this up), but either way, the

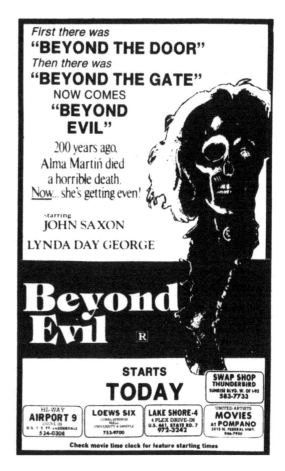

First there was
"BEYOND THE DOOR"
Then there was
"BEYOND THE GATE"
NOW COMES
"BEYOND EVIL"

200 years ago,
Alma Martin died
a horrible death.
Now... she's getting even!

starring
JOHN SAXON
LYNDA DAY GEORGE

Beyond Evil R

STARTS
TODAY

SWAP SHOP
THUNDERBIRD
SUNRISE BLVD. W. OF I-95
583-7733

HI-WAY
AIRPORT 9
DRIVE-IN
U.S. 1, S FT. LAUDERDALE
524-0306

LOEWS SIX
CORAL SPRINGS
MALL
UNIVERSITY & SAMPLE
753-9700

LAKE SHORE-4
4 PLEX DRIVE-IN
U.S. 441, STATE RD. 7
972-3242

UNITED ARTISTS
MOVIES
AT POMPANO
3215 N. FEDERAL HWY.
946-7950

Check movie time clock for feature starting times

film quickly had everyone's attention.

The next thing I know John Saxon and his wife (played by Lynda Day George) arrive on the island, and I was as happy as a Sasquatch in the woods. Why? Because Saxon had co-starred on a couple of episodes of the 70s TV series, THE SIX MILLION DOLLAR MAN, a few years earlier during the classic "Bigfoot" episodes, so I was a fan. (Of course Saxon and George would sort of RULE early-80s horror and exploitation cinema, starring in such classics as CANNIBALS IN THE STREETS (1980), BATTLE BEYOND THE STARS (1980), PIECES (1982), TENEBRE (1982), and MORTUARY (1983), to name just a few). Saxon has arrived on the island to oversee some construction job (I believe he was an architect) and one of his wife's ex-boyfriends was supposed to get them an apartment. BUT guess where they wind up? Yep–at the aforementioned mansion, which we eventually learn was once the home of a crazed witch. The audience howled in laughter when George said she wanted to know who any ghosts living in her house were!

(PAUSE: I usually write this column STRICTLY from memory, but this time I simply had to peek at a few reviews to spark my brain into action: one thing most reviews raved over was how good the acting was. I'm sorry, folks, but the acting and dialogue is what most people made fun of at the screening I attended. I believe a DVD viewing is in order here. NOW BACK TO OUR REGULARLY SCHEDULED COLUMN...)

In a flashback sequence, we learn the woman who had lived in the mansion began to practice witchcraft to get back at her abusive husband. When he discovered what she was up to, he poisoned her. NOT bothered by the mansion's history, Saxon and George settle in and it doesn't take long for typical haunted house happiness to begin.

More laughable than some of the acting here are the low-grade special FX. In one sequence, Saxon is startled by a dopey-looking green light and topples down a spiral staircase, then is almost killed by a falling devil statue. I remember someone yelling "Take the hint!" when Saxon basically brushed himself off and went back to his regular routine. I don't know about you, but if I heard my new home was once owned by a murdered witch, then saw a devil statue at the top of the staircase, I'd either change the décor or high-tail it back to the city.

The insanity clicks into high gear when Saxon meets his neighbors out front; it's at this same time the ghost-witch decides to strike, causing George

to stab herself, leaving an occult mark that looks like the one the witch had. While I found the scene a tad disturbing (remember I was a sixth grader at the time), most of the crowd laughed at George's facial expressions as she jabbed away. I bet I would have, too, had I been a bit older and more experienced with bad acting...

My favorite scene features Saxon kicking ass at the hospital when an orderly or nurse admits to losing his wife's test results. I was hoping Bigfoot would make an appearance at this point, but no such luck. Saxon's doctor/neighbor soon advises them to leave the house (DUH!) but, of course, they don't, and more terribly choreographed attacks go down and the FX get worse. One ridiculous scene has George's ring finger all puffed up. Saxon's neighbor claims this is a sign she is becoming possessed so he attempts to heal her. Of course he takes her to the hospital to do this and when he removes her wedding ring, things get chaotic, although not in an exciting way.

For some reason that's never explained, those possessed by the ghost-witch gain the ability to shoot green laser beams from their eyes in embarrassingly bad FX. Each time this happened people screamed X-MEN! or some other dumb comment that really didn't enhance the viewing experience. Not all grindhouse commentary was witty!

Saxon and George eventually blow up the crypt that holds the ghost-witch's body, but it only causes her spirit to become more powerful (WHY? YOU tell me!). Realizing they can't fight her anymore, Saxon shoves his wife's ring back on her inflamed finger, which somehow slows the witch down, then they jump in their car and floor it, leaving the mansion and the witch to wait for the next couple of suckers.

My biggest problem with BEYOND EVIL isn't the shady script, the constant haunted house clichés, the bad FX or the lame acting. It's the fact it received an R-rating. There's almost no blood, no sex or nudity, and nothing really scary about it. Thinking back, perhaps my moustache had less to do with me getting in than I like to believe. This is EASILY a PG-13 film, although at the time a simple PG would've sufficed. It's a real turkey, but one I at least had fun getting into without adult supervision.

For John Saxon and Lynda Day George completists only. (Also of note here is director Herb Freed, who went on to make the vastly superior slasher film, GRADUATION DAY, just a year later).

YOU'LL WISH IT WAS JUST DANDRUFF!

While most people saw it as part of a double feature VHS release, 1983's SCALPS had a brief theatrical run in late December of that year. Directed by future schlock-kingpin Fred Olen Ray, this slasher/ possession film is a mixed bag that doesn't quite live up to its eye-catching poster ad.

Six archeology students head out to the desert to the site of an old Indian burial ground (thank you, POLTERGEIST, 1982, for helping this to become one of the most clichéd horror plots of all time) and despite hearing a word of warning (if they disturb the site, the spirit of an Indian warrior will seek revenge), our generic slasher film throw-a-ways decide to get busy with their shovels, anyway. It doesn't take long for weird things to start happening around their campsite, including the team eventually being disposed of in gory ways. The tension (attempts) to grow as we learn the culprit may be one of their own, possessed by the spirit they've unleashed by tampering with ancient artifacts.

SCALPS is one of those films that rewards ONLY those patient enough to get through its first hour. Most of the action goes down during the third act, and gorehounds who may have heard about this one need only to fast-forward their DVD to the final half hour (although there IS a decapitation during the opening moments, perhaps placed as a slight teaser). A couple of people walked out during one of the endless digging-scenes, one guy yelling, "Keep digging, a$$holes!", causing me to both crack a smile then wonder what someone had expected, paying to see a film titled SCALPS.

The spirit that possesses one of the campers pops up from behind rocks a few times, once actually scaring the audience. Known as Black Claw, this Indian spirit is TRULY annoyed his stuff has been discovered (and, of course, WHY we're never told) and thankfully there's a bunch of freshly-dug-up weapons at his disposal.

Call me crazy, but if people found stuff I created a long time ago and wanted to put them in a museum, I'd be thrilled. Black Claw, however, only wants

people to die. Horribly!

What drove the (now defunct) Fox Twin Cinema audience crazy were the seemingly ENDLESS scenes of our archeologists gabbing on and on about their work, both how important it was (another thing never fully explained why) and also how risky it was in light of the post-dig events. If there's one film I wish I had a tape recorder playing through, it'd be SCALPS, where more profanity was offered to the onscreen cast than any other film I could recall attending. One full-figured guy two rows in front of me (complete with a backwards STP baseball hat—perhaps he drove in from New Jersey?) must've tossed half his tub of popcorn at the screen whenever one of the more annoying female students opened her mouth (which seemed like every four seconds).

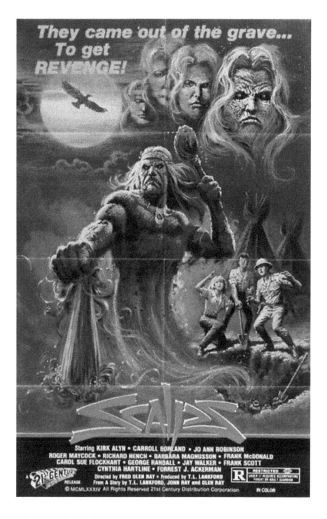

I have to tell you, folks—if not for the entertainment provided my fellow suburban grindhouse maniacs, I doubt I could've made it to the end of this thing.

BUT alas, when Black Claw finally gets his minion to go ballistic, the blood begins to spurt like soda from a shaken can: one poor guy has an arrow shot right through his eyeball from about 10 feet away, while another poor sucker becomes a human pin cushion from a hail of them. Living up to its title, SCALPS contains a couple of graphic scalping scenes, one comparable to Tom Savini's work on the classic MANIAC (1980). Sadly, that was the only believable effect: one scene (that had the audience audibly gagging) features another poor victim

SCALPS

having her throat slashed in a tight close-up, then she gets scalped, causing one of the goriest kills of the early 80s (although it doesn't look as convincing as the FX team had hoped for). So in retrospect, yeah, the last third of this one is a gorehound's delight, although those gorehounds best be prepared to deal with some terrible acting, sloppy effects, and an ending that still has me scratching my head.

As mentioned, SCALPS was released on VHS in a double feature with a film titled THE SLAYER (while I didn't see that one theatrically, I did watch the video and am beyond thankful I missed its cinematic release—if it even had one). For the curious, SCALPS is available on DVD, a format that mercifully allows viewers to scan directly to the "good" stuff.

Sometimes, being a pre-DVD child of the 80s wasn't all it was cracked up to be.

For generic, bad acting, sloppy effects, plotless slasher film completists only! (OH YEAH—there's also a cameo by FAMOUS MONSTERS OF FILMLAND icon Forrest J. Ackerman. Go figure.)

Suburban Grindhouse Memories No 50

A VERY MESSY NESSIE...

*I*f there's anything special to point out about 1981's THE LOCH NESS HORROR, it's the fact that it's a PG-rated monster movie, yet still qualifies as a grindhouse film (you'll see why as this column unfolds). And while I had just started to get into R-rated films in 1981, my life-long obsession with monsters, coupled with the AMAZING poster for this flick, caused me to hit the (now defunct) Amboy Twin theater one Saturday afternoon for a solo viewing, fully aware there'd be little violence and a 99.9% chance of nothing too objectionable.

In an attempt at a scary opening, a man (in 1940) is watching a plane through his telescope when it takes a dive toward a lake. The man follows the plane down, but instead of seeing it hit the water, the Loch Ness Monster's head pops into the viewfinder. It's an undramatic sequence but sets us up for the events to come, which take place forty years later.

A couple of dopey-looking scientists are floating on Loch Ness in a rubber raft with cheap-looking equipment when Nessie sticks her head out of the water. (NOTE: While the film slows down, I have to give the director

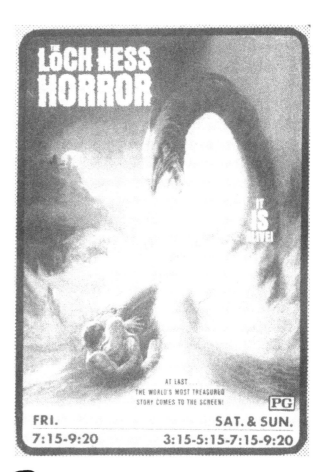

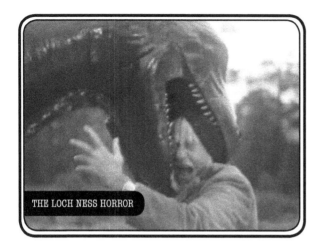

THE LOCH NESS HORROR

credit for these two well-paced opening segments). Not scared—because, y'know, scientists just don't scare easily—our heroes decide to dive into the loch and see if they can locate the creature. What they find are the remains of the forty-year-old plane (featuring two pilots whose bodies look like as good as new!) as well as a large egg that we assume belongs to Nessie (it does). One of the guys is eaten, but the other manages to make it to shore with the egg, where an old man in a mobile camper is waiting.

When they go to sleep that night, Nessie comes out of the water and drags the egg-stealer back into the lake as he screams in his sleeping bag (!), leaving the old man to look on in (poorly acted) horror. Laughs erupted around the decently-crowded afternoon screening.

After this, THE LOCH NESS HORROR becomes an orgy of incoherence. I'm assuming the screenwriters only wanted to show off their cheap-looking Nessie costume (that no one told them looked about as menacing as a Muppet), as they bring in several college age-looking characters, for no other reason than to become monster chow. And for some reason no film critic in the world will ever be able to explain, the old guy in the camper kidnaps one of the college girls.

At this point it should be noted that it's PAINFULLY OBVIOUS this film was not shot in Scotland, and the actors were most likely friends of the filmmakers who weren't taught how to speak like Scotsmen and women. The kidnapped girl has one of the worst Scottish accents you'll ever hear—but apparently Nessie liked her—because the monster ends up eating the old bag that kidnapped her, picking him up by consuming his whole head (a great little scene that had us all cheering!).

WHEN the crowd cheers for the monster, you know you've entered GRINDHOUSEVILLE. There are several fun monster-eating scenes, and while not graphic, they each brought a satisfied grin to my seventh grade face.

BACK to the incoherence: we find out the plane that crashed in the beginning

was a Nazi craft, and Scotland's military has been trying to cover up something It was involved with (but again, WHY we're never told). NOTHING is ever explained, and thanks to the Nessie-feeding sequences we eventually just go with it and learn not to care.

We DO learn (about halfway through this mess) that Nessie ONLY kills those with low moral standards. Why? Who knows!? Perhaps she's a Jehovah's Witness, or an underground Mormon? Or maybe some bizarre cult financed half the film and wanted this obscure quirk thrown in there?

If there's ONE reason to see THE LOCH NESS HORROR, it's for a sequence where Nessie's trying to hide from some soldiers. She hops out of the lake and hides behind a tree (remember, this is NESSIE, who must be 50-70 feet long) and the soldiers walk right by her without noticing anything! This is UNBELIEVABLE stupidity at its finest.

There's also a silly axe murder (don't ask), a few scenes of Nessie stalking the van holding its egg from behind the bushes (it's amazing how this huge creature hides behind tiny vegetation while on land) and plenty of Scottish stereotypes (one guy even wears a kilt through the whole film), enough that I'd love to know what Scottish folks thought of this.

This disaster of a film concludes (SPOILER ALERT!) when a bomb planted in the aforementioned Nazi plane goes off, taking out Nessie and the guy who planted it. One of the college students then drops the Nessie egg into the lake, and the HORROR ends as we hear the baby-Nessie heart beat, promising the Loch Ness Monster will live on (but thankfully there was never a sequel).

Director Larry Buchanan has delivered some real gems in his day (including 1967's MARS NEEDS WOMEN and 1966's ZONTAR: THE THING FROM VENUS) but this one has to be in the Top 5 of his worst offerings.

Recommended for hardcore Nessie completists and those who may be on a mission to see every single cheap monster movie ever made. Everyone else, run away like your pants are on fire...

NERDS, BABES, BARITONE IMPS AND INTERGALACTIC BROCCOLI
(OR, SG RETURNS TO TIMES SQUARE!)

*J*ust a few months after the first Urban Classics double feature hit New York City, I returned to Times Square to see another double bill of exploitation insanity, again at the lovely Cine 42. On a mild January afternoon in 1988, I took a solo trip to Manhattan to see one film that featured the three (at the time) reigning scream queens, while the opening feature was made by those responsible for one of my all-time favorite horror comedies, PSYCHOS IN LOVE (1986).

GALACTIC GIGOLO (1988) is a wonderfully funny sci-fi comedy, starring the amazing Carmine Capobianco as an alien who—after winning a game show on a planet where all the inhabitants are vegetables—wins a trip to Connecticut where he proceeds to chase women and drink bourbon, all the while being chased by a bunch of brain-dead gangsters. In his new human form (if you don't know what Carmine looks like, Google him), he drives the ladies crazy and turns into a total party animal. On his home planet, he's a 6-foot tall stalk of broccoli! It's goofy and stupid but MAN did I laugh myself into tears, even among a noisier than usual Times Square crowd. Fans of PSYCHOS IN LOVE who might have missed this should do themselves a favor and get the DVD, as most of the PSYCHOS came back for this one under the direction of PSYCHOS's Gorman Bechard (who has since become a semi-successful author and pop / art film director).

In classic NYC style, the main feature was delayed, I'm assuming due to projector trouble. But once SORORITY BABES IN THE SLIMEBALL BOWL-A-RAMA (1988) began (after continuous screaming and snack-throwing that lasted a few minutes into the feature), the mostly teenaged / early 20s crowd sat transfixed as sleaze director David DeCoteau unreeled his latest celluloid abomination to his thirsting fans.

Brinke Stevens and Michele Bauer (here credited as Michelle McClellan) are two sorority pledges being stalked by a trio of super-nerdy frat boys.

When the boys are caught spying on a secret hazing/spanking ritual (that goes on for WAY too long), the house mother catches them and forces them to join Stevens and Bauer on the only mission that will allow them into the sorority: they must break into a local bowling alley and steal something to prove they were there. Okay, so the plot is lame, but the opening scenes of Stevens and Bauer running around in g-strings and showering butt-nekkid had the place cheering and drooling like

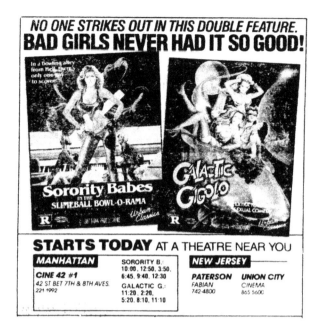

typical degenerates that go to a Times Square double feature like this in the first place. (Wait...did I just insult myself?).

The bowling alley is located inside a shopping mall, and shortly after our group arrives, they meet up with a tough biker-chick named Spider, played by the legendary Linnea Quigly, who uses the F word more than Joe Pesci did two years later in GOODFELLAS (1990). Instead of grabbing a bowling pin or pair of silly-looking shoes, our group decides to take a trophy, which is quickly dropped and unleashes a small demonic imp who speaks like Bo Diddley (I stood around for the closing credits to make sure it wasn't him ... it wasn't) and looks about as threatening as a toy from a crane game. The imp begins to grant everyone personal wishes, but of course doesn't answer them they way anyone had hoped. Chaos ensues, including our sorority girls becoming possessed and Spider kicking both nerd and imp ass, each time sending the crowd into a screaming frenzy.

The late Robin Stille (of 1982's THE SLUMBER PARTY MASSACRE fame) shows up (apparently EVERYONE decided to break into the joint on the same night) and has a less-than exciting cat fight with Spider before becoming imp fodder, but the few of us who recognized her from her classic duel with the driller killer let our satisfaction be known (mine in the form of a loud "ARRR-YEAH BABY!").

Back to the imp: I found out its voice was done by Dukey Flyswatter, who sang for horror-punk band HAUNTED GARAGE (if you can find their double 7" with the 3-D cover, you're in for a real rockin' treat).

As far as double features go, this second (and I believe final) offering from Urban Classics was a real hoot. In the long run I enjoyed GALACTIC GIGOLO a bit more, as I'm a huge fan of the cast and crew, but SORORITY had its moments, the best being Michelle Bauer showcasing her flawless rack for about three-quarters of the film's running time, and thinking back this is one of the more memorable characters in Linnea Quigley's arsenal. What hurts SORORITY is its nearly impossible to decipher plot and/or point, whereas GIGOLO is a solid spoof of sci-fi and sex comedy cinema.

Both films are now available on DVD, but I doubt either is as fun without a proper grindhouse crowd behind them.

A chat with Galactic Gigolo's star and co-writer

CARMINE CAPOBIANCO

SUBURBAN GRINDHOUSE (SG):** Did you get to see GALACTIC GIGOLO when it played in Times Square? If not, did you get to see it theatrically elsewhere?
CARMINE CAPOBIANCO (CC): I actually did see it in Times Square. As you know, it played with "Sorority Babes in the Slimeball Bowl-A-Rama" which I liked better. It had Linnea Quigley in it and, like every other guy in the theater, I was smitten.

Years later, I mentioned that to her and she looked me straight in the eye and told me she was a fan of PSYCHOS IN LOVE. I haven't washed that eyeball since.

GALACTIC GIGOLO played first. I remember sitting down and was so freakin' excited that I was going to see myself on the big screen. The lights dimmed and the movie started. All of a sudden, this enormously obese black woman with hair out to here and an armful of popcorn, soda and assorted confections, waddled down the aisle past us, breathing heavily, and plopped noisily into a chair with a great sigh of relief. I am not fond of late-comers to a movie but I

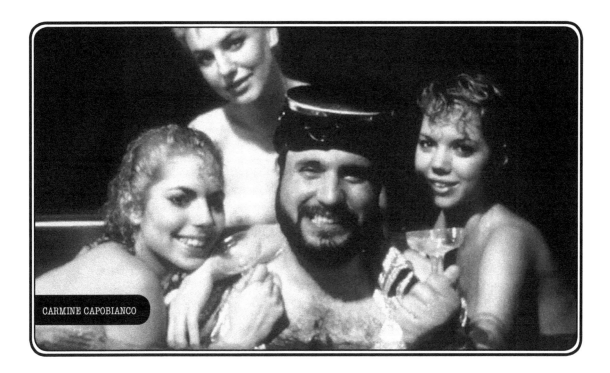

CARMINE CAPOBIANCO

was ecstatic that she was late to a movie that I, yes I, was starring in!

After the credits ended and the first few "jokes" were delivered, I was relieved to hear a few chuckles from the audience. It got silent for a moment when I saw and heard this enormous woman gathering up her feast as she screamed out, "Dis ain't ROBOCOP!" and, puffing quite loudly, waddled back up the aisle and out of the theater.

The other memory is, between movies, a few of us went to the men's room. We got plenty of stares in there and I was happy that no one tried to get a peek at my equipment in case this movie made me a megastar and would tell that story. Well, no one saw "Little Carmine" and "Galactic Gigolo" didn't make me a megastar. But it opened some doors. The movie, I mean.

SG: What made you guys decide on the aliens being from a planet inhabited by living vegetables?
CC: Well, all vegetables are living at some time and as I recall, broccoli was the only vegetable eaten in this movie.

The original title of the movie was CLUB EARTH and this is how that came

to be. Charlie Band bought PSYCHOS IN LOVE from us and wanted to give us a four picture deal. He asked us to come up with 10 story ideas of which he would choose four and we would do the scripts.

Obviously, one of the ones he chose was CLUB EARTH and we began work on the script. In the meantime, Charlie commissioned the posters for the four films and they appeared, like, the next week in Variety. My character, Eoj Oilgamert, was a tall skinny asparagus in the poster.

I have no idea how or why vegetable were chosen. It's possible that, because we used a lot of grape references in "Psychos in Love", we had to make the vegetable growers happy and give them equal time. I thought we should have used pork chops in the next film but that idea didn't fly.

SG: Your earthly character, Eoj, is quite the stud in the film with an eye for bourbon. Is it safe to say the bourbon was flowing on the set of this film?
CC: It's not safe to say that, no. I'm not a drinker but I imbibed real Old Grandad on screen. I am, however, a stud in real life.

There were a lot of late night shenanigans and sleeping around things but I was well-behaved. Trust me, there were some gorgeous women on the set including my two onscreen "conquests", Ruth Collins and Angela Nicholas that any man in his right mind (or wrong mind) would have loved to get all cuddly and intimate with. Fortunately, like a martial arts master who never practices his art unnecessarily, I held back my studly abilities and didn't have to leave these lovely ladies with broken hearts.

When the movie was finally released, many other men came up to me and asked me what it was like to be in a hot tub with three naked women. In all seriousness, it was the scariest scene I have ever filmed (yes, FILMED, we shot this in 35mm). Why, you may ask? We filmed this scene in a place in Waterbury, CT that used to rent hot tub time out to the public in the 80s. Now that I think back on that business, the word "yick" comes to mind. I knew what couples did in there. Anyway, I digress.

We were in this little room and, yes, I was very excited to be in a hot tub with three naked babes (including the stunning Leanne Baker who is no longer on Facebook but was in a ton of classics in the 80s). As I watched them set up the lights around the perimeter of the tub, all I could think of from that moment on was, oh God, don't let some bourboned-up oaf trip on a light stand and knock it

over into the hot tub and force a billion watts of electricity into it, killing me and the owners of 6 boobs.

As you probably know, we all survived.

SG: Were or are there any grindhouse or grindhouse-like theaters in your neck of the woods (Connecticut), and if so any interesting experiences there?
CC: I didn't get out much.

I did open a chain of video stores in '91 and my cult/grindhouse sections were amazing. Naturally, I had every movie starring Carmine Capobianco up to that time.

Sometimes people would rent GALACTIC GIGOLO, not knowing me and I used to get a lot of weird looks when they returned it. One older gentleman actually said to me, "The guy in this movie looks a lot like you." I just smiled and said, "Yeah. I get that a lot."

I don't know if you knew this, but GALACTIC GIGOLO was banned in Prospect, CT. I was working for the city and received permission from the mayor and his staff to film the press conference scene in city hall in Waterbury. We thanked him in the closing credits. When the film was released on tape, someone who rented it from a video store in Prospect was insulted that we made the town appear to be full of Hasidic rednecks, dumb mafiosos and loose women and then noticed the mayor's name in the credits. He reported it to Prospect's mayor who called the Waterbury mayor about this insult. The mayor of Prospect asked the video stores in Prospect to pull ALL copies of the movie off the shelves and the mayor of Waterbury called me into his office along with the city lawyer. They asked if I had a copy of the movie so they can view it in case there was a lawsuit. I ran home, retrieved my VHS copy and sat uncomfortably in the mayor's office while they watched bits and pieces of the movie. Then they began to chuckle. When it

was over, they handed the tape back to me and the lawyer told me there cannot be any lawsuits and nobody had anything to worry about. The next day, it was front page news and we got a crap-load of great publicity.

SG: What's the most memorable thing that has ever happened to you inside a movie theater?

CC: I'm a die-hard movie fan and when I go to a theater, I am there to watch the movie and anyone that interferes with my mission gets his ass kicked.

However, when I was a kid and we had two classic theaters downtown that sat like 3000 people, I would go pretty much every week. There were double features and you could go in anytime and watch half of the first movie, the whole second movie and stay and watch the first movie again.

One Saturday, we went to see NIGHT OF DARK SHADOWS and HOUSE OF DARK SHADOWS in the early 70s. We sat and watched both films and decided to stay and watch the first one again. That was when I saw the most beautiful creature walk down the aisle past us. I was about 12- or 13 -years-old and so was this blond Goddess!

She sat down three rows in front of us with her friend and I told my friend, Jeff, that I wanted to sit behind her. He teased me for a few minutes then reluctantly agreed to change his seat and advance closer to the screen with me.

We sat behind the girls and I barely glanced at the screen hoping she would turn her head so I could see that beautiful face again. She would just lean into her friend and whisper.

I told Jeff that I was going to walk all the way around the theater and then UP the aisle so I could see her full on. I rose, walked out to the lobby to gather courage for my trek and then re-entered the dark.

I walked down the far left aisle, took a right in front of the screen and slowly tip-toed up the center aisle pretending to look for Jeff. I saw her and my heart stopped for a second and I thought it wouldn't start again. I may even have stopped walking. Our eyes locked for a moment and she smiled first. I smiled back, waved at her and then pointed to Jeff like I was a major derp. I continued to my seat and Jeff asked me if I got to see her face. I sighed and nodded.

She must have known I was sitting directly behind her as she threw her hair over the back of her seat. My knees were inches from it and I so wanted to touch it.

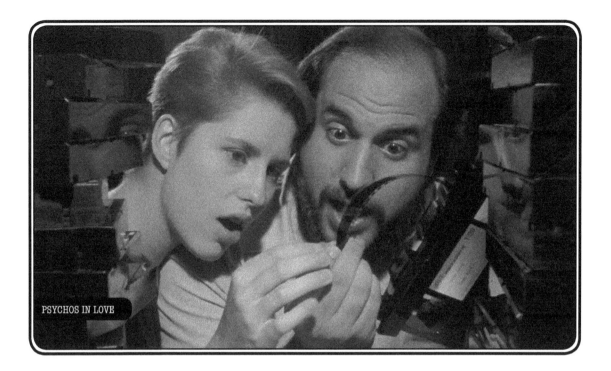

PSYCHOS IN LOVE

I looked at Jeff and he nodded towards her hair. I slowly reached out my hand and lifted the ends up with my fingers. As the movie went on, Jeff concentrated on Quentin Collins and Kate Jackson and I became bolder with the hair touching. She knew I was touching her hair and would glance at her friend so I could see her smiling profile. I leaned into Jeff and told him what I was doing and he tried to tell me that she couldn't feel what I was doing. I told him that she could. Jeff turned to me and told me I should do it harder. I shook my head. He sighed, reached over and tugged hard on the girl's hair and her head sprung back. She stood up, her friend stood up and I think they went and sat in the balcony. I never saw her again. I also never went to the movies with Jeff again.

Forty-two years later, another memorable thing happened. I went to the Alamo to see a Fangoria-sponsored screening of "Killer Klowns from Outer Space" with my three daughters. Michael Gingold from Fangoria introduced the movie. When it ended, I approached him and introduced myself. He said he knew who I was. That was memorable.

I may not be a megastar, but it's nice to be recognized.

"IF YOU SURVIVE THE DAY, WILL YOU SURVIVE THE NIGHT?"

ometime in 1983 (despite racking my brain, I can't recall if it was March or October), a double feature hit the NY/NJ area that turned out to be one of the most brutal experiences I've ever had in a movie theater. Someone had decided to re-release 1980's MOTHER'S DAY and 1981's NIGHTMARE (a.k.a. NIGHTMARES IN A DAMAGED BRAIN) on the same bill, and this young gorehound couldn't have been happier as I had missed each one upon their initial releases.

MOTHER'S DAY ran a wicked late night TV ad campaign when released in 1980; horror fans thirsted at its promises of Drano and electric knife attacks (YouTube it if you don't believe me) and in my case, my parents had said "Who the hell do they make these movies for?" I silently said "ME!" Needless to say, I was psyched when I entered the (now defunct) Fox Twin Cinema and the first feature began to unreel.

If you haven't seen it, MOTHER'S DAY is not exactly a pleasant film, despite its few instances of dark humor and the three entertaining antagonists (two murdering sons and their slightly unbalanced mother). The plot is pure exploitation: Three girlfriends go for a weekend get-away camping trip and become victims to the crazed clan. After the two sons (named Ike and Addley) kidnap the girls by making their sleeping bags escape-proof, they dump them in the back yard of their isolated two-story home and proceed to rape them under the moonlight...as their spooky-looking, elderly Mother cheers them on and takes pictures. The audience, which was made up of mostly high school-aged patrons, remained silent throughout this uncomfortable sequence. To this day I list this as one of the top 10 most disturbing scenes of all time, mainly due to the mother's gleeful facial expressions during such a horrific attack.

The film does build some fine tension. After being raped and severely beaten (one of the girls is even killed), the two survivors plan their revenge, and this is where MOTHER'S DAY becomes more than a standard rape/revenge film: it turns into a slasher/revenge hybrid and features the aforementioned scenes of Drano being poured down one brother's throat, a TV being smashed over another brother's

head, a plugged-in electric carving knife put to good use, plus an antenna shoved into one brother's neck, and more mayhem than you can shake an amputated arm at. AND just when our ladies think they're safe (SPOILER ALERT!), a mutated sibling named Queenie hops up to extract her own revenge in a genuine shock ending.

There's a lot of goofs in this one (even during the infamous opening decapitation

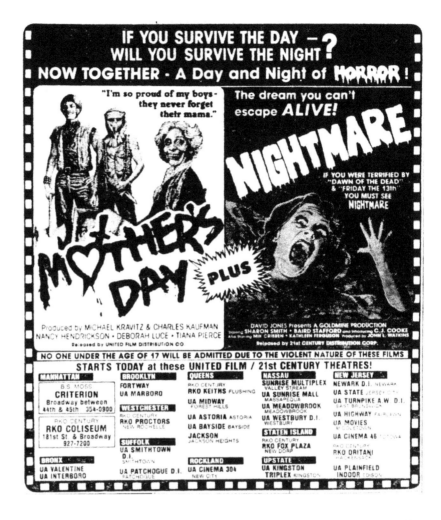

scene, where blood splashes across a woman's face even before her boyfriend's head is hacked into), but its flaws still don't hurt its overall intensity factor. MOTHER'S DAY is one of the most brutal R-rated horror films I've ever seen, evidenced by the audiences' complete silence throughout the film.

Next up was 1981's NIGHTMARE (known more commonly as NIGHTMARES IN A DAMAGED BRAIN), a film I remembered seeing TV commercials for, but never paying it much mind. By the time it was over, I had become a head-over-heels fan, and have written extensively about it over the years on top of showing it to countless people on both VHS and DVD. And the odd thing is, NIGHTMARE is a standard, by-the-numbers, "psycho released too early from

a mental institution" film, complete with bad acting and a couple of tedious stretches. But for some reason, it WORKS in ways few other slasher films do.

George Tatum is released from an institution after being placed on experimental medication (which is barely explained in the film). He travels from somewhere north of New York down to Florida to murder his family, wasting innocent bystanders along the way. Unlike most films of its kind, NIGHTMARE's graphic gore sequences are actually scary and hard to watch, especially the infamous double-homicide finale where George flashes back to the time when, as a child, he murdered his dad and his mistress with an axe ... a scene that's shown in quick hints throughout the film, making it nearly impossible to handle once it's finally shown in full. It was the first time I actually SWEAT watching a horror film, and afterwards, I saw a bunch of people standing outside the theatre, leaning against the wall, actually collecting themselves over the insane images they had just seen. How many FRIDAY THE 13th or HALLOWEEN sequels ever did that to someone?

This grueling double feature was unique from all of my other grindhouse experiences due to the fact both films kept the crowd in submission: both were serious doses of hardcore horror that—at the time—no one was expecting, other than those who had seen them a couple years earlier. My friends and I agreed we felt like someone had punched us in the face for the past three hours, and with few exceptions, we had not gone through a feature quite this barbaric since.

Both of these films hold up well today, although they may not be as intense to hardcore horror fans in light of some of the ultra-graphic splatter films that have come after them. But it's not just the gore FX that made MOTHER'S DAY and NIGHTMARE so gruesome and horrific: each film was a rebellious work of no-holds-barred anarchy that's seldom seen in the theater today, in any genre. They're films today's multiplex crowds just won't get to behold.

(MOTHER'S DAY is readily available on DVD and Blu-ray, while NIGHTMARE finally came to DVD the summer of 2011 and quickly sold out (then to Blu-ray two years later). Today it can be found on the second hand market for as high as $99.00. As of this writing, a company called Massacre Video has announced yet another Blu-ray release).

UPDATE: I finally got to see NIGHTMARE again on the big screen at a drive-in in Coaxsackie, NY, in the summer of 2014, and again at the Alamo Drafthouse in Brooklyn, NY in the summer of 2017. It's still a very disturbing experience.

BUZZI'S BEING IN THE LAND OF THE SPUDS

 eleased shortly after Halloween in 1983, THE BEING may very well be the epitome of low budget 80s horror/exploitation cinema. Directed by Jackie Kong (who would go on to create BLOOD DINER (1987), the first sequel (of sorts) to 1963's BLOOD FEAST) and featuring a simply mind-blowing cast of psychotronic superstars, I don't even know where to begin explaining the trashy goodness this baby has in store...

...once again the (now defunct) Amboy Twin Cinema hosted this gem for one week only. Opening night had a near sell-out crowd, and whether that was due to people thirsting for an ALIEN-type film or to see Ruth Buzzi's career continue to go down the toilet is anyone's guess. After a music-free opening credit sequence (I wonder if this was the director's way of attempting to create tension?), we see some guy running for his life through a toxic dump yard (that looks more comical than the TOXIC AVENGER's back yard) but we don't see what's chasing him. He manages to steal an abandoned car (because, y'know, cars in junkyards are always tuned up and ready to rock 'n' roll) but it doesn't take long before something rips the roof off and tears the sucker's head clean off: talk about a wild transition from the lifeless opening credits! THE BEING then hides in the trunk, and when a couple of brain-dead

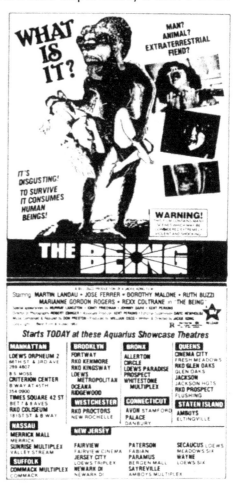

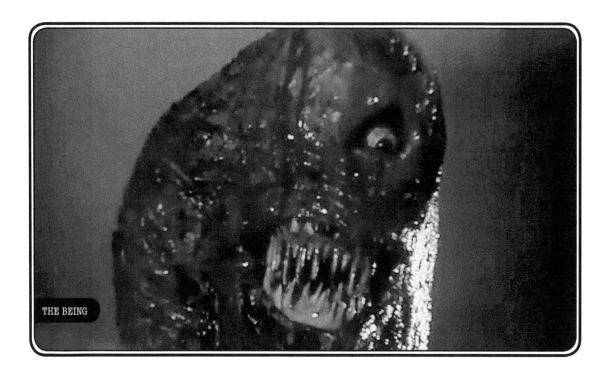

THE BEING

cops come to investigate the car (which has crashed into a warehouse and is covered in blood), neither one of them figures on checking the trunk.

At this point, you're either walking out the door asking for your money back (or if you're at home, hitting the EJECT button), or cheering in uncontrollable glee at the onscreen stupidity. No one left the screening I attended, despite several groans heard around the room. And when I realized the film was taking place in Idaho, I was even more sold on the whole project, hoping this beast would turn out to be some kind of mutated potato. Sadly, it wasn't.

THE BEING spends a lot of time hiding in trunks and back seats, making me wonder if it was at one time a car salesman. What little we do find out about the creature is it was once human, and its mother is played by the legendary Ruth Buzzi (best known as a cast member of ROWAN AND MARTIN'S LAUGH-IN from 1967 to 1973). Toxic waste has turned the poor kid into some kind of ever-changing shape-shifter: in one sequence, it attacks a drive-in after turning itself into a slime state and oozes through the dashboard of an unsuspecting couple. In another scene, the monster looks like a large stuffed animal covered in latex gelatin. And yet again it shows up looking like a poor-

man's ALIEN. But I guess, considering this abomination was spawned from toxic waste, anything is possible.

Filled with plenty of gore and cheap monster goodness, THE BEING also works well as a "drinking game movie": have some friends come over and make everyone take a shot each time the film's 'day-to-night-differential-within-too-short-a-time' goes down. You'll be hammered within 25 minutes. If memory serves me, a dull single-night house party seems to go on for two or three days. Besides special effects, the producers apparently saved money by not hiring a continuity supervisor. But these are the quirks that make B-movies more entertaining than your standard Hollywood fare.

Fresh off his role as an escaped mental patient in ALONE IN THE DARK (1982), Martin Landau plays a government scientist who spews some of the worst lines you'll ever hear in a horror/sci-fi film. While the dialogue isn't his fault, it makes his role on the classic MISSION: IMPOSSIBLE TV series look like Oscar worthy material. Then again Landau did win an Oscar for his role as Bela Lugosi in 1994's ED WOOD, so maybe I'll stop ragging on the poor guy and move on...

Ruth Buzzi plays a real whack-job here (talk about stretching things for the screen) and dies in a gloriously over-acted choking-by-mutant-monster-son-tentacle-strangulation sequence that must be seen to be believed. With its various bodily forms, THE BEING sometimes has tentacles, sometimes human-like arms, and sometimes has a tongue that would make KISS's Gene Simmons envious. And for some reason it decides to mutilate some victims yet simply throws others into walls, while allowing others to live. Perhaps the toxic waste has messed with its conscience, too?

Cult film icon Jose Ferrer stars as the small town's mayor. I need to do an IMDb check on him one day to see if he or Dick Miller have starred in the most cameos and throwaway roles. It's probably Miller, but Ferrer seemed to be everywhere in the 70s and 80s.

With decapitations, a heart ripped out of some poor redneck cop's chest, all kinds of cheesy blood galore, a lengthy flopping boob shot, priceless dialogue, a plot that's beyond incoherent, and arguably the worst daytime/nighttime continuity ever to (dis)grace a film, grindhouse cinema is rarely as fun as THE BEING.

Add a HUGE plus here for the sequence where two potheads are attacked during the drive-in assault. I still laugh just thinking about it...

Suburban Grindhouse Memories No 54

A UNIVERSE OF ALIENS, DRAGONS, AND BOOBS...

hile most young men got their kicks by swiping a copy of Playboy from their dad's secret stash in the closet, nothing brought me more joy than an issue of HEAVY METAL, the illustrated fantasy magazine that has been going strong since its first issue in 1977. And in 1977 or '78 (when I was in the fifth grade) I managed to obtain an issue and was instantly hooked. But it wasn't just the sex and violence that grabbed my attention; many of the stories were just so much better than what you found in "regular" comic books, and I was familiar with some of the artists and writers whose work appeared within its pages, even at my young age.

Needless to say, I was beyond psyched when I learned HEAVY METAL was going to be adapting several of its more popular stories into an animated film. After what seemed like an eternity, August of 1981 arrived, and a Saturday afternoon trip to the (now defunct) Hylan Twin Cinema left my buddies and me a bit nervous: sure, this was an animated film, but it was rated R and we weren't sure if the Hylan would let us in (this was one month before I started the 7th grade!). But the space gods shined their light upon us and we walked right in … apparently they were too busy turning kids away from their other feature, Blake Edwards' S.O.B. Go figure.

The film opens with an astronaut returning to Earth via intergalactic sports car in a segment titled 'Soft Landing.' The blaring soundtrack (that's not all heavy metal bands) kicks into high gear with the song 'Radar Rider' by some band called Riggs (to this day I'm still in the dark on who they are). The whole look and feel of the animation brought several stories from the magazine to life, and my blood was pumping like crazy. The astronaut then walks into his house, and the film's inter-locking story, 'Grimaldi,' begins. Grimaldi has brought his daughter home a green sphere, which then proceeds to melt him to the bone before introducing itself to the terrified girl as "The Sum of all Evils." The sphere then goes on to show the girl several stories of good vs. evil throughout the universe, with itself involved in each one.

The first tale, 'Harry Canyon,' is a neo-noir tale set in a distant Manhattan about a cabbie-anti-hero who gets involved with protecting a famous scientist's daughter from criminals. I think this is the first time I saw animated sex on the big screen, and at the time it was a real hoot! Kudos for the gore level here, too. (NOTE: to this day I am convinced the screenwriters of THE FIFTH ELEMENT (1997) robbed this hook, line, and sinker). A great opening story and one of the best in the film.

Next up is 'Den,' based on Richard Corben's famous character, who is a nerdy teenager, transported to another world where he becomes a bald-headed, muscle-bound hero. The film does a great job bringing Den to life, and John Candy's voice works well as both versions of the quirky character. As soon as Den lands on this strange new world, he witness a sacrifice to a Cthulhu-like creature, and before long he's battling crazed religious zealots and having sex with big-breasted women. Yeah ... they pretty much nailed the magazine with this one!

I was all too happy to see one of my favorite Bernie Wrightson stories from the magazine make the film: 'Captain Stern' is a short but sweet tale of a corrupt starship captain in a courtroom full of weird aliens as all kinds of charges are brought to him. The green sphere

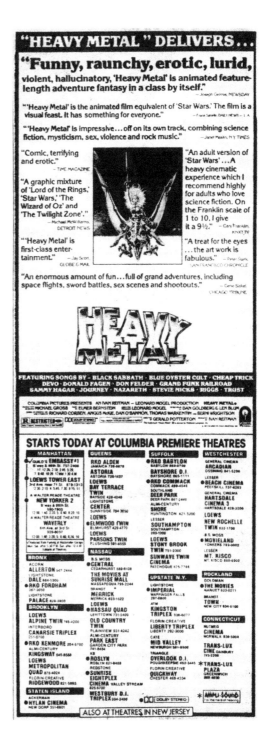

happens to be in the hands of the court ship's janitor, turning him into a Hulk-like maniac who then goes after Stern (and kills most of the ship's occupants). Crazy little segment, highlighted by Cheap Trick's great, seldom-heard song 'Reach Out.' The crowd loved this one, too.

Next up is a genuinely creepy EC-comics type of tale titled 'B-17.' A B-17 bomber is taking heavy damage from enemies (in space!) but the crew manages to get through. When the co-pilot goes to check his men, he finds them all dead and notices the green sphere following the plane. The sphere turns the dead crew members into zombies, and only the main pilot escapes onto a plane-graveyard island. But what awaits him is anything but safety. It was nice to see one horror-oriented story here, even if it didn't have the best plot.

'So Beautiful and so Dangerous' is the weirdest piece in the film. A scientist tries to talk to the Pentagon about a series of strange mutations that have been showing up across the United States. He goes crazy when he notices the green sphere attached to the cute stenographer's necklace. But just as he attempts to rape her in front of the entire Pentagon personnel, a huge space ship lowers a tube into the room and sucks the two of them upward. The scientist's body explodes while the stenographer, Gloria, loses her clothes and soon has sex with the ship's mini-robot. Meanwhile, two Cheech and Chong-like alien pilots are sniffing more cocaine than you've ever seen before and partying like maniacs as they attempt to land aboard a humongous space station. I still don't know what the point of this one was, but it's hysterical and ridiculously entertaining.

The film ends with a serious (and its longest) segment titled, 'Taarna.' The green sphere has now become gigantic and crashes into a volcano, where it mutates a bunch of outcast workers into a vengeful gang, bent on taking over a nearby peaceful city. They kill everyone inside but the elders manage to summon the last of a warrior race (the Taarakians) to come help them. Taarna (a beautiful but tough-as-nails swordswoman who doesn't waste time talking) arrives too late to save the city, but goes on a bloody course of Conan-style revenge with her pet dragon. (The sequel, HEAVY METAL 2000, was basically a 90-minute remake of 'Taarna' with heavier music). The scene of the workers being swallowed by green lava while Black Sabbath's 'EV150/Mob Rules' plays in the background is a real sight to see/hear. Taarna is standard sword and sorcery fare, but well done, and with great animation.

HEAVY METAL

In the brief epilogue, the young girl from earlier in the film witnesses the green sphere (or "Loc Nar") explode and destroy her home. She then goes outside and finds a dragon similar to Taarna's, and takes off into the moonlight.

HEAVY METAL still holds up well all these years later, and while I've enjoyed it on cable and VHS (and DVD), this is one film that truly needs to be seen on the big screen to enjoy all its nuances, and with the proper sound system to appreciate it's killer soundtrack (the soundtrack album still sells well today). The packed theater I witnessed this with featured countless cheering teenagers, moms dumb enough to take their young kids (uncomfortable giggling was heard at each and every sex scene), and fans of the magazine like myself who went back the next day for a second viewing. Too bad the long-awaited sequel was so sub-par; I wish they would've done another anthology film like this, with other tales that had appeared in the magazine.

As far as animated cult films go, I'll take HEAVY METAL over FRITZ THE CAT (1972) and any anime offering with no hesitation.

GENERIC, BUT FUN

he late 1980s were a semi-sad time for grindhouse aficionados. The VHS craze had left theaters a barren-wasteland for horror and exploitation film fans. But every once in a while something interesting was granted a theatrical release: 1988's slickly-titled, late-to-the-game slasher outing HIDE AND GO SHREIK was one of them.

I took a solo trip to the (now defunct) Fox Twin Theater around Thanksgiving of 1988, as most of my friends were either in college or passed out drunk somewhere by this stage of the game. Despite being opening night, the theater was relatively uncrowded. I noticed several other people my age (all guys) in attendance, and there was that certain "I hope this doesn't suck" expectation on all their faces. Be it desperation or some act of otherworldly celluloid intervention, by the time the film had run a mere 5 minutes, the place was applauding and cheering on this low budget stalk-and-slash fest like we were at some kind of sporting event.

The "plot" here is simple: a bunch of high school graduates (who, of course, look 10 years older than high school graduates) decide to celebrate by having an overnight party at one of their father's furniture stores (yes … you read that correctly). The humongous, multi-floored store features mostly beds, so I'm guessing this was one of the guy's ideas. In fact, this place could easily have been called BED DEPOT. After some drinking and horsing around, someone suggests they play a game of hide and seek, and everyone agrees (I'm guessing alcohol clouded everyone's judgment here). Naturally, there just happens to be someone else in the store who begins to kill those he finds. Most of the cast are typical big-haired 80s types, as well as your token nerd. (NOTE: we DO learn earlier that an ex-con is living in the building as one of the stock workers, so naturally he's the prime suspect. You have to give the boss of this place a hand for helping out those trying to readjust to society. One scene of this guy cooking dinner had the audience laughing out loud … he really made those veggies his bitch!).

Close your eyes. Count to 10. And run for your life.

It's the last game you'll ever play.

There are plenty of goofy sexual situations (none too graphic), so it's safe to assume the director was as inspired as much by PORKY'S as he was FRIDAY THE 13th. One strip-tease seduction sequence is laughably bad, and one poor guy is insulted for not "lasting" long enough. There's not much nudity but most of that can be blamed on the film's poor lighting.

Then there are the kill scenes (which, after all, is the main reason to see a slasher film), but unfortunately about half of the teens survive the ordeal. Our killer does manage to off the few he catches in inventive ways (one is deep-sixed by a mannequin arm, and one poor girl loses her head via elevator in the most crowd-pleasing scene).

Like any classic low budget 80s slasher, HIDE AND GO SHREIK has its moments of confusion (the killer dresses in drag in one scene, then in S&M leather in the next) and the opening sequence of him raping and killing a hooker left everyone dumbfounded. I'm guessing they had to explain his craziness somehow? And despite its R-rating, the gore level is kind-of low and the language used by annoyed teens is laughable (perhaps the screenwriters had an aversion to profanity?). Either way, "teenagers" haven't spoken this calmly since LEAVE IT TO BEAVER. There's also an attempt at the killer blaming his actions on someone else, which leads to a showdown finale that has been done a zillion times before (it's sort of like SLEEPAWAY CAMP (1983).Sort of. Kind of. Trust me on this one).

With all this one has going against it, it's hard to pin-point why it manages to work. Perhaps it's the setting; what horny teenage guys wouldn't want to spend the night in a huge bed warehouse with a bunch of cute babes? Or maybe it's some genuine suspense seldom seen in films of this type: a few stalk scenes build solid tension and lead to gut-cringing murders (one girl has her head smashed into a sink, filmed from the bottom of a see-through prop!). There are also several shots of mannequins staring at you that bring TOURIST TRAP (1979) to mind and further increase the film's spooky atmosphere. Either way, HIDE AND GO SHREIK is one of the last of the truly fun 80s slasher films, complete with a very latent gay theme and a rare appearance by the beautiful Annette Sinclair (Google her).

While this was released on VHS, an official DVD release is still eagerly awaited by we legions of the obscure … but ah, the memories.

Suburban Grindhouse Memories No 56

THE ULTIMATE PARRTY FLICK

arch 1983. President Reagan refers to the Soviet Union as an "Evil Empire." A transit strike cuts off train service for 70,000 New Jersey commuters. Pope John Paul II begins an 8-day, 8-nation tour of Central America. And here on Staten Island, my friends and I went to the opening night premiere of SPRING BREAK, a FAST TIMES AT RIDGEMONT HIGH / PORKY'S-like teen comedy that features more beer-guzzling, wet T-shirt contests, and bad jokes than any other film in existence. We may not have been politically conscience at the time, but at least we had our priorities straight.

Directed by Sean (FRIDAY THE 13th) Cunningham, SPRING BREAK was another in a long line of early 80s teen comedies, and while it's not all too funny, it is remarkably entertaining (at least if you're a high school freshman, as I was upon this initial viewing).

Nerdy buddies Adam and Nelson rent a room in a party-motel in Fort Lauderdale, Florida. But just as they're settling in, two cool dudes (Stu and O.T.) show up and claim they had already booked the same room. Figuring it'd be easier to score chicks with two cool guys as roommates, Adam and Nelson agree to let them crash there. The first time we see O.T., he enters the motel and chugs a large bottle of Miller like it's spring water as bikini-clad babes run around looking for their rooms. He's a big, shirtless dude with a goofy headband, on a mission to party like it's the end of the world … and along with Stu, his mission is accomplished less than twenty minutes into the film.

During the first night with their new roommates, Adam and Nelson watch from the corner of the bedroom as Stu and O.T. shag two Playboy model-looking girls. It's a private lesson neither one of them will ever forget, and their spring break is off to a rockin' start.

BUT (cue villain music) not wanting his stepson to have any freedom (or give his political career a bad name), Nelson's stepdad shows up to try and stop the fun. His right-hand doofus henchman, Eddie (played by legendary

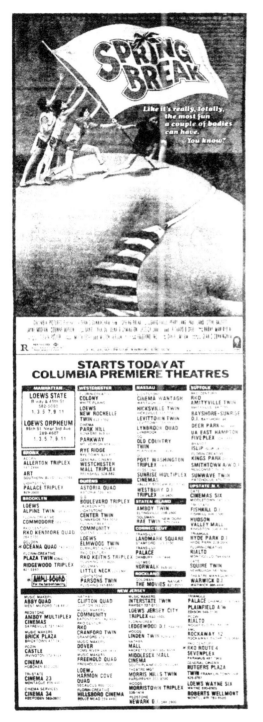

character actor Richard B. Shull) is also some kind of building inspector who attempts to shut the motel down, but of course is thwarted every step of the way by Stu and O.T. via cases of Miller beer and inflatable sharks(!).

SPRING BREAK is a silly film that was created for no other reason than to make money off teenage boys (::raises hand::). It suffers from some lame acting, a terrible script, and basically exists to show off some of the hottest bikini babes the producers could find (they did quite good). Among them is a fictional all-girl "rock" band called HOT DATE that performs a song unsubtly titled "I Wanna Do It To You." O.T. even falls head-over-heels in love with their singer (played by gorgeous former Penthouse Pet of the Year Corinne Alphen) and doesn't care if he has to let his coolness factor down to try and get her. Also on hand (besides the fantasy girls) is the cute, all-American girl next door Susie (played by 'Seventeen' magazine cover model and then future TV star Jayne Modean) who eventually hooks up with Nelson and "turns him into a man."

In one scene (to show how these two-pairs of unlikely friends are all now true buds), the four of them take a drunken leak into the toilet at the same time. It's more heartwarming than you'd expect! Another is when the foursome goes to buy pot off some older freaky Latino

hippie who lives in a van. It's probably the funniest scene in the film (although that's not saying much).

I'm pretty sure Miller beer had something to do with the production: not only is it chugged and product-placed all over the screen, but it's used to wet down the participants of countless wet T-shirt contests and poured over everyone else's head (apparently in Ft. Lauderdale you're supposed to wear your beer before you drink it). At least this is what I took away from the film, besides the idea that having cooler guys than yourself as roommates can get you laid easier.

The soundtrack features Cheap Trick and .38 Special's hit song 'Caught up in You,' which is used during a rather frustrating sequence (Nelson gets lost after he attempts to get back to Susie's room after he runs out to grab a can of Coke!). And even though Hot Date's song is terrible, the band is easy on the eyes, so we'll let their lack of musical ability slide…

Perhaps this film was the inspiration for those GIRLS GONE WILD videos that ruled late night infomercials in the early 2000s? Or maybe even a vehicle to try and popularize the infamous sport of belly-dive competitions? Or maybe SPRING BREAK is simply a standard to the coming-of-age, nerds-lose-virginity, party animal films of the 80s done the right way. Sure, it's a mindless exploitation film, but the characters are a lot of fun (especially the motel's manager Geri, who will remind you of your cool elderly aunt) and it's a great way to forget both the dreary winter months and adulthood: use it to get away to a much more fun time and place, even if it's for just 90 minutes.

Judging by the laughs and applause from the crowd I watched this with, everyone had a blast. SPRING BREAK is probably the best way to vicariously enjoy spring break if you've never made it down there or can't afford to do so.

An extras-free DVD was finally released in 2009, so if you're curious, check your brain at the door, kick back, crack open a Miller, and enjoy the fun. You also might want to have a towel handy to dry all that beer off your head.

(BEST SCENE: O.T. doing a drunken belly-flop from the top of a tall palm tree as an equally drunken crowd cheers him on!)

SEASON OF THE ZZZZZZZZZZ...

I n October of 1982, fans of the HALLOWEEN series were confused about the third film, which was titled HALLOWEEN III: SEASON OF THE WITCH. While technically it had more to do with the actual holiday than the others in the series, the film didn't feature infamous slasher Michael Myers or star Jamie Lee Curtis. In time, the film gained a cult following and a loaded Blu-ray edition has finally been released. But when the film was originally unleashed theatrically, someone thought it would be slick to simultaneously repackage a 1972 film titled HUNGRY WIVES under the title SEASON OF THE WITCH and put it out the same weekend as the third HALLOWEEN film to swipe some of the successful series' revenue (got all that?). And while I couldn't find any proof they were successful, I can testify that the theatre I saw George A. Romero's SEASON OF THE WITCH in (the now defunct Amboy Twin) was packed to the rafters … and the second showing sold out as well.

Despite being a huge Romero fan, I had never heard of SEASON OF THE WITCH (or HUNGRY WIVES) until I opened my local paper that Friday afternoon and saw an ad for HALLOWEEN III: SEASON OF THE WITCH and, right across from it, and ad for another film simply called SEASON OF THE WITCH with the tagline, "An early work from the master of horror, George A. Romero!" And seeing this, I knew where I'd be that night; HALLOWEEN III was going to have to wait a day or two. I also convinced two of my buddies to put off their HALLOWEEN III screening and, knowing we were doing it for a Romero film, they joined me. In the pre-Internet days, there was no Googling to see if something was worth it or not.

I still have the black and blue-marks on my upper arms from being punched for a few hours after SEASON OF THE WITCH ended. And I couldn't blame my friends for their anger.

The film takes forever to get moving. And, even then, it moves like a horse being dragged to the glue factory at high noon. We meet a bored housewife

named Joan (Jan White) who has a husband who's always away on business and a college-aged daughter who has the personality of a handball. Joan spends her days as a bored housewife and her nights at her neighbor's boring parties, as well as a ridiculous amount of time walking through the woods in artistically-shot, trippy sequences. I think this was the first time I heard an audience start yelling for the film to get going so early on … maybe after fifteen minutes? As a Romero fan, I was getting annoyed at all the noise, but by the middle of the movie I had joined them.

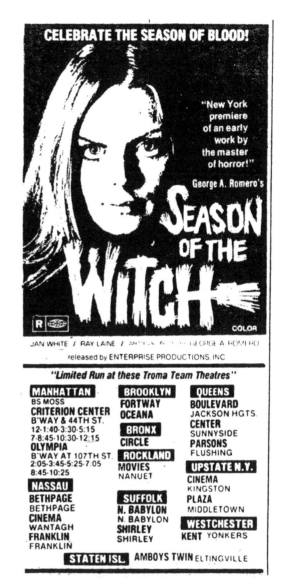

The boredom is broken up with dream sequences of Joan being attacked in her home by a masked assailant. She seeks therapy for her nightmares but it doesn't help and the dreams continue, as did the audience's cheers for the masked assailant to kill her. Joan eventually visits a woman who gives her a tarot reading, and she develops an interest in witchcraft after finding out the tarot woman is part of a coven.

In the only sequence I enjoyed, Joan goes to some kind of underground hippie-owned store to purchase witchcraft supplies. I couldn't stop laughing over a sign on the wall that said "Take Some Trash" posted over several garbage cans right inside the store! Over the years I've wondered if this was some kind of comment on the end of the hippie era, but now think it was just Romero tossing some goofy fun into this dreadful mess that I recently read is the only film of his even he wishes he could remake.

One amazing thing here: I don't recall a single person leaving the theater. The film, while slow and painfully boring, does tend to keep your interest in the wake of the nightmare scenes. I think most audiences had a crazed bloodlust by the final minutes, hoping this masked intruder would finally decapitate Joan and end this celluloid torture session.

But in the "shock" ending, Joan is having another nightmare when she wakes; someone is pulling on the front door handle, trying to break in the house. She grabs a shotgun. The crowd I was part of went nuts, and I'm talking *scream out loud nuts!* Most cheered for the guy breaking in to kill Joan. A few even begged her to blow her own head off! (Yeah, we New Yorkers are a happy bunch). But neither request happens. Joan ends up shooting the intruder.

And the intruder ends up being her husband Jack, back early from yet another business trip.

Boos erupted to the point I was partially deaf for a good half hour.

I still can't remember what happens after that, but I'm pretty sure Joan joins the tarot reader's coven. Either way, some older woman next to me said, "Man, that was really for the birds!"

And despite being a George Romero fanatic, I had to agree. SEASON OF THE WITCH (a.k.a. HUNGRY WIVES, a.k.a. JACK'S WIFE) is a slow, tedious, boring-as-you-can get feature that even the most die-hard horror fan will have trouble getting through without a fast forward button. Being in a suburban grindhouse made it kind-of fun (and barely bearable), but I'd love to know how other audiences around the country reacted to this "early work from the Master of Horror."

I'll take another dozen of Romero's …OF THE DEAD films before sitting through this thing again. Until next time, I'll be putting ice packs on my upper-arm bruises…

I'LL TAKE A COUPLE OF BEAR CLAWS, PLEASE...

Among the endless list of 80s slasher films is GIRLS NITE OUT (1982), a semi-dud that at least tried to be a bit different from the crowd. *Tried to be.* Its newspaper ad made it seem much more exploitative than it is, and did a fine job of luring high school freshman like myself into the theater, which in this case was the (now defunct) Amboy Twin Cinema.

A young man is found hanging at a sanitarium in his bathroom. When two gravediggers are digging his grave, they're both attacked and buried. The film quickly had the crowd's attention.

We're then taken to a college where the basketball team has just won a championship game. The entire school is in a festive mood, and we learn the female students will be having a scavenger hunt the next day (because, you know, what better way to celebrate a sports victory than with an all-female scavenger hunt?). But of course the night of the game there's a serious party, where everyone talks about the poor guy who is now at the local nuthouse for killing his girlfriend, unaware he has hung himself. Then the film takes a tedious nose-dive as the students fight like junior-high students over girlfriends and boyfriends and generally act like idiots for approximately 20 minutes (although it seemed like an hour).

After the party, the guy who is the team mascot is murdered in his dorm

room, and the unseen assailant steals his bear costume. I need to pause (paws?) here to say that my friends and I laughed our butts off over this development and didn't hear a word the police were saying when they came to investigate the next morning.

Later the next day, a local DJ starts giving clues as to where the scavenger hunt items are, and our goofy "college" students listen in on their small portable radios. Meanwhile, our mysterious killer customizes the bear suit by attaching serrated knives to a wood block then placing it where the claws should be (NOTE: this predated Freddy Krueger) and prepares to go on a rampage.

It takes a good half hour or more for the killings to begin, as GIRLS NITE OUT tried a bit too hard in its first section to make us sympathetic to these throwaway characters. There are also a few subplots that don't amount to much, and although most of the kill scenes are dark, they are gory, but I just couldn't help myself from giggling whenever the bear-suited killer shows up. Neither could the crowd.

Like most 80s slashers, there are suspects all over the place, and a couple of kill scenes are quite brutal (especially one poor lass who is ripped to pieces then left to die chained up in the shower). But again, whenever the bear-suited killer is seen, the face is just so silly-looking, it's hard to take any of this seriously (and you can forget about any genuine tension).

In the "shock" ending, we discover the killer is the sister of the guy who hung himself at the beginning of the film. She is told by our hero cop that her brother is dead, but she claims he's fine, and shows him his corpse in a freezer. Yep … it's multiple personality time again, folks (sorry for the spoiler).

I guess the only people who will enjoy this are serious slasher completists and those with an unusual thing for bear costumes. The killer, played by Rutayna Alda, does a good enough job despite her non-threatening countenance (which she used to her advantage the same year in AMITYVILLE II: THE POSSESSION (1982) and on soap operas like SANTA BARBARA and AS THE WORLD TURNS). Fans of cutie-pie Julia Montgomery (of the REVENGE OF THE NERDS films) might also want to take a look, as she's the main star here.

In the end, the crowd seemed indifferent, I left still laughing over the idea of a slasher in a bear suit, and one of my friends' hatred of the horror genre was strengthened.

GO TEAM!

Suburban Grindhouse Memories No 59

GODFATHER OF THE SYFY CHANNEL MOVIES...

 hile anyone can turn to the SyFy channel on any given Saturday to see an endless list of horrible, made-for-cable killer shark/alligator/piranha/octopus films, back in the late 70s/early 80s, JAWS-inspired rip-offs had to be seen in your local theatre. 1981's CROCODILE is one of the more memorable of this hokey subgenre.

I hit the (now defunct) Amboy Twin Cinema one chilly afternoon in late November of said year for a solo viewing, and while films like GRIZZLY (1976) and PIRANHA (1978) were better made JAWS rip-offs, CROCODILE has that certain low budget charm that makes it more memorable ... at least if you're a trash film junkie.

A hurricane destroys a small island off the coast of Thailand. As houses become rubble, we see crocodiles scampering around trying to survive the chaos. Then the quick opening credits feature a couple of naked women being eaten by the crocodiles, causing applause from the small daytime crowd who chomped popcorn around me. A doctor and his family are then seen eating dinner, wondering if the hurricane had been caused by an atomic explosion (and just why they think this is anyone's guess).

They use this as an excuse to travel to a resort beach-side hotel where the doctor's wife and two daughters are eaten by an oversized croc. Pissed, the doctor, along with the fiancé of one of his daughters, vows revenge. You can almost hear JAWS' famous theme music kick in at this point.

The men visit a crocodile expert who

FROM THE SLIMY DEPTHS OF THE OCEAN... NATURE EXPLODES WITH SAVAGE FURY!

CROCODILE

HERMAN COHEN presents "CROCODILE"
Starring NAT PUVANAI • TANY TIM • ANGELA WELLS • KIRK WARREN
Produced by DICK RANDALL and ROBERT CHAN • Directed by SOMPOTE SANDS

says the only way a crocodile could have survived in the sea would be due to radiation, which caused much deserved laughs among my Saturday afternoon creature feature brethren. The film then goes into a few badly edited sequences of the croc wiping out waterfront towns and eating a bunch of people. In the most memorable scene, the sucker consumes an entire water buffalo! Good thing PETA members were unaware of this or the film would've probably been picketed.

THIS is when the JAWS rip off-ness kicks into high gear: our two heroes employ the help of a local fisherman who agrees to use his boat to hunt the croc down. Meanwhile, my fellow suburban grindhouse mates laughed for a good 10 minutes when the police set a trap for the croc in a river: a king-sized bear trap stuffed with a huge chunk of meat. Of course it doesn't work, so our trio heads out to sea along with an irritating news reporter (a.k.a. LUNCH) to track the monster croc.

Most of the scenes of the croc attacking the villages are quite phony, and there are times you can't tell if the close-ups are cheap stock footage of a real croc or a sad attempt to make a latex croc head. Another PETA moment features someone stabbing a regular sized croc in the head, making me wonder if the director had some kind of real life vendetta against aquatic animals.

The JAWS rip off goes so far as our makeshift seamen using brightly-colored barrels to attempt to lure the croc to their boat! The only thing missing was the fisherman telling the boys a spooky night time story about his experiences with a croc swarm during World War II.

The continuity in this flick is ridiculous, especially when you have the croc, in some scenes, almost as big as Godzilla, then in others, maybe a few feet larger than the people it's eating (one poor guy has his legs chomped off and tries to swim with stumps in a particularly cruel, but effective, scene). And speaking of Godzilla, this Thailand import features atrocious overdubbing and acting.

With an abrupt ending that leaves the audience wondering if the croc and the main hero are dead or alive, most people at this particular screening booed and tossed the rest of their popcorn at the screen. Me? I loved every second of this terrible croc-caper despite all its shortcomings.

Who knew three decades later films like this would be big money makers (such as LAKE PLACID [1999] and regular fare on cable TV stations such as SyFy).

If you want a killer croc film that works, try ROGUE (2007). If you want a JAWS rip off that's insanely entertaining, is so-bad-it's-good, and will actually make you cheer for the monster, CROCODILE is your film.

Remember to watch your step next time you visit Thailand...

NOT ALL E.T.'s ARE FRIENDLY...

eleased less than a year after the success of Steven Spielberg's E.T., low budget British sleaze-fest XTRO (1983) exists basically to support its infamous tag line: "Some extra-terrestrials aren't friendly." And in the case of XTRO, not all E.T.'s make much sense, either.

A father (Sam) and son (Tony) are playing around on their isolated farm when the son witnesses his father being abducted by a UFO. Three years go by and the poor kid is still having nightmares, and worse, no one believes his story, figuring his old man took off on them. His mother, convinced her hubby has met another woman, grows tired of waiting for him to return and gets involved with another man, leaving young Tony not too happy.

From here on out, XTRO is a bit difficult to follow because it truly doesn't make a heck of a lot of sense.

A space craft crashes in a wooded area, setting most of the place on fire. We see a humanoid/spider-like alien emerge from the wreckage and examine its new surroundings and it's eventually hit by a car (apparently these XTRO's aren't only unfriendly, but are rather stupid considering they've traveled from space to get here). The alien doesn't die, and manages to make it to a small house where it rapes a woman, which leads to one of the most absurd sequences I've ever seen on the big screen: the woman gives birth to a full-grown Sam, apparently now returned

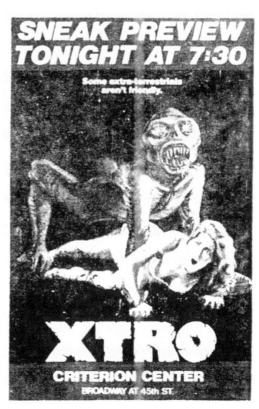

SNEAK PREVIEW TONIGHT AT 7:30

Some extra-terrestrials aren't friendly.

XTRO

CRITERION CENTER
BROADWAY AT 45th ST.

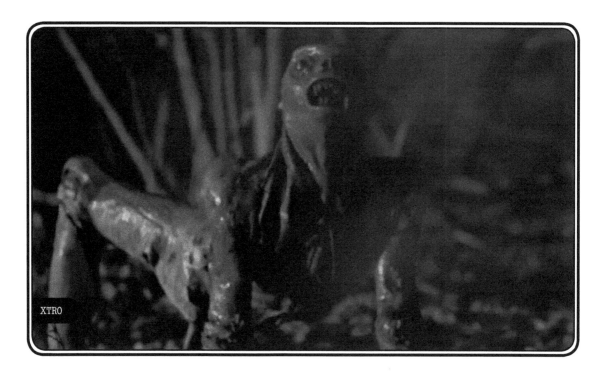

XTRO

to Earth in a most strange manner (don't bother to ask why...it's just not worth it). The scene is truly gross and still sticks with me thirty years later.

Sam is now on a mission to find his son, who is living in an apartment with his mother Rachel and new boyfriend Joe. He starts to pick Tony up from school, pissing off Joe and causing Rachel concern. Sam claims he can't remember a thing that's happened in the past three years (where he has been, his former job, etc), so against Joe's wishes, Rachel allows him to move in with them for the time being.

One night, Tony catches his father eating his pet snake's eggs, and high-tails it out until his old man catches him and bites into his shoulder (we later learn he's planting alien seed in his son).

And the film gets even more asinine: Tony discovers he has gained a bunch of new powers, including the ability to make his toys come alive. He puts this skill to use when one of his neighbors kills his pet snake. He makes one of his toys turn into a midget (dressed as a clown) and it attacks people with a lethal yo-yo-type of weapon. He also sends a toy soldier after his neighbor for some snake-revenge.

If the theater I saw XTRO in (the now defunct Fox Twin Cinema) had a bar, I would have definitely pounded down a few shots at this point.

For some reason Sam and his wife (ex-wife?) decide to visit the farm they used to live on and leave Tony home with a gorgeous nanny (played by Maryam D'Abo of the 1987 James Bond film THE LIVING DAYLIGHTS), who of course has her boyfriend come over for a shag session (and 007 fans might want to note Miss D'Abo does a generous nude scene here). Tony keeps bugging them to play hide and seek, and they eventually do, but during the game the nanny is knocked out by the aforementioned midget clown and impregnated with alien eggs (remember, I told you this thing makes little sense) while Tony sends one of his toy army tanks to deep-six her boyfriend.

Meanwhile, back at Sam's old farmhouse, he manages to have sex with his wife (ex-wife?) but during the act his body starts to bleed profusely and transform. Joe shows up with Tony looking for Rachel, and this is when total chaos ensues: Sam and Tony follow the light from a UFO, and Sam turns into an alien, who manages to kill Joe with his ear-shattering screams. The alien Sam then takes Tony and heads toward the space craft as a confused Rachel goes back to her apartment … and is raped by the same alien who raped the poor woman earlier in the film.

The more you consider XTRO, the more you'll be convinced the makers of it were determined to create the exact opposite of E.T.: where Spielberg's film was family friendly and featured a positive, wholesome ending, XTRO is a mess of gore, splatter, alien slime, and one of the most nihilistic, depressing endings to ever grace a sci-fi/horror film. All the strangeness with the toys still baffles me, but it did provide some laughs for the grossed-out audience.

I recently watched this film for the first time since seeing it theatrically, and found it even more confusing than I had remembered. I'm surprised this one has such a healthy cult following, especially since stretches are a bit slow and the acting stiff, with the exception of Rachel (played by Bernice Stagers, of Fellini's 1980 CITY OF WOMEN), who most of the film revolves around, despite an ad campaign that would let you believe Tony was the focus.

XTRO is a real mess. It's gross, nasty, and ends on such a low note some might consider the director a manic depressive. Yet at the same time, lovers of B-movie schlock should enjoy it well enough. This here's one father/son relationship tale I doubt any parent would approve of. I still haven't seen the sequel.

Live long and SUFFER!

eleased 6 years after DEATH WISH (1974) but two years before FIRST BLOOD (1982), 1980's THE EXTERMINATOR is a combo of these two classics with a dash of TAXI DRIVER (1976) thrown in. I recently revisited this on DVD, but in the fall of 1980 (when I was in the 6th grade), me and a buddy managed to get into this violent R-rated flick one Saturday afternoon at the always reliable (and now defunct) Amboy Twin Cinema, Staten Island's best bet of being admitted when you were underage.

After an opening flashback scene set in Vietnam (which features a grisly, non-CGI decapitation courtesy of FX whiz Stan (ALIENS) Winston), we flash forward to 1980 New York City. John Eastmand (played by popular TV star Robert Ginty) works at a meat packing plant along with his best friend Michael, who had saved his life in Vietnam. When they bust a group of thugs robbing beer from an adjacent warehouse, Michael again comes to John's aid, but the gang follows Michael home and throws him a severe beating that leaves him paralyzed. Fueled by this event, and fed up with the state of the city's crime rate in general, John goes on a mission first to get the guys who crippled his buddy, then wage all-out war against the mob, pimps, and all kinds of low lives.

John transforms into a vigilante a bit too quickly (in the scene immediately after he visits Michael in the hospital, John already has a gang member tied up and threatens him with a flamethrower). But this is a sleazy action flick, so subtly and character build-up be damned! His arsenal includes a .44 magnum with custom, poison-tipped bullets, an AK-47, and a foot locker full of military-issued hand grenades and knives.

Minutes later, John goes to the gang's hideout (one is played by THE WARRIORS' (1979) Irwin Keyes), tells the girls to leave, and then proceeds to shoot one thug and take two others hostage. But his partial-heart leads to one guy surviving, and one of the hookers he let go is interrogated by Detective James

Dalton (played by Christopher George), who is on the trail of the vigilante the news has labeled "The Exterminator." Former ABC-TV news anchor Roger Grimsby appears as himself during a newscast, giving the film a real-time feel (at least if you lived in NY at the time).

With the gang taken care of, John sets his eyes on a mob boss who has been shaking his employer down for years. He does some stake-out work and manages to drug him and drag him to an isolated warehouse, where he chains him from the rafters and dangles him over a huge meat grinder, then proceeds to shake him down for money to support his fallen friends' family. After he gets the mobster's keys, safe-lock combination, and a promise that there are no surprises at his house, John goes out to his NJ home and is attacked by a guard dog the gangster "forgot" to tell him about. Now severely ticked, John returns to the warehouse and lowers the Don into the meat grinder, and while nothing is shown (besides shadows and chop

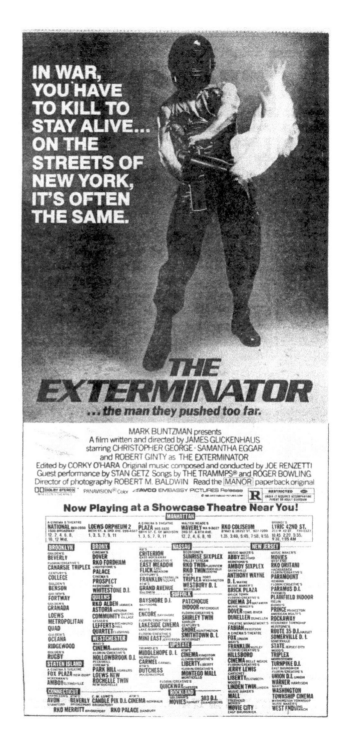

meat coming out of the bottom), the scene is still quite disturbing. It also received the loudest cheers from the evidently blood-thirsty (or justice-thirsty?) audience I was with.

In the second most memorable sequence, John visits a hooker (ala TAXI DRIVER) who gives him info on an underground operation that exploits young boys. John shows up at the illegal brothel and quickly destroys the place by burning the owner and shooting a freaky-looking pedophile in the groin (said pedophile is played by FRANKENHOOKER's (1990) scene-stealing freak David Lipman). The pedophile also turns out to be the State Senator from New Jersey!

In between investigating the vigilante killings, Detective James manages to find the time to date a doctor (played by Samantha Eggar). In one scene they meet for a late-night shag session in an empty hospital room, but as things heat up they're interrupted by an alarm: it seems Michael's ventilator has gone off, and little do the detective or doctor realize John had come by to help his buddy pull the plug on himself. This John's a real angel of mercy I tell ya...

With plenty of shoot-outs, a motorcycle vs. car chase scene, a goofy side-plot involving the CIA that leads to a partially head-scratching finale, a poor old woman getting a beat-down, and a nasty scene of the aforementioned State Senator burning/raping a hooker with a red-hot soldering iron, THE EXTERMINATOR is a trashy revenge/vigilante film that has developed quite a cult following over the years. And like most NY-lensed genre films from this time, there are plenty of shots of Times Square back in all its sordid glory, complete with pimps, hookers, and glorious theater marquees that will have cinema-philes hitting the pause button to read the film titles (of course we couldn't do this in the theater so it was nice finally seeing what was playing!).

This is a genuine blast of old-school, politically incorrect action film-fare that has almost no conscience whatsoever, and it manages to work despite its ho-hum performances from most of the actors. Too bad the sequel, 1984's THE EXTERMINATOR 2, failed to deliver the goods.

Suburban Grindhouse Memories No 62

MODERN MEMORIES: HENENLOTTER STRIKES AGAIN!

rank Henenlotter may have made his name as a director among horror film fans with classics such as BASKET CASE (1982) and FRANKENHOOKER (1990), but after watching his second documentary, THAT'S SEXPLOITATION! (2013) at NYC's Anthology Archives, a new generation of fans may come to see him as a true bizarre film historian.

His previous documentary, 2010's HERSCHELL GORDON LEWIS: THE GODFATHER OF GORE (also produced by Something Weird Video) was a loving tribute to the man who brought splatter films onto the world stage. THAT'S SEXPLOITATION! features the late exploitation producer David F. Friedman as

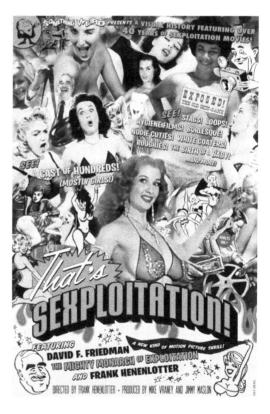

he gives a lengthy history of films that pushed nudity and other sexual taboos from as far back as the 1920's, and while it's a bit long (almost 2 hours and 15 minutes), the film moves along at a fine pace and is as hilarious as it is absurd.

Director Henenlotter opens the film at a bar, where he explains what we're about to see. A topless woman wearing 60's-era pasties stands near him to try and distract the audience … and she does (along with a bare-bottomed male bartender). Frank then travels to Friedman's home in Alabama, where the interview takes place. In between Friedman's insightful and informative dialogue, we're treated to scenes from some of the craziest films and shorts ever to grace movie screens … some only seen in "adult arcades" and porn houses of the past.

Friedman gleefully guides us through clip after clip of films that pushed the envelope when it came to nudity and breaking other taboo subjects. Among the more memorable moments is a silent film from the 1920s where four women swimming in their underwear have their clothes stolen by a young girl and are forced to walk home half naked, and a bar scene in a film from the 30s/40s where the director managed to sneak in two men kissing on the side of the screen.

THAT'S SEXPLOITATION! covers all kinds of softcore films that were released from the 20s until the mid-70s. During the World War II era, films of this nature often came out disguised as sex education films, and had to feature an educational-type feel or they wouldn't have been released. Most of these films featured graphic scenes of childbirth, close-ups of genitals in various stages of venereal disease, and a host of other areas that are a hundred more times disturbing than if censors would have just allowed plain old nudity to be shown. But that's the American way, I guess, and Friedman's latent sarcasm as he discusses this is priceless.

While there's plenty of obscure material covered, the film also takes a look at sexploitation films directed by cult directors such as Russ Meyer, Doris Wishman, and Herschell Gordon Lewis (you can't beat a nudie film with a title like GOLDILOCKS AND THE THREE BARES!). The audience I saw this with laughed the loudest over clips from Doris Wishman's NUDE ON THE MOON (1961) and a superhero spoof from the early 70s titled BAT PUSSY that has to be seen to be believed.

There are loving shots of Times Square in its heyday as well as smut theaters in Los Angeles and other cities, but oddly enough, Henenlotter states at the film's conclusion that once hardcore films came into play in the early 70s, "that's when all the fun ended." And from the looks of the clips presented here, audiences will see what he means: some of the films presented feature truly funny story lines, off-the-wall scenarios, and often used sex and nudity as a way to get a laugh or shock the crowds. Most of them were goofy fun, from nudist camp films to burlesque dance shorts to science fiction/horror sex parodies.

THAT'S SEXPLOITATION! looks at the films our grandfathers and great grandfathers considered risqué, and it's all done with wit and charm. Both Henenlotter and Friedman go about this with a genuine zeal and will surely have many who watch scrambling to find some of the films shown within. Even those who think they know all there is to know about exploitation cinema are sure to learn something new here.

A chat with...

FRANK HENENLOTTER

rank Henenlotter burst onto the film scene in 1982 with his debut feature, BASKET CASE. The film quickly became a cult classic, and was followed by BRAIN DAMAGE (1988), BASKET CASE 2 (1990), FRANKENHOOKER (1990), BASKET CASE 3: THE PROGENY (1992), and BAD BIOLOGY (2008). When not directing films, Frank is also a film historian and has done a tremendous amount of work restoring forgotten and thought-to-have-been lost exploitation and sexploitation films with Something Weird Video. I was fortunate enough to speak with Frank about his two documentaries, HERSCHELL GORDON LEWIS: THE GODFATHER OF GORE (2010) and THAT'S SEXPLOITATION (2013), as well as his time growing up as a film lover in Long Island and later in Times Square.

SUBURBAN GRINDHOUSE (SG): How did you first hear about Herschell Gordon Lewis and what inspired you to make a documentary about him?

FRANK HENENLOTTER (FH): I grew up in Lynbrook, Long Island, which was typical hometown Americana. In one of our local pharmacies, I would often check out the paperbacks. When I was 12 years old, I saw a paperback of BLOOD FEAST, which featured some gory black and white photos. I hid it in the store and peeked at it for two months before it finally disappeared. I found out it was a film, and when I finally got to see it I was disappointed that it was in color. The black and white photos from the book reminded me of real crime photos you'd see in the newspaper.

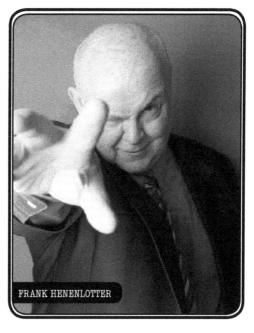

FRANK HENENLOTTER

THE TENANT IN ROOM 7 IS VERY SMALL, VERY TWISTED, AND VERY MAD

BASKET CASE

an IEVINS / HENENLOTTER production starring KEVIN VanHENTENRYCK TERRI SUSAN SMITH BEVERLY BONNER
Director of Photography BRUCE TORBET Music GUS RUSSO Executive Producers ARNIE BRUCK TOM KAYE
Production Executive RAY SUNDLIN Produced by EDGAR IEVINS Written and Directed by FRANK HENENLOTTER
FROM SATIN FILMS LTD

I was always a fan of gutter-level film making, and no one made better gutter-level films than Herschell Gordon Lewis, so it was a no brainer that my first documentary would be about him.

SG: Your second documentary, THAT'S SEXPLOITATION, features some fascinating early material. How difficult was it to obtain the footage used in your film?

FH: It wasn't difficult to get the material, as Mike Vraney (of Something Weird Video) and myself had endless archives to go through. But it was a lengthy process. We could have easily used another hour's worth of material. THAT'S SEXPLOITATION was a real labor of love and I enjoy watching it.

SG: What's one of your fondest memories of 42nd Street during its heyday?

FH: Well, I was there quite a bit, from 1965 when I was 15-years-old, when I'd go as often as possible, maybe every two or three weeks. But when I moved to Manhattan in the early 70s, I was in a theater on 42nd Street 6 or 7 nights a week, and if I wasn't on 42nd Street I was in another theater somewhere in Times Square. This was the greatest "film school" anyone could ever hope to go to.

One of the craziest memories I have is of who was known as the Lyric Laundry Lady, who may or may not have been homeless but was always doing her laundry in the Lyric Theater. She would wash her clothes in the women's room,

and then lay them out on the backs of seats in the auditorium to dry. She'd yell at people and guard the aisles where her clothes dried. The Lyric always featured first run films, so there was usually a crowd when she was doing her laundry. She'd growl during intermission and turn her clothes over to dry their other sides.

Another time, at the New Amsterdam Theater, during a screening of FRANKENSTEIN'S CASTLE OF FREAKS, a woman in the front row began to make noise and the guy behind her told her to be quiet. About a minute later, the guy jumps out of his seat and heads to the back exit. A few seconds later, the people behind him did the same. And so on. I was sitting toward the rear, and was wondering what the hell was making its way up the aisle. Suddenly I was hit with the most disgusting stench and made my way up to the balcony with everyone else.

It turns out the woman in the front row had taken an incredibly bad bowel movement, and the smell cleared the place out. We spent the rest of the film watching people walk in—then run out—of the floor level seating area. An usher or manager eventually went to check out what was happening, but no one bothered to clean the mess. In fact, I don't think the theater was cleaned until Disney finally bought the place out.

Of course, I also saw so many films there it'd be impossible to recount. But I did see several Jess Franco films before I realized they were Jess Franco films such as 99 WOMEN and THE HORRIBLE DR. ORLOFF.

SG: Were there any non-urban grindhouse-type theaters you frequented?
FH: in the 60s and 70s, neighborhood theaters would show everything. They all carried the AIP Vincent Price movies. You could see everything from Doris Day films to biker film double features, horror films and westerns. Some theaters were surely shoddier than others, but all of them played first run films. In my hometown on Long Island, I even saw two Andy Milligan films, and all these theaters were single screen. I thought the world was coming to an end when the twin theaters started. At that time, anything that played at a drive-in also played at a hard top (regular) theater. So theaters outside of Times Square featured the same films you'd see on 42nd Street. I mean, I saw BEYOND THE VALLEY OF THE DOLLS just 6 blocks from my house in Long Island!

As far as the term "grindhouse" goes, grindhouses were theaters that

A TERRIFYING TALE OF SLUTS AND BOLTS.

FRANKENHOOKER

"If you only see
one movie this year
It should be
FRANKENHOOKER."
—Bill Murray

TIMES SQUARE

were almost always open (they'd usually close from 4 a.m. to 9 a.m. to allegedly clean). They ran their film prints so often that projectors literally grinded the films down, resulting in scratchy and worn looking movies. The term grindhouse is used in a lot of ways today, but most theaters now aren't what you'd call a grindhouse. And as far as calling films themselves "grindhouse films?" I just call them exploitation films.

SG: What are some of your favorite films that inspired you to direct your own?

FH: Oh God there are just so many! Two of my favorites are Fellini's LA DOLCE VITA, and Hitchcock's PSYCHO. The first time I saw PSYCHO I was 10-years-old in the backseat of my parent's car at a drive-in. The film did nothing for me. But when they re-released it 5 years later in 1965, I went to see it again and was flabbergasted! I mean, the film is just so full of sick, dark humor (although it wasn't a comedy). Just pay attention to the scene where Perkins and Leigh—right before her famous shower scene—have dinner. I knew what was going to happen having seen it before, and the dialogue took on a whole new dimension. It is pregnant with sick jokes! You could almost imagine Hitchcock chuckling when you watch this scene.

SATAN SLEEPS WITH A BOND BABE...

When you're an eighth-grade horror film *and* 007 fan and you open the newspaper to see an ad for a movie that combines the two, two things go through your mind: one is 'YES!' and the other is 'OMG! Plenty O'Toole in an R-rated film!' For those not in the know, star Lana Wood (yes, the late Natalie's younger sister) played the goofy-named character in the 1971 007 classic DIAMONDS ARE FOREVER, and while SATAN'S MISTRESS (1982) was released 11 years after DIAMONDS, Wood looked as beautiful as ever. Now, add to this another Bond girl, the lovely Britt Ekland (who played 007's love interest in 1974's THE MAN WITH THE GOLDEN GUN), and this here film geek was completely psyched for an early Saturday afternoon screening.

In my never-ending attempt to write this column completely from memory, please bear with me: SATAN'S MISTRESS has never officially been released on DVD, and I had no desire to rent it when it came to VHS. I state this because the film is just so slow and dreary I had a rough time writing this month's column. But there are a few sequences worthy of Lana Wood's fans' time, as well as anyone who simply must see every occult-themed horror film ever released (and with that, know that this film has also been released around the globe under the titles DEMON RAGE, DARK EYES, and FURY OF THE SUCCUBUS).

Staten Island's (now defunct) Amboy Twin Cinema admitted this underage patron for a 12 or 1 o'clock show. I believe there were maybe 6 others in attendance, all men who seemed to be in their 30s or 40s. Again, I thank my family's genetic werewolf curse for giving me a mustache at such a young age. With my bucket of popcorn and large soda, I took a seat in the back row, not knowing if this was going to be an EXORCIST rip off or some kind of softcore T&A fest. And while it was nothing like THE EXORCIST, Lana Wood spends much of the film walking, showering, and laying around in the buff, much to the delight of us 007 geeks.

But on to the story: Lana plays Lisa, who lives in a nice little beach-front

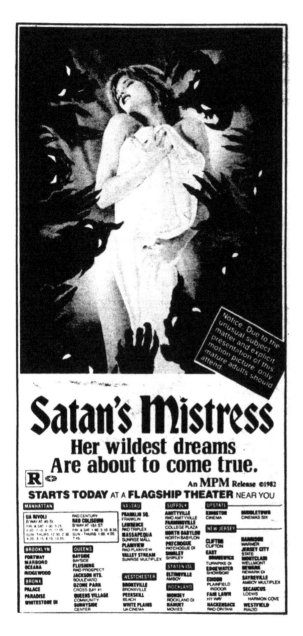

Notice: Due to the unusual subject matter and explicit presentation of this motion picture only mature adults should attend

Satan's Mistress
Her wildest dreams
Are about to come true.

R ⊖⊏⊐

An **MPM** Release ©1982

STARTS TODAY AT A **FLAGSHIP THEATER** NEAR YOU

home with her husband and teenage daughter. They're constantly fighting as he's always (allegedly) at work and wants nothing to do with her sexually (apparently this guy needs his head examined). Depressed, Lisa decides to walk around the empty house naked one day, when a terribly cheap-looking purple mist appears and covers her body, causing her to become aroused. It rapes her, but Lisa ends up enjoying it! After a couple of shag sessions, the mist turns into a man and Lisa continues to enjoy these unusual trysts, at times groaning worse than a seasoned porn star. She spends her days painting pictures of her mysterious new sex toy and acting odd in front of her family. (It should be noted that like the similar (but far better and serious) film THE ENTITY (1981), there's a mention early in the film about this being based on actual events after an opening nightmare sequence).

One night, her daughter is visited by a woman who claims to be a demon and starts babbling about the man her mother is with. It should be mentioned that at this point the film is not only confusing but tedious, as the screen is either Lisa's husband walking around the house aggravated and taking solo-swims in the ocean, or Lisa having sex with her supernatural lover. And while anyone can appreciate Lana Wood's beauty,

even that gets played out after a while.

In a few scenes, Lisa's hubby and daughter start bleeding for no reason, and they each meet people who say they're Satan's disciples (some with cheaply-glowing eyes). But this little nod to ROSEMARY'S BABY (1968) goes nowhere fast and teases the audience that a story actually lurked somewhere in this mess.

Lisa's husband (now as confused as the audience I was with) contacts his wife's friend, a psychic (played by Britt Ekland). He tells her what has been going on and manages to get her to help. When she comes to the house, she's eventually almost boiled to death in the hot tub, and she brings along her husband (one of those "AH! That guy!" actors who has appeared in dozens of TV shows) who goes into Lisa's basement and ends up being decapitated by a guillotine! Now, hear me out, folks: I'm a big fan of weirdness in films. The stranger, the better, I always say. But just what on earth a guillotine is doing in the basement of a beach-front American house is anyone's guess. And worse than this hard-to-believe development, is that it's only used once! This brief moment of grindhouse fun is wasted and adds to the growing puzzle of this increasingly obscure film.

The legendary John Carradine has a ridiculously brief cameo as a priest that's a complete waste of time (his blind priest in 1977's THE SENTINEL was much more endearing) and we eventually learn that the demon who has been shagging Lisa is in some kind of purgatory, not sure if he wants to go to heaven or hell. I truly need to see this again to even attempt to recall the ending, but (spoiler alert!) the demon winds up choosing hell (I guess the constant sex with Lisa started to bore him as much as us?) and some kind of mumbo jumbo about the great battle between good and evil is discussed between Lisa and her family. If memory serves correctly, only four of us made it through the entire film, the others taking off at various stages of boredom.

Often when I review a film like this, readers accuse me of making these snooze-fests sound more exciting than they are. So be warned: despite the boobies, bond girls, and guillotine, SATAN'S MISTRESS is a lame affair, treating rape in an almost comical manner and testing the patience of even the most jaded bad movie lover. And when you figure in the absolutely terrible soundtrack, this is pure garbage from start to finish.

Unless you're completely ga-ga for Lana Wood, just move along …

EVEN IN 4-D YOU'D FALL ASLEEP...

eleased a few months before FRIDAY THE 13TH PART 3 in 3D and two years after the lame 3D western comedy COMIN' AT YA, 1982's PARASITE was another in a small line of early 80s films that attempted to resurge 3D cinema. TV commercials promised a "Terrifying New Experience" and "The First Futuristic Monster Movie in 3D!" What the ads didn't tell anyone was that this turd (despite being Demi Moore's debut film) was incredibly boring.

At the time, it was difficult to follow the story not only because of the film's lifeless nature, but also due to everyone in the audience fussing with their two-colored 3D glasses. "This is so uncomfortable!" was heard nearly every 10 seconds from someone in the packed (and now defunct) Rae Twin Cinema. My friends and I even had to sit by some guy who we asked to purchase our tickets, and he had said, "Sure, just stay near me in case the manager says anything." Thankfully the guy wasn't a creep looking to score a bunch of teenagers, but ended up being a cool older gent happy to help us underage horror fans get into an R-rated feature.

The film takes place in a post-nuclear accident / incident America, where there's no more government but instead a secret group of paramilitary leaders who hire a doctor to create something that will help control overpopulation (funny, as there seems to be no people wandering around besides the main characters). Nothing in the film looks post-apocalyptic and if not for an audience-free second viewing on VHS a year or two later, I'd still have no idea what the set up of this film was.

The doctor manages to escape from the mysterious leaders with his creation, an eel-looking creature with a big mouth full of teeth. The thing infects him, and he spends much of the film trying to study it as he runs from town to town with the creature living in his stomach. In one seemingly deserted town, he is attacked by a goofy-looking biker gang (one member played by former RUNAWAYS vocalist/cult film star Cheri Currie) who steal the doctor's container

that holds the parasite (cue spooky music. In fact, cue *anything* that will help this film move along). When he gets away from the gang, he comes across a pretty farmer girl (played by Demi Moore) and tells her his story. Of course she feels compelled to help him find and destroy his creature, and the two are off on an action-packed adventure (OOPS...sorry... they walk around "searching" for the monster with the concern of the leaders of a retirement community).

They eventually meet up with the gang, and from what I can recall most of them have become infected by the parasite, one even growing a parasite-looking mouth full of jagged teeth. The 3D "attack" sequences are quite lame, including the film's "iconic" scene where the creature falls from the ceiling onto a gang member's head (filmed for the sole purpose of attempting to get a good 3D effect. They failed).

Demi Moore's character eventually gets the doctor's parasite off him, they

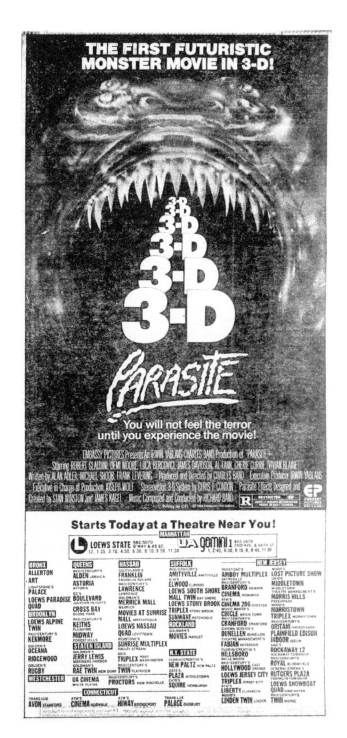

electrocute it in more unconvincing (but non-3D) effects, and the main parasite is soon blown up as it battles with the gang's leader.

PARASITE 3D is a tedious mess. It never exploits its post-nuclear landscape or society, and never gives any of its characters time to grow, which is funny considering the doctor is in almost every shot in the film, as is Demi Moore once she comes into the picture. The 3D effects themselves didn't even look half as good as a child's View Master (remember those?) and the few scenes of the parasite biting and latching onto people are laughable despite a couple containing generous bloodshed.

Directed by Charles Band (who is just SO much better as a producer), PARASITE is for 3D completists only. I'm not sure if a 3D version was ever released to VHS or DVD (the VHS I had rented was non-3D), so you'll have to keep your eyes peeled on your local revival house if you want to see this the way the director had originally intended.

The ONLY thing PARASITE has going for it (on a B-movie level at least) is a government agent named Wolf, who is after the doctor and drives around in a customized black Countach. His over-acting was the only thing that gave the audience I saw this with a few chuckles. The saddest (and weirdest) part of this whole project are the creatures. They were created by the late great special FX legend Stan Winston, but to me they just looked silly, like escapees from a really bad children's television program. I'll go out on an amputated limb here and blame most of that on the poor 3D (nah, take that back. They even looked silly during my non-3D viewing).

3D may have come back with a vengeance these past few years, but in the early 80s, stinkers like PARASITE helped keep the gimmick in the closet.

Suburban Grindhouse Memories No 65

SOME SHARP WISCONSIN CHEESE...

asn't anyone ever told beer-guzzling fisherman that if they attempt to bring fish to the surface with dynamite, the results will never be good? Apparently the sap we meet at the beginning of 1983's BOG never received this memo. He tosses a stick into an isolated pond and within 5 seconds after the explosion, something surfaces and drags him underneath his cheap rowboat. And in classic b-grade monster movie style, the film then cuts to the opening credits and one of the corniest love songs you've ever heard (and in my case, plenty of groans from the audience).

And so begins yet another entry into the Aquatic Monster-Attack subgenre. I didn't find out until the Internet age that BOG was actually shot in the late 70s and (I'm assuming) was one of the first films to be released theatrically and on home video around the same time (a practice that has grown over the past several years due to contract agreements, so at least BOG has this slight footnote going for it).

And while BOG is a terrible film, it's without a doubt a genuine so-bad-it's-good.

Two middle-aged buddies bring their wives fishing (to, of course, the pond where the aforementioned fisherman just became creature chow). They drink themselves silly, cracking open cans of beer nearly every thirty seconds. The wives get pissed and spend the night in the station wagon while the men rough it outside in sleeping bags. One of the guys looks incredibly like Avery Schreiber (70s/80s TV/movie star best known for his classic Doritos

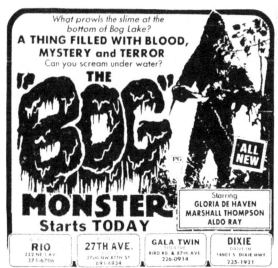

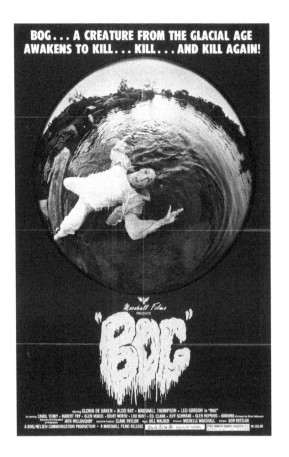

BOG... A CREATURE FROM THE GLACIAL AGE
AWAKENS TO KILL... KILL... AND KILL AGAIN!

commercials). The next day, it doesn't take long for both women to fall victim to the bog monster, and while nothing is shown (this is PG-rated), we learn the beast sucks their blood out in an almost mosquito-like style. And while the film later on claims the creature needs women, it has no problem wasting men who get in its way.

Our two buddies make it into town and alert the sheriff (played by film legend Aldo Ray), who claims they already have 25 guys out looking for their wives. Another TV/film legend, Gloria DeHaven, plays his friend/ scientist who is now on the case trying to find out what this thing is using a high school lab-looking microscope while a romance develops between her and a small town doctor (played by Marshall Thompson of the classic 1958 sci-fi film IT! THE TERROR FROM BEYOND SPACE). I do remember wondering if BOG was intended to be a vehicle for middle-aged and senior actors, or if this was all the producer was able to afford. The only younger cast members are two girls who ride their bikes right by a road block (one of them ends up deep-sixed).

In one suspense free sequence, the sheriff has one of his officers place a large explosive in the pond. With the two now heavily-armed beer-drinking buddies watching, the sheriff hooks the bomb up to his car's battery via electric cables and attempts to blow the monster to the surface. When nothing happens but a loud boom, he leaves with his officer, but 10 seconds down the road they hear gunshots so they turn around and discover the two buddies floating in the water. Why the Sheriff didn't offer them a ride back to town is anyone's guess, but this is only one of countless questions that arise nearly every 5 minutes during this soggy celluloid atrocity.

Among some of BOG's most (un)memorable moments are: a silly and darkly shot "love" scene between DeHaven and Thompson as we're again treated to the sappy title song; in a dual role, DeHaven also plays a hippie/witch/freak who tells our two buddies the history of the bog monster (she looks like a cross between Stevie Nicks and Andy Warhol); a cartoonish, stereotypical hillbilly who helps our two buddies get their hands on some major firepower; and despite the films veteran stars, the acting, dialogue, and especially editing are just plain terrible.

And then we have the creature itself. We barely see him throughout the film, and the one time its face is shown, if you stop laughing long enough, you'll see a resemblance to the monsters in the seldom seen Italian stinker ISLAND OF THE FISHMEN (1979). But hey, at least that one had some major eye candy in the form of Barbara Bach, fresh off her stint as 007's love interest in THE SPY WHO LOVED ME (1977).

Our scientist devise a plan to lure the creature using some kind of air-born blood mixture (don't ask), and once he surfaces, he kills the sheriff right before our group of cops and town locals hose him down with some kind of substance that knocks him out. The creature is then kept in DeHaven's lab, but the second the men leave it abducts DeHaven and brings her back to the bog.

Thompson and a colleague are the first to catch up to the beast. One guy falls victim but the creature drops DeHaven, sending her into the arms of Thompson. And here is where possibly the most ridiculous thing I've ever seen in a monster movie goes down: despite all the firepower that has been thrown at it, despite the chemicals used to subdue it, guess how they finally kill the big-eyes beast?

By running it over with a car.

The groans and profanity hurled at the screen at this point in the (now defunct) Amboy Twin Cinema are as loud in my head thirty-four years later as they were at the time. With the monster now on fire (because, y'know, anyone who gets hit by a car goes on fire), the film then switches to an underwater shot where we see a host of bog monster eggs. The inevitable "The End?" appears across the screen.

Wow. While I do remember laughing through the whole film, I doubt too many people will be able to get through this today without the aid of a fast forward button. Unless, of course, some lunatics decide to revive this in a theater, in which case you'll be as stuck as I was. BOG is for swamp monster completists only, or young film students who need to see how to not edit a film.

DA BEARS!

une 1979. It was the last month of my elementary education, summer vacation was on the horizon, and a cool-looking PG-rated monster movie had invaded NYC. I cut out a black and white newspaper ad of the above poster for PROPHECY and obsessed over it for a week until the film was released. I attempted to draw it. I continually envisioned what this thing was going to look like on the big screen. And I continued to thank the horror gods that there was FINALLY a film I could get into without bothering an adult to take me.

I hit the (now defunct) Rae Twin Cinema with my brother and cousin for an early afternoon screening the first Saturday of the film's release. Despite it being June and from what I could recall warm outside, the theater was crowded with mostly younger monster movie fans. I didn't realize, until this time, so many existed so close to where I lived. But chances were most of the audience went to little league games or bar-b-q's when the film was over, not back to their bedrooms to draw a comic version (for the rest of the day and evening) of what they just saw. Okay, geekdom now partially over...

PROPHECY opens with a few lumberjacks chasing their dog through the woods. Something has disturbed it, and it doesn't take long for the loggers to fall off a cliff and become prey to something we can't see.

A pseudo-hippie-looking man named Rob (played by Robert Foxworth, a popular 70s TV actor who was just off a role in DAMIEN: OMEN 2 (1978)) takes a job with the Environmental Protection Agency in Maine. He's working on an article about the effects of an industrial logging facility that's located on a river, a site of controversy as employees have been having issues with the local American Indians.

Talia Shire plays Rob's wife Maggie, and at the time (I was eleven), I kept waiting for Sylvester Stallone to jump out of the woods and throw Rob a beating. To this day I still can't picture Talia in any other role except for Rocky Balboa's wife Adrian (that includes her role as Connie in THE GODFATHER films). It

turns out that Maggie's pregnant, but still hasn't told her hubby, and good thing: the head of the logging plant tells Rob about his missing lumberjacks, adding to his quickly growing, more-than-he-bargained for job assignment.

The American Indians (known as Opies) are claiming the lost loggers have been taken by a forest spirit who has been angered over the activity of the logging plant. The Opies are first encountered when the logging plant director drives Rob and Maggie to their new cabin. The Opies block their path, and a potential chainsaw/axe fight ensues. But the head Opie (played by Armand Assante) backs down, and this young horror fans was a bit disappointed over the quick standoff.

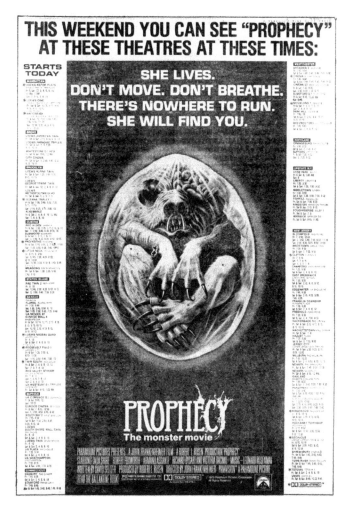

At their cabin, Rob notices some of the fish seem larger than normal while fishing, and shortly afterwards he and Maggie are confronted by a rabid raccoon. It seems the locals and the wildlife around their new home have issues with them being there.

John (Assante) meets up with Rob again on more peaceful terms, and tells him he needs to understand something is hurting their children, causing birth defects and also making adults go crazy. John's father in law also claims he has seen the forest spirit that has killed the loggers, and says it is coming for revenge. For further proof the plant might be leaking something into the river,

John manages to net a tadpole that's way bigger than a full-grown frog. And after John and Maggie investigate the seemingly clean plant, John discovers traces of mercury on his wife's shoes, and with a little research, finds out mercury is being used to stop rotting in the logs ... but it also causes all sorts of side effects, such as birth defects and (cue creepy music) unusual growth.

I remember at the time I saw this, I was thinking, "Oh yes! This must be what caused Nessie to grow so big over in Scotland!" But of course I kept that thought to myself, afraid my cousin would give me a shot to the ribs for being too much of a geek.

This is when PROPHECY's semi-lengthy set up pays off. We flash to a scene of a family camping in the woods, all snug in their sleeping bags, when something attacks them. In one of the most famous scenes in the films, a camper attempts to hop away in his zipped-up sleeping bag when the creature flings him into a boulder, causing an explosion of feathers sprinkled with red stuff. The audience howled in appreciation, despite the brief glimpses of the monster.

The local authorities believe the Opies have killed the campers, but John escapes into the woods. Rob, Maggie, and John's wife go looking for him via helicopter, but instead find two mutant bear cubs, A.K.A. proof of John's theory about the plant contaminating the area. John decides to take one of the cubs to prove everything, when a storm hits and grounds the helicopter.

Then all monster-hell breaks loose.

The rest of PROPHECY is full of mutant bear attack mayhem, as the beast attempts to get its offspring back from human hands. While this is a simple storyline that has been featured in many monster films (GORGO (1961) for example), here the suspense level still works (I watched this again recently for the first time in over 30 years) and the final battle between man and monster in and around the river is a blast.

For a PG-rated monster movie, PROPHECY delivers. And I'll never forget this initial screening of mine, when we all thought the horror was over; we see a plane carrying Rob and Maggie away from Maine, going, going ... and when you think the credits are about to roll, the head of another mutant bear pops up from the bottom of the screen and scared the pants off of everyone in the audience!

This is one fun, exciting monster movie that attempts to say a little something more than your standard horror fare.

AVOCADOS FROM MARS

H ere's one film I simply had to revisit before writing this column. While my memory of the film was blurry (you'll see why in a second), I've heard in the years since that ALIEN CONTAMINATION, which invaded the NYC area in 1982, was a heavily edited version of a film originally titled CONTAMINATION. And after recently watching the Blue Underground DVD release, yes, the film was a bit edited, yet there was still plenty of gross goings-on to make the (now defunct) Fox Twin Theater scream out in appreciative glee.

A freight ship pulls into NYC. An investigating crew (who had the foresight to wear white toxin suits ala THE CRAZIES) discovers everyone onboard has been killed, and then they find an area full of football-sized eggs that resemble mutant avocados. And before I could shovel a second handful of popcorn into my mouth, most of the crew comes into contact with one of the eggs, causing their chests to burst open in ALIEN-like fashion. I do recall this opening sequence being quite graphic, so it's probably not one of the allegedly edited scenes. Either way, only one member of the team escapes, and the Saturday afternoon crowd at the Fox Twin began cheering and whistling, one guy even asking out loud, "Where's the f__ing alien?"

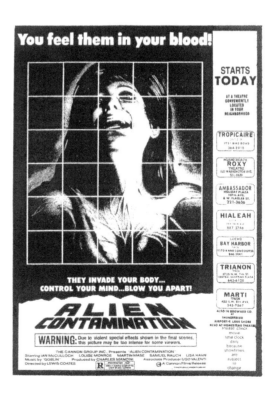

Unfortunately for him, ALIEN CONTAMINATION, despite its ALIEN-like eggs and chest-bursting shots, is more like INVASION OF THE BODY SNATCHERS (and I'll cite the superior

ALIEN CONTAMINATION

1978 version here). We eventually learn an expedition to Mars has brought back some of these eggs, as well as a one-eyed alien (who looks about as threatening as the aliens on THE SIMPSONS. In fact, I'm willing to bet Matt Groening was directly influenced by this). One surviving astronaut of the Mars voyage is Commander Ian Hubbard (played but Euro-horror film legend Ian (ZOMBIE, DR. BUTCHER) McCulloch). He is contacted by Colonel Stella Holmes, who has learned thousands of these eggs are onboard the ship. They're also stored in boxes that bear the logo of a Colombian coffee company (my goodness do I love Italian horror films). After the army freezes half the eggs and flamethrows the other half (why in two ways is anyone's guess), Stella, Ian, and the NYC police lieutenant who survived the opening egg assault travel to Colombia where they eventually find the mother alien as well as another astronaut who survived the trip to Mars and is now under the alien's control. Ian also discovers the alien eggs being harvested by local coffee farmers!

I had remembered a lot more chest-bursting scenes before my recent DVD viewing, and there are several, but not as many as viewers seem to believe there are. Each time some poor sap comes into contact with an egg, the audience at

the Fox Twin went wild, but when the bodies would hit the floor with an empty chest cavity and no alien baby in tow, people seemed disappointed. The same guy from earlier kept yelling, "Where are the aliens?" over and over to the point a few people told him to shut the f___ up and watch the movie. Cursing back and forth continued throughout most of the film, which I remembered more than the film itself. It actually became quite funny. But who could blame this poor guy? The poster outside the theater featured a face screaming over a field of green alien eggs and the word ALIEN was in the film's title! We were all expecting aliens to show up at some point, but it wasn't until the very end where we see the lone, one-eyed, goofy-looking monster.

I love animals, so if you're sensitive about animal violence you might want to skip this paragraph. The most memorable scene in ALIEN CONTAMINATION comes early in the film when a lab rat is injected with green glop taken from one of the eggs. As a few people stand around watching the rat walk in circles in its glass tank, the poor bastard eventually explodes, bathing the walls in more sauce than any rat could actually contain. The actors on the screen somehow kept straight faces. The audience I was with did not. In fact, I laughed even harder upon my recent DVD viewing. It's more graphic and gory than any human chest-burster in the film (with the exception of the film's final scene). Exploding vermin haven't been this much fun since ROCK N ROLL HIGH SCHOOL (1979). Don't hate me but, man … this is just too silly and has to be seen to be appreciated.

During the finale, the one-eyed alien (referred to as…wait for it… "Cyclops") eats one of our hero's whole in disgusting, non-CGI latex glory. But thankfully, no fancy weapon was needed to rid the Earth of this impending takeover from outer space: Ian manages to take Stella out of the Cyclops' trance, and shoots its eye out with an average handgun. BOOM. Earth saved. That is, until the "shock ending" that caused boos and laughs from the crowd. I think someone even slapped that talkative guy on the way out.

ALIEN CONTAMINATION is a good bet for fans of "so-bad-it's-good" cinema and ALIEN rip off completists. There's actually one decent suspense sequence when Stella is locked in a bathroom with a glowing, throbbing egg. But like most films covered in this column, it was the audience that made it a memorable experience. The constant yelling for people to shut up and watch the film hindered my understanding of the plot, but thankfully there wasn't too much of a plot to miss.

I still skipped guacamole for a while after my initial viewing just to be safe.

MONDO MAYHEM IN THE BIG APPLE

his week we once again go back to 1986. I was either just out of high school or about to be released when a Friday night trip to the Big City led my friends and I to 42nd Street. The infamous Manhattan block was still thriving at this time with almost a dozen theaters showing horror, kung fu and exploitation films and another bunch showing the latest porn releases. And of course there were several peep-show establishments whose doorways were blocked by prostitutes, drug pushers, bouncers trying to lure you in with flyers, and an endless array of cops who seemed to be sick and tired of dealing with the area.

I, however, couldn't have been happier, although on this particular evening I couldn't convince my friends to take a break in our peep-show bouncing to see a film whose poster outside the theater stopped me dead in my tracks. SAVAGE MAN, SAVAGE BEAST had opened on 42nd Street in 1981, and I later found out it played on and off all throughout the 80s. But this was the first time I'd heard of it, and I stared up at the marquee of the Lyric Theater drooling over the title as well as its co-feature, SHOCKING CANNIBALS (which I'll touch on in a bit). I'd give anything to have had a cell phone back then as the marquee and entranceway was gloriously decorated with lobby cards and posters.

I woke up early on Saturday morning and began my trek back to the city for a solo viewing. I figured how bad could 42nd Street be for an afternoon show? It turned out, not that bad at all, although there were still a few choice characters at the infamous Liberty Theater for the 12:30-ish screening.

I had already seen FACES OF DEATH on VHS, and figured SAVAGE MAN, SAVAGE BEAST, playing in Times Square, had to be even crazier. But when the film opened with footage of a hunter tracking a stag and narrating why he hunts, I had my doubts. When the title credits finished, we see the stag blown away in an almost artistic slow motion, then get decapitated as the hunter asks the audience why should we feel sad that it's dead? Ummm … okay. Then the film switches to footage of hippies sitting around playing guitar and singing at a Woodstock-type festival in France. Then it switches to footage of monkeys climbing trees to avoid

a cheetah (or a tiger, I can't recall) and a baby monkey getting strangled to death by an anaconda. A National Geographic special this was not! Yet I watched on in morbid fascination as the off-screen narrator went on to explain why natives hunt and do what they do, and one sequence features the discovery of a few dead human bodies that were partially eaten in some kind of cannibalistic tribe rite.

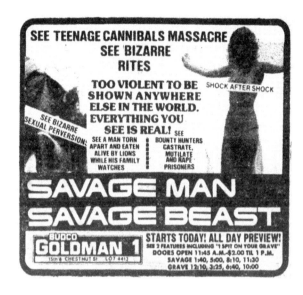

There's a bit too much time spent on some sophisticated hunting association who use dogs to locate stags, and a Peruvian "hunting cult" who engage in satanic-sounding chants before they go seeking innocent animals so they can mount their heads in their clubhouse.

About halfway through SAVAGE MAN, SAVAGE BEAST, I grew tired. Despite FACES OF DEATH being mostly staged, it was far more entertaining (and exploitive) than this "mondo" documentary that I later found out was released in Europe in 1975. This feature grows tedious and I only made it to the end with the hope that the second feature, SHOCKING CANNIBALS, would be better. It wasn't.

My favorite sequence had me and the 9 or 10 other patrons in hysterics: a family on vacation (I believe in Africa) watches on in horror as the father is eaten by a few lions after he gets too close to them with his movie camera. If the scene was staged, from what I can recall, they did a pretty good job until they showed the man's infant son crying through the back seat window, and showing one of the lions trot off with the poor bastard's camera in its mouth. Then they went on to show the footage taken from the recovered camera after a local game warden kills the lion. Thinking back it's almost like a Saturday Night Live skit!

After what seemed like forever, we go back to that hippie festival where the narrator starts speaking some mumbo jumbo about anthropology (there's some full frontal nude shots of the pot smokers getting dressed and ready for something). The film attempts to associate ancient tribes with modern people, and supposedly hippie communes date back to African tribe-living arrangements. But a guy a few rows behind me kept yelling for the people on the screen to

"Gimme some 'o dat shit!" as hippie pot smoking is featured in close-ups that had me thinking the two directors of this madness must've dealt it on the side.

The hippie commune insanity continues as we see hippies bathing, cooking, dressing, walking around with spears, eating meat naked, and doing anything the filmmakers could find to make them look like an ancient tribe. It's quite hilarious. almost as funny as a tribal hunting rite (shown in slow motion) of male tribe members jumping around with their junk flopping wild, before they engage in ritual masturbation in hopes of a bountiful hunt.

Most of SAVAGE MAN, SAVAGE BEAST's "mondoness" takes place during the first half. The second half is basically a slightly more violent National Geographic program, teaching us about salmon migration and how scientists track penguins, and plenty of scenes of animals fighting each other. PETA members or those who can't take nature footage will definitely want to avoid this, and lucky for them this film is a bit difficult to find (although it does occasionally pop up on YouTube). In one scene even I found hard to watch, hunters (with several hunting dogs) try to capture a puma when one of the dogs is gutted. A hunter tries to stitch the poor pooch back up with a crude needle and thread, and we're never told if the pup makes it. Either way, I love dogs and could've done without this and another segment about dog catchers working in some poverty-stricken area.

If you're a fan of mondo films you'll want to see this, but others will most likely lose interest early on. I only made it about 20 minutes into the second feature, SHOCKING CANNIBALS, when I just couldn't take it any longer, not because of anything too graphic, but due to boredom. The film is supposedly an attempt to show how magic is still practiced among African tribes (hence it's future VHS title of MONDO MAGIC), but what I saw was 20 minutes of natives sitting around naked talking in their native language doing their native daily routines. There's only so much of this one can take, and it isn't entertaining in the slightest bit. Like SAVAGE MAN, SAVAGE BEAST, I later found out this, too, was made in 1975 and released in America two years later. I'm guessing the Lyric (and other grindhouses) ran this one whenever they needed a second feature. Lucky me!

When I left the theater, I was offered weed and coke about three times before I reached the subway, and began to wonder if the directors of SAVAGE MAN, SAVAGE BEAST weren't actually right about a few things.

Just thinking of these two films is making me want to take a shower and then go hug my dogs...

WHEN JASON WAS SCARY

ay 1981: 7th grade was coming to a close, and us young horror fans were in for a 1-2 punch of treats. First up was the release of FRIDAY THE 13TH PART 2 (that I managed to get into with my friends and younger brother thanks to an unconcerned theater manager and my premature moustache). And two weeks after this, the original 1974 TEXAS CHAIN SAW MASSACRE was re-released (but that's a story for another column). After months of looking at pictures in Fangoria magazine, we were beyond excited about FRIDAY THE 13TH PART 2, and, confession time for me … I still hadn't seen the original. That was taken care of shortly after this screening when I caught it on WHT at a friend's house a few weeks later (does anyone remember that early cable TV service? They actually showed a lot of good horror films).

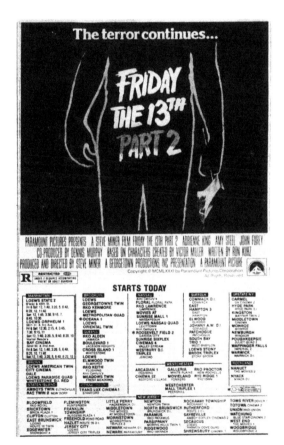

The (now defunct) Amboy Twin Cinema admitted my usual crew and I, but this time my brother tagged along, a decision I would live to regret. It was a nice, sunny Saturday afternoon, and once the lights dimmed the crowded theater fell into a serious silence that lasted until the final reel unspooled. For those who might not know or who weren't around at the time, the first couple of FRIDAY THE 13TH films were serious business: Part 2 in particular is a genuinely horrifying film, especially when you're 13 years old watching it in

a dark theater. To my surprise, I recently caught a late night screening on cable and found the film held up quite well.

For those who don't know, Part 2 is the first time Jason Voorhees went on a killing rampage to avenge his mother's death (at the end of Part 1), and as far as I'm concerned, it's still the best of the series, and certainly the scariest. Before Jason became a hockey-masked and predictable genre icon, here he caused real goose bumps in a simple mask made of a pillow case (or potato sack depending on who you believe). Horror fans were treated to inventive kill scenes, suspense and terror that had the Amboy Twin's audience screaming out loud, especially during the finale when Jason crashes through a window as he attacks our heroine. That sequence scared my brother so bad he almost jumped in my lap.

And that, my friends, is what a horror film is supposed to do.

The opening finds Alice (Adrienne King), who decapitated Mrs. Voorhees at the end of Part 1, living in an apartment in a sleazy-looking part of the city. For those who hadn't seen the first film, there is a flashback, and for that I was appreciative. Someone is stalking Alice. Within minutes the stalker ends her life by sticking an ice pick through her temple … but not before she opens the fridge and sees the

rotted head of Mrs. Voorhees she had cut off. It's a brutal sequence that had us young teenagers on the edge of our seats. Any film that opens this way simply isn't playing games. This was a prime example of an early 80s slasher film that had balls.

The rest takes place at a camp next to Camp Crystal Lake, the site of the massacre in Part 1. A new crop of counselors is getting the place ready for a new group of kids, but standing in the way is a mysterious assailant who offs them in a variety of gruesome ways. The FRIDAY THE 13TH films were never big on plot, but seeing this at age 13 it didn't matter. We were there for the gore that had made the original an instant legend in the horror film community. And gore we got, courtesy of FX artist Carl Fullerton (he did several other horror films, then bigger things such as THE SILENCE OF THE LAMBS [1991], GOODFELLAS [1990] and 2001's TRAINING DAY). Our young eyes were treated to such wonderful sights as a deputy being slammed in the back of the head with a claw hammer, a machete throat slashing, a wheelchair-bound victim hit in the face with another machete, a couple speared at the same time as they do the horizontal mambo, and another poor sap strangled to death with barbed wire. This Jason guy was PISSED.

Yeah, FRIDAY THE 13TH PART 2 was everything a horror fan wanted in 1981 (not to mention a full frontal nude shot of actress Kirsten Baker, who had a short but respectful run in several exploitation films in the late 70s/early 80s).

The FRIDAY THE 13TH series declined after Part 4, then eventually became absurd. I understand the series has ardent fans, but the idea of Jason in space and Jason being resurrected by a psychic teenager was just plain silly to me. Personally I think Part 4: THE FINAL CHAPTER should've been Part 3, and it should've ended as a great trilogy. But money talks, so it went on for way too long. Either way, none of the films featured the scares, suspense, and just plain great time as Part 2. The screaming crowd (who continually yelled at the victims to "LOOK OUT!") were all the proof I needed, especially during the aforementioned 'Jason Crashes Through the Window' scene that, I believe, was done 10 times scarier than his classic 'Jump Out of the Lake' scene at the ending of Part 1.

Oh ... about my brother. He begged my parents to let him sleep with them for a couple of nights, which caused my old man to give me the "You bastard, I told you this would happen if you took him to that friggin' movie!" look for a few days.

But they both got over it.

Chh-chh-chh ... haa-haa-haa ...

Suburban Grindhouse Memories No 70

CANADIAN PINBALL... AND BIKINIS!

arch 1981. When you're a 13-year-old guy and you see an ad in your local paper featuring sexy, scantily clad babes, there's no question what film you're going to go see that weekend. And thanks to the fine, merciful staff at the (now defunct) Amboy Twin Cinema, me and another underage friend were admitted to a Saturday afternoon screening of what looked to be a funny (and sexy) teen comedy. For the sake of any youngin's reading this, before the Internet, most films like PICK UP SUMMER were only advertised the Friday of the weekend they were released in newspapers, so for film freaks like myself, getting the papers every Friday morning was a religious responsibility as many of the classics I cover for this column didn't have TV or radio ads.

But moving along ...

Greg and Steve are two buddies on their way to a local arcade. Excited it's the last day of high school, they fling their books out the window. I always got a kick out of scenes like this. I recall having to hand my textbooks in on the last day of school or you wouldn't get promoted, but perhaps things are less strict in Canada (where this film was shot) than they are in New York City. Our buddies are cruising along in their custom van when they see Donna and Suzy in a convertible sedan, who they whip around to follow. During this opening credit sequence, we also meet Bert, the head of the most least threatening-looking biker gang of all time (well, at least until a year later when 1990: THE BRONX WARRIORS was released). He wears oversized, square headphones and big eye goggles that make him look like an alien from a 50s sci-fi movie. He also kind of looks like David Hess from LAST HOUSE ON THE LEFT (1972)

The craziness of PICK UP SUMMER begins almost immediately, as we're taken to Pete's Arcade where a line of sexy cheerleaders are out front cheering for some reason. An old man in a trench coat comes by and flashes them, wearing full Frank 'N Furter-style garters. If you're a 13-year-old 8th grader, you're already thinking this is the greatest film of all time. Two older people (who, now that I think about it, were probably only in their 30s) got up and left as one said, "Oh please. What

Suburban 210 Grindhouse

is this crap?" What they were expecting from a film called PICK UP SUMMER is anyone's guess, but they didn't give it a chance.

The rest of the film is basically Greg and Steve making out and feeling up Donna and Suzy, at least when they're not drooling over the gorgeous waitress Sally, who also happens to be biker Bert's girlfriend. In one unforgettable sequence, Whimpy (a fat nerdy kid who works at the arcade) plays a game of strip pinball with Sally at a pool party. Of course the bikers (and the fire department) show up and put a damper on things, but it's the best teen comedy "sporting" scene since the topless football game in 1979's H.O.T.S.

This whole goofy mess leads up to a pinball competition at Pete's Arcade, which ends in a chase scene with the lovely Sally riding on top of a pinball machine in a pickup truck's flatbed. For the life of me I can't

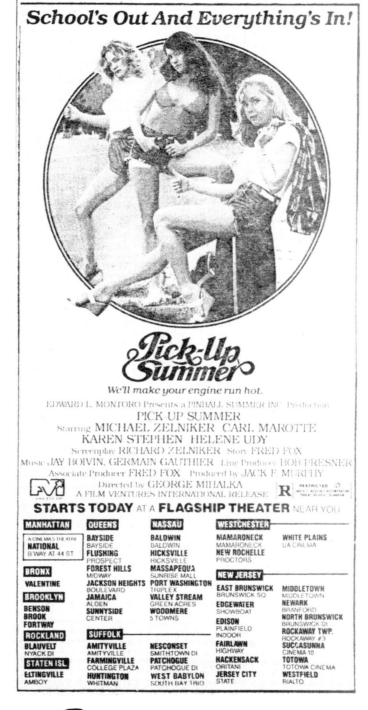

remember exactly why, but when there's a bikini-clad bombshell riding a mobile pinball machine, do the circumstances that led up to that point really matter?

I can also barely remember:

- Some politician's wife trying to close the arcade full of juvenile delinquents.
- A nerdy rich guy with a slick car being tormented by the whole cast.
- Food being shoved into a muffler's tail pipe at the drive-in.
- Lots of shots of short, short, short dungaree jeans and endless scenes of topless ladies.
- The biker's hang out looking like a tiny shack, but when Greg and Steve knock it down, the interior looks like its two floors!
- Two bumbling cops, one senior and one younger, who disappear halfway through the film.
- Bikini chicken fights in the lake.
- Bikini pool party dancing.
- Nerds on mini bikes.
- Disco dancing at a night club called "Oz," further proving this film really was shot in either 1979 or 1980 despite its 1981 release date. Chances are it was shot even earlier.
- Pot smoking bikers and politicians.

Unlike horror films, I have a hard time remembering these teen sex comedies, hence the reason I am going to revisit PICK UP SUMMER on YouTube and make my final comments.

(A few days after my 34-year revisitation ...)

Yep. PICK UP SUMMER, despite its R-rating (which includes even more nudity and pot smoking than I remembered) was either aimed at 13 year olds or nerdy older guys who couldn't get dates. Perhaps both? Either way, the film isn't very funny today, a giggle here or there, but mainly goofy, dumb fun that's good enough for some brain-dead late night viewing. A FF button is definitely required.

As for Sally (the lovely actress Joy Boushel in her first screen role)? She still looks incredible in her leopard bikini, and the pinball machines actually made me long for the days of old school arcades. Other than that, PICK UP SUMMER is for teen comedy completists only, and those who are really, really into pinball (the film is also known as, and has been released as PINBALL SUMMER).

Suburban Grindhouse Memories No 71

THE CANNIBAL DAD GHOST STORY SLASHER

In 1982 an ad appeared in the Friday weekend sections of all major NY newspapers featuring spooky eyes looking down at a forest with the tag line "Daddy's Gone A Hunting!" My 8th grade companions and myself were hoping for a wicked good time as we hit the (now defunct) Fox Twin Cinema for an early Saturday screening of TERROR IN THE FOREST. Unfortunately, they wouldn't admit us, so we asked a gent to buy our tickets, and he gladly agreed, although we had to go to a later screening that began around 3:00 p.m. Not. A. problem.

TERROR IN THE FOREST turned out to be an awful film, highlighted by an audience who clearly wanted their money back, yet for some reason stuck around until the final asinine minute. Perhaps it was the film's mix of slasher and supernatural elements, or perhaps, despite the nearly constant booing and laughing at the screen, people were more entertained than they cared to admit. Either way, I laughed my butt off for 90 minutes and had much more fun than I did watching the similar DON'T GO IN THE WOODS a year earlier.

After a couple is killed during a tedious opening hiking sequence, we meet two middle-aged buddies stuck in an L.A. traffic jam. It seems Steve and Charlie are stressed out and need to get away for a while, so one of them suggests a

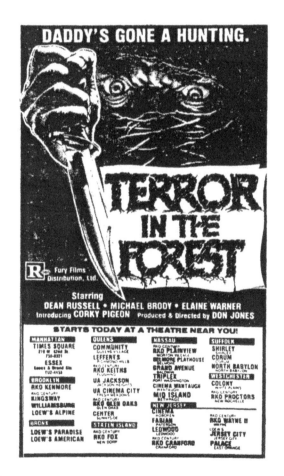

213

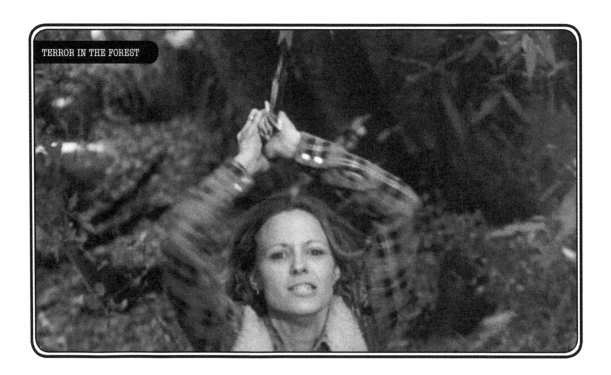

camping trip. Over dinner that night, they seek their wives' permission, only to discover they want to go camping on their own, too. And when the guys laugh at them, the girls make it a point to go ahead without them. But as I recall, the men go up separately, following their wives in a pickup truck that starts to overheat.

As the woman arrive at the campsite's parking area, Steve and Charlie pull into a gas station and end up waiting four hours for their radiator to get fixed at the hands of some goofy mechanic. I always find it funny that mechanics are usually portrayed as jackasses on screen. *Have you ever tried to fix a transmission?* Then again, by the looks of this guy, I was surprised the truck didn't break down again once our pals were back on the road.

Even though there are no other cars or signs of campers, the wives (Sharon and Teddi) head out to seek the campsite Steve and Sharon had gone to when they were younger. We're treated to more tedious scenes of the California forest before they finally decide to set up camp near a small rock formation.

The guys eventually arrive and spot their wives' car. They head out to find them when a park ranger cruises by and warns them to be careful, that people have been missing in these here parts. If there's one slasher film cliché that

angered slasher film audiences—*even in 1982*—it was the ranger/police warning scene. Laughs filled the Fox Twin as our buddies headed into the woods. More boos came when *yet another* tedious hiking sequence commenced.

I'm not sure if it was at this point, but I recall the crowd going nuts when a very silly and corny song filled the soundtrack. In fact there were a few, but the one about being aware of the darkness (or some such) had us all in stitches.

Then TERROR IN THE FOREST becomes a bit stranger than your usual slasher fare. As our women sit near their campfire awaiting the men, a couple of children show up and speak in echo-filled voices. Are they ghosts? Considering they vanish after warning the ladies that "Daddy's gone a hunting!", we didn't know what to make of this startling new revelation. A few seconds later, a woman with a gash on her forehead appears, asking the women if they've seen her children. Is she another ghost or just an injured hiker? Either way, I recall Sharon and Teddi not being too scared by the unusual occurrence.

Then we see the ghostly kids appearing in a cave, speaking with some old guy who looks an awful lot like director George Lucas. The kids mention the camping women to him, so he grabs a knife and heads out to find them. Despite being a couple of supernatural rats, the kids beat the old man to the camping women and warn them again that "Daddy's gone a-hunting!" The women have split up, and the old man stabs one of them several times before killing her. The other woman (I believe Sharon, but who knows) watches her friend die then takes off into the forest and escapes the old man by jumping into a wild river. Well, at least the wildest river the filmmakers could find close enough to their filming location.

Steve and Charlie are still trying to locate their wives' campsite as it starts to rain. The find refuge in a cave, inhabited by an old man who sits on a wicker chair and is roasting 'meat'. He offers our buddies food, but only Charlie accepts, taking a small bite (I believe the old man said the spit-roasted meat was dog).

A lengthy flashback shows us why the old man has become a cannibalistic hermit: he caught his wife cheating on him with a refrigerator repair main (the audience lost all control laughing at this), and ends up killing her by smashing her head on an end table in a very unconvincing manner. He then kills the repair man by pushing his chest onto a large circular saw blade in a PG-level kill scene (how this film received an R-rating is anyone's guess, as there is little gore, no nudity, and from what I recall no swearing). The old man buries his wife and her boy toy, then heads off into the forest with his two young children in tow.

You'd think Steve and Charlie would be freaked out by this tale. Well, Charlie is a tad concerned, but they both end up spending the night in the old man's cave. For some reason the old man doesn't harm them and they head out the next morning to find their wives. I'm pretty sure at least one person left the theater at this point, but there was still a nice sized crowd for a Saturday afternoon.

Charlie and Steve finally locate the campsite, but neither of their wives are around. They split up to find them, then meet back ·up (I *did* mention this film gets tedious), then split up yet again as Charlie offers to try to make it back to the mainland for police help. But he hurts his leg. As he tries to get around in agony, the ghost kids reveal themselves to Steve's wife, and she learns they committed suicide after their mother's beatings and realizing their dad had gone berserk.

In the nearly suspense free finale, the old man drowns Steve in the river, then begins to skin him as George's wife looks on. She is spotted but the ghost kids stop their psycho dad from killing her. He flees, and soon discovers Steve with a broken leg. He attempts to kill him with a big stick after his knife is knocked away, only to be stabbed to death by George's wife in a truly non-climatic conclusion.

This whole mess ends with the ghost mom searching for her dead kids and (now) dead husband as one of the *worst original songs* in the history of cinema plays over the closing credits. An interesting blend of laughs and boos rung out from the Fox Twin's audience, and I sat back scratching my head, wondering if I had just cruised the very bottom of the horror film barrel. Looking back, it might not have been the bottom, but it was awfully close. During the end credits, the song titles drew even more laughs from the crowd. Wow. This one was rich!

TERROR IN THE FOREST, notwithstanding a "slasher" who is about as threatening as a retired gas station attendant, should get some kind of credit for at least trying to be a little different with its ghost family side-plot. Star Gary Kent, who plays our old man bad guy John, has an impressive exploitation film credit sheet, but few of his films are as downright insane as this slab of 80s slasher goofiness. For those who simply must see every slasher film in existence, this was released as THE FOREST on DVD by the lunatics at CodeRed in 2006, and it also appears on a different double feature DVD with the aforementioned DON'T GO IN THE WOODS. I still have no plans to revisit it.

Again, I have no idea how an R-rating was given to this harmless flick, as I've seen PG-rated films that are far more graphic.

They truly don't bang 'em out like this anymore. Count your blessings.

It has been almost four years since I first reviewed a women-in-prison film (that'd be 1983's CHAINED HEAT for my 46th column), so what better time than now to look back at what was (I believe) the very first WIP film to play theatrically in the United States in the 1980s: 1982's THE CONCRETE JUNGLE, which was directed by Tom De Simone who I had quickly become a fan of just a year earlier after seeing his sleeper horror hit HELL NIGHT. It wasn't until a few years ago that I looked De Simone up online and discovered he had an impressive exploitation film career under his belt, including a 1973 X-rated WIP film titled PRISON GIRLS as well as a gay vampire film released the same year titled SONS OF SATAN. But let's get back to the 80s...

In September of 1982, I was getting ready for my first year of high school when an ad for THE CONCRETE JUNGLE caught my attention in the local paper. I had never seen a WIP film before, but of course had read about them, so naturally I was more excited for this than my forthcoming freshman year. I grabbed a buddy and we hit the (now defunct) Amboy Twin Cinema for a Saturday afternoon screening where there were only a handful of people in attendance.

The film opens at a ski resort somewhere outside of the USA. Elizabeth (played by the 'purdy Tracey Bregman of HAPPY BIRTHDAY TO ME (1981) fame) is leaving to go home

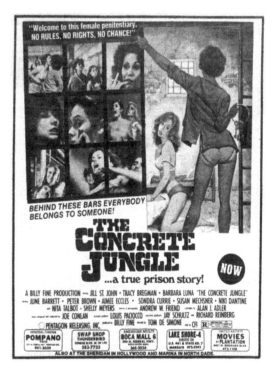

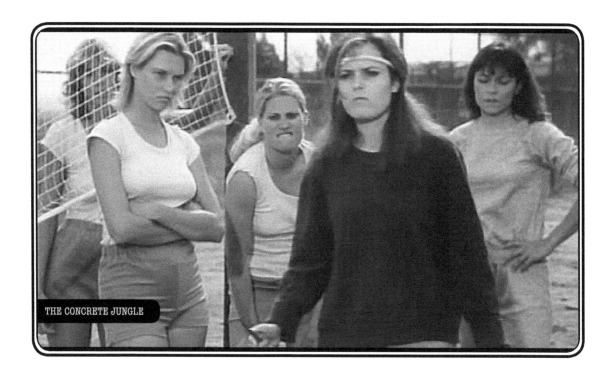

THE CONCRETE JUNGLE

from a weekend with her boyfriend, but unknown to her the sleazebag has hidden a bunch of cocaine in her skis in very thin clear packets. When she lands in California, the authorities seize her and claim their security dogs sniffed out the narcotic. Helpless and furious, Elizabeth is sent to a female correctional facility where all the tropes of WIP films run rampant: there's the crooked warden, played by Jill St. John (yes, the hot Bond babe from 1971's DIAMONDS ARE FOREVER as well as a bazillion other films, although she wasn't a very good choice here), her right-hand (wo)man, Cat (played by popular TV actress Barbara Luna), plus your standard black girls who take no crap from anyone (but this time it's mentioned that they're drug-free Muslims for some reason), a rapist male prison guard, and his first victim played by none other than Camille Keaton of I SPIT ON YOUR GRAVE (1978) infamy (I'm guessing she was the perfect choice for this brief, throwaway role)?

Cat tries to bribe Elizabeth to work for her, but after watching Cat murder the one woman who friended her (she's killed by a hypodermic needle full of air!), Elizabeth decides she needs to go rogue, which costs her time in the hole (*every* WIP film has a hole, or place of solitary confinement) and things become more

difficult between her and the warden.

An interesting note here is co-star June Barrett, who plays Cat's hench(wo)man, Icy. She had starred in the terrible 1978 TV movie DR. STRANGE (which I still liked because I was only 10 when it aired and I was a major Dr. Strange fan), and I was thrilled to see her on the big screen despite her looking like a complete junky. Icy was the last character she played on film and there's little on the Internet of her whereabouts. Anyone out there in grindhouse land know?

There's a brief scene of lesbian sex (not graphic), a couple of decent cat fights, and a final brawl between Elizabeth and Cat that causes a riot that's attempted to be put under control by hoses, which of course leads to mud and wet t-shirts. THE CONCRETE JUNGLE, despite not being too violent and containing very little nudity, is perhaps the best overall WIP film in terms of story and acting. Sure, this had been done countless times in the 70s, but there's very little camp here as the film plays out more like a serious hard drama with its exploitation elements latently brought in and used as tastefully as possible. That's not to say this isn't an exploitation film, because it is. But for whatever reason, in De Simone's hands, it's a bit of a classier one.

A case worker who is attempting to expose the abuse in the prison eventually gets to Elizabeth, and the warden is taken down shortly after the brawl/riot sequence where Cat meets a shocking end, and Elizabeth is finally set free. I'm guessing the audience was taken in by the story, as there was very little noise in the theater for this type of film (which wasn't the case with most other WIP films I was fortunate enough to see theatrically).

After writing this review, I revisited the film for the first time since my theatrical viewing and was surprised it actually held up so well. While director De Simone would find a bigger hit in his 1986 film REFORM SCHOOL GIRLS (which was basically a silly, intentionally campy remake of THE CONCRETE JUNGLE, notable for its star, former Plasmatics vocalist Wendy O. Williams and a very goofy warden), this earlier effort is easily the superior of his WIP films (although I have yet to see the aforementioned PRISON GIRLS, which I recently learned was a 3D porno film, so I'm not holding my breath).

If you're looking for a sleazy WIP film, you might be disappointed with this. But story wise, it's one of the best and well made of the entire subgenre, and was a great way for two 14-year-old boys to spend their last weekend before high school.

Suburban Grindhouse Memories No 73

AN UNCOMFORTABLE SILENCE

In the mid-late 1980s, there was a network of underground horror film fanzines (one which I published titled STINK) and a bunch of us were avid VHS tape traders. I managed to see a lot of unreleased films this way back then, and one of the hottest titles on the snail mail trading circuit was HENRY: PORTRAIT OF A SERIAL KILLER (1986). The film played festivals from 1986-1990 when it was finally given a limited theatrical release, which thankfully came to my area. But by 1988-ish I had managed to get my hands on this film that people who were lucky enough to see had been raving over.

Shortly before I landed this prized videotape, I went to see a Texas thrash metal band named RIGOR MORTIS, and two of their members told me about it at the bar. They actually had a copy on their tour bus, and I did all in my power not to raid their wheels while they were on stage. In retrospect I'm glad I kept my cool and avoided jail time…

When I found out the film was scheduled to play in Manhattan at the Angelika Film Center in September of 1990, I knew I'd be there despite having seen it a few times on my decent VHS copy.

And I'm glad I did.

My buddy Billy drove us into Manhattan for a 10PM screening at the Angelika Film Center (which was only open for about a year at this time, and featured mainly foreign and independent films). The place was about three-quarters full, and I'll assume from the reactions heard during and especially at the ending it was the first viewing for most in attendance.

For those who have been on Mars these past 30 years, this was the film debut of Michael Rooker, who would go on to star in films with such hot shots as Tom Cruise, Gene Hackman, Al Pacino, and become a beloved cast member on TV's THE WALKING DEAD series. But in HENRY, he was mainly unknown and his presence in the film is nothing short of terrifying.

Henry is a serial killer who moves from city to city to avoid getting caught.

He moves to Chicago and poses as an exterminator to gain entrance into unsuspecting women's homes. He moves in with his old friend and jail buddy Otis, as well as Becky, Otis' sister who has recently fled from a bad marriage. Henry spends his days killing and his nights sitting around Otis' apartment playing cards and watching television, until one night when Otis goes out with Henry and they pick up two hookers. Henry kills them with his bare hands in Otis' car, and while Otis freaks out, he eventually is brought into Henry's mind set of "It's us vs. them," and together they become a killing duo.

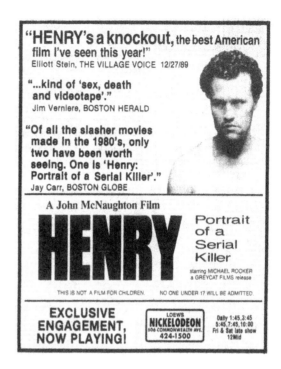

The film gets progressively darker as it unreels, and one sequence where Henry and Otis break into a house and murder a family stands as one of the more disturbing moments in horror film history. To make matters worse, they film their act and go back home to watch it for hours on repeat. (I got to meet actor Tom "Otis" Towles at a horror convention in NJ a few years ago, and he told me the woman who gets killed in this "home invasion" scene actually needed three months of therapy afterwards. That's intense).

HENRY is a violent film, although much of the carnage is implied. We do see the aftermath of some murders, while hearing what happened during the attack, which allows our minds to picture things scarier than the director could have captured in image form. On this level, HENRY works as one of the most intense psychological horror films I've ever seen.

The audience at the Angelika Film Center (this was my first and only visit) watched on in fascination, although there was one laugh during a conversation between Henry and Otis' sister Becky, which is fine, because it's one of a couple of "breaks" you get in this film (although some would argue the murder of a used appliance salesman was humorous: I guess it depends on how dark your humor level is).

What made this particular screening memorable for me was the audience's reaction when the film ended. After killing Otis (who despite being Henry's friend was continually abusing his sister, who we think Henry had taken a liking to after she expresses her love for him), Henry and Becky head off to California and spend a night in a secluded motel during their trip. They go to sleep, and in the film's final sequence, we see Henry leave the motel with a suitcase, which he leaves on the side of the road when he pulls over, then heads back out on his own.

Wow.

The power of suggestion in this film is just incredible. I looked around as the credits rolled and smiled as everyone understood what had just gone down. The Angelika was in silence, even as the lights came up and people started heading out of their seats. I'm talking complete, contemplative, disturbed silence. It was then that I realized my friend and I were possibly the only two there who had seen the film before. There was a sense that everyone had just been mentally blindsided, and for that, director John McNaughton gets my highest compliments, as does the amazing performance of Michael Rooker.

I hadn't seen the film in many years, but finally purchased a copy on Blu-ray in 2013. I've watched it two times since, and it truly stands the test of time. HENRY: PORTRAIT OF A SERIAL KILLER is quite possibly one of the all around best horror films of the 80s, although it's seldom seen that way (I believe) due to its late release date and seldom seen festival screenings.

Loosely based on real life serial killers Henry Lee Lucas and Ottis Toole, director McNaughton managed to create this gripping, unforgettable film on an extremely low budget ($110,000) and gave it a gritty, dark feel with the use of 16mm film. If the film ever plays on the big screen in your area, do whatever you must to be in attendance. You'll thank me for sure.

The Angelika Film Center may be known as an artsy-fartsy type theater, but for this limited engagement in 1990, HENRY turned the place into a true, terror-filled grindhouse.

UPDATE: I caught a screening in 2017 at the (now defunct) Landmark Sunshine Theater in Manhattan, and it holds up incredibly well.

WHO NEEDS AN EXORCIST?

May 1983: As my freshman year of high school was drawing to a close, it seemed there was a new horror film being released every week … and looking back over the past columns I've written for Cinema Knife Fight, I'm pretty sure that's an accurate statement. A typical Friday afternoon browse through my local newspaper revealed an ad for a film titled MAUSOLEUM ("Centuries of Evil Have Just Awakened") and yet another Friday night was now booked. How could any teenage guy resist a horror film ad with a skull on it? Impossible...

Unfortunately the film was playing at the (now defunct) Rae Twin Cinema, so we had to ask a few people before someone finally agreed to buy my friends and I tickets to get in. If memory serves right, an older teenaged couple grabbed them for us, if for no other reason than they were cool (so if you're reading this, THANKS!). Popcorn was purchased and we took our seats in one of the back rows: at the time the last 7 rows allowed smoking, and a friend of mine puffed away throughout the entire feature.

MAUSOLEUM started out well enough, with a young girl named Susan mourning the death of her mother at a cemetery. Her aunt is now her caretaker, but the young girl runs off and eventually stumbles upon a mausoleum. She enters (with her aunt nowhere in sight, so the kid was either a very fast runner or we were about to witness a blooper-filled flick. The later won). In the middle of the dark crypt, the girl spots a coffin that's covered with rats, but instead of shying away something draws her. It turns out some kind of demon is ready to be unleashed, and we eventually learn the girls in Susan's family have all been victim to this creature's horny brand of possession. Someone (Susan's uncle?) comes into the mausoleum to get her, but the man runs outside and some otherworldly force causes the top of his skull to blow off. A round of applause let the projectionist know everyone was happy ... for the time being, anyway.

Flash forward 20 years. Susan is now 30-years-old (and played by the voluptuous Bobbie Bresee, who 4 years later would go on to star in the direct-to-video snooze fest EVIL SPAWN). She's living in a gorgeous home with her husband Oliver (actor Marjoe Gortner, who when is first seen, drew screams from the crowd as he was recognized from 1976's giant rat epic THE FOOD OF THE GODS). In fact, I started everyone off by yelling out, "It's that guy from FOOD OF THE GODS!" to which someone toward the front of the theater yelled back, "Shut the f___ up." But it only took a little while longer before the Rae Twin became much noisier than this friendly little exchange.

Susan's husband spends a lot of time at work. One day she is hit on by their gardner, and while she rejects him at first, she eventually flashes him as he works in the yard. Naturally he comes into the house and they get down to business. But as the poor guy is about to go a second round, Susan's eyes glow green and she kills him with her now-demonic fingers and a small rake. From this point on, Susan starts acting weird and killing people with her satanic power. Kudos goes out to her housekeeper, an elderly black woman who, when she realizes her boss was acting strange, grabs her bags and high-tails it out of there! Was nice to see one smart person in this film.

Susan's shrink, Dr. Andrews, has been treating her since her traumatic experience as a kid. Why it has taken 20 years for her to show signs of possession is anyone's guess, and even after a revealing hypnotism session, the shrink has to be further convinced things aren't right with his patient by a colleague.

While shopping in a mall, the possessed Susan steals a painting the

MAUSOLEUM

gallery's owner said wasn't for sale. When he runs after her on an upper level of the store, she uses her green glowing eyes to levitate the poor sap and chuck him over the railing, where he falls about three stories to an impaled demise. The scene turned out to be an audience favorite as cheers and laughs filled the theater.

Susan eventually kills her husband as she turns into a goofy-looking demon (complete with boobs that house two biting demon heads!). But she seems to turn back to human form whenever her killing (or shagging) is finished.

Dr. Andrews, with the aid of a diary Susan's father kept, learns the only way to stop the demon is to place a crown of thorns on its head. The crown is located in the mausoleum Susan had visited as a child, and he has little problem getting it. In fact I believe he finds it right near the entrance!

In the showdown between Susan and her shrink (because I'll assume they couldn't afford an exorcist here after paying Bresee to do a few nude scenes), she begins to turn into the demon when Dr. Andrews tosses the crown of thorns on her head, causing the demon to transport back to the mausoleum and Susan to remain in her home with Andrews. Shouts of "What the frig?" could be

heard from everyone (and if I'm not mistaken, the theater's usher voiced his confusion, too). The demon returns to the rat-infested coffin, and Susan has been spared the same fate as her mother.

Then in an ending that makes as little sense as Fulci's THE GATES OF HELL (see my review here: http://balzertown.com/cinemaknifefight/2011/10/06/suburban-grindhouse-memories-lucio-fulcis-the-gates-of-hell/), we see Dr. Andrews place Susan in his car at the cemetery (why they are there and not at her home is yet another mystery of this film) and then he steps over to a nearby grave and says something I can't recall to a hooded man sitting atop a tombstone. When they drive away, the film ends with the hooded man looking into the camera and laughing hysterically. What makes this weirder is the hooded man is the gardner Susan had killed earlier in the film.

Huh? Say what?

While lacking in logic, coherence, and any sense of continuity, MAUSOLEUM still manages to be wickedly entertaining. It's a definite so-bad-it's-good party film, best viewed in a crowded theater or at least in a living room full of drinking friends. I remember being a big fan of special effects artists at the time of this screening, and was thrilled to see John Beuchler's name in the credits as the head FX man. But despite his growing reputation within the pages of Fangoria magazine at the time, the demon creature here looked plain awful, and caused laughs whenever it was seen on screen. While he is a fine FX artist (most notably in FROM BEYOND (1986) and BRIDE OF RE-ANIMATOR (1989), this surely wasn't his finest moment.

But the loud audience of the Rae Twin helped this crap-fest to be far more entertaining than it was during my recent DVD revisit, where I was reminded the aforementioned housekeeper had been played by none other than LaWanda Page, better known as Aunt Esther on TV's SANFORD AND SON! While it's still a fun way to blow 90 minutes, it's a forgettable film that's rarely mentioned even among the most hardcore of bad movie lovers.

For possession film completists and fans of Bobbie Bresee only. All others approach with at least two cases of your favorite brew...

RAPISTS (AND INNOCENTS) BEWARE!

eleased between 1980's THE EXTERMINATOR and 1982's DEATH WISH 2, Abel Ferrara's gritty rape/revenge thriller MS .45 was an instant hit with grindhouse audiences and we suburbanites who were too young to get to the city to see it. Thankfully some of us had the (now defunct) Amboy Twin Cinema to go to, and in the spring of 1981 my buddies and I (despite being in 7th grade) were gladly admitted to a Saturday afternoon screening.

The lovely Zoe Tamerlis stars as Thana, a deaf mute who works for a fashion designer in Manhattan. She has an eccentric male boss who flirts with her, and three co-workers who take her out for lunches. One day Thana is walking home from work and is pulled into an alley by a masked man. Her rapes her at gunpoint (in one of the quickest rape scenes ever filmed). As this is happening, another guy has broken into her small apartment and is looking for some cash. When Thana returns home bruised with torn clothes, she is raped for a second time by the intruder, but this time she manages to grab a paperweight and crack him in the head, then finishes the job off by slamming an iron into his skull. She drags the body into her bathtub and calls it a day.

This simple rape/revenge set up had the small crowd at the Amboy

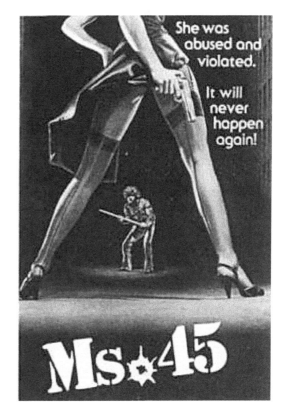

She was abused and violated.

It will never happen again!

MS•45

Suburban 227 Grindhouse

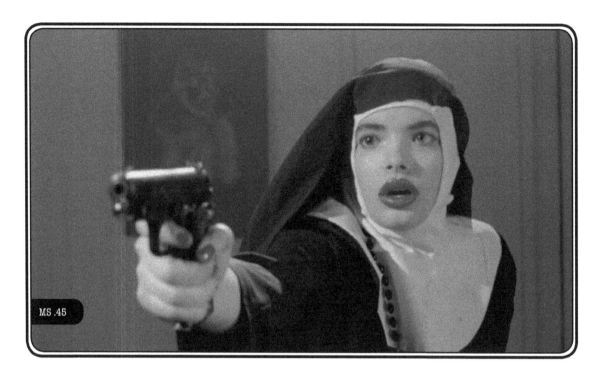

MS .45

Twin cheering Thana on. The film switches to the next day where we see her really lose her cool: Thana's boss gets pissed off that someone designed a shirt wrong, so he rips it off the mannequin. This act startles Thana and reminds her of her rape. She also watches someone change the trash can liner bag, which gives her the idea to go home and hack up the body she has in her tub.

Although not graphic, the sequence of Thana sawing her attacker to pieces with a long serrated kitchen knife is quite grim and as disturbing as anything in more "extreme" films: the (mostly) underage crowd groaned and let their discomfort be known. Mission accomplished by the director!

In an unusual twist, Thana is now primed for a killing spree: she isn't bent on finding the first man who raped her (and if she is we're never told), but instead starts to bring her justice via a .45 that she has taken from her second rapist to pimps, lowlifes, and in the end, anyone who isn't female! She also spends her time when not at work ditching shopping bags around the city containing the body parts of her second rapist. One man sees her drop a bag near an abandoned lot, so he picks it up and tries to give it back to her only to get a bullet between his eyes. Thana has gone a bit nuts, and isn't exactly an "Angel

of Vengeance" (as the film was titled in other countries). In fact, radio reports heard in the background bring to mind the Son of Sam murders of 1977, and although we as an audience cheered Thana on, it's a bit disturbing that she has decided to kill innocent men even if some of them may seem a bit shady.

But such is early 80s exploitation cinema, and few people did it as well as Abel Ferrara (who also appears here as the first rapist in a clown mask).

Among the more memorable moments are Thana being picked up by a rich oil sheik, then shooting him in the crotch in the back of his limo (after he hands her a one hundred dollar bill) and also wasting his driver; 5 gang members circle Thana in a park only to be cut down like blades of grass; and the finale which takes place at a costume party, where Thana looks incredibly sexy as a nun with garter belts. She finally delivers some lead justice to her boss and almost every other guy in the room before a female co-worker stabs her in the back to end the madness. The look on Thana's face that a fellow female has killed her is genuinely heartbreaking.

My theatrical experience seeing MS .45 wasn't too eventful, other than the fact my friends and I were all 13 years old when we saw it, and were perhaps a bit disappointed there was barely any nudity. But the film easily earned its R-rating (I've read some reviews over the years claiming it was released rated X, but if so, it wasn't in the USA) and had its share of Bronson-esque handgun justice and offbeat characters, especially during the opening scenes where it seems every guy in New York City is a rapist!

I recently watched MS .45 for the first time since my initial 1981 screening on a very nice looking Blu-ray (from Drafthouse Films) and it holds up quite well. The late Zoe Tamerlis' performance is even better than I remembered, and the aforementioned body-sawing sequence has lost none of its gruesomeness. The film is also a lot more, shall we say, classy than I remembered (for an exploitation film, anyway), due in no small part to the director's skill.

For fans of the rape/revenge subgenre and those who miss the glory days of grindhouse cinema, you pretty much can't go wrong with this offering from Abel (DRILLER KILLER) Ferrara.

Suburban Grindhouse Memories No 76

SMOKING CAN SAVE YOUR LIFE...

ew men (and women) who grew up in the 1970s/early 80s could say they weren't fascinated with the beautiful Barbi Benton. She was the main reason to watch TV shows such as HEE HAW, THE SONNY AND CHER SHOW, THE LOVE BOAT, and FANTASY ISLAND, where she'd appear sporadically as various characters. She appeared on many other TV shows and dated Hugh Hefner for several years (which led to her appearance on the cover of PLAYBOY four times). She was one of the hottest babes of the 70s, so it was no small thing when I saw the ad for HOSPITAL MASSACRE one Friday in the spring of 1982 in my local paper. Hmmmm ... Barbi Benton in an R-rated horror film? SOLD!

The (now defunct) Fox Twin Cinema admitted my friends and I with no questions asked to a Friday night screening (who says having a mustache in the 8th grade wasn't a good thing?). The theater was about half full, but I recall a larger crowd showing up for the later screening.

HOSPITAL MASSACRE turned out to be a fun if generic slasher film, typical even for 1982. It starts with a young boy killing another classmate over a girl. Our little psycho freaks out after the young couple mock his valentine card. Our killer-in-the-making manages to hang the young boy from a coat rack. How he pulls this off is not shown and had the audience laughing as the film then flashes 16 (or 17?) years into the future.

The young girl from the opening scene is now an adult named Susan (Barbi Benton). She's divorced with one kid and her current fiancé drives her to a hospital to pick up the results of a recent check up. Susan is told to go to the 8th floor to get her results, but her doctor is missing and she is jerked around by the staff for what seems like hours.

Outside, her fiancé is waiting in the car until it gets dark. He is seen sleeping, which earned the film more laughs from the crowd. In fact I don't think he goes to see what's taking his future wife so long for a couple of hours, despite her telling him she'd only be 10 minutes!

As Susan tries to get help from other doctors, it seems one of the surgeons is killing off the hospital's staff. Although everyone in the Fox Twin knew who the killer was from the get-go, suspects abound, and at one point I was certain the entire hospital were in cahoots against Susan (I was wrong). Early 80s hospitals apparently had horrendous security, as our killer moves around with no problem.

For a slasher film there are some decent kill scenes, including death by surgical circular saw, a couple of nasty stabbings, a face shoved into a sink full of acid, and some mini-ax mayhem. But what kept this Barbi Benton fan glued to the screen was a tense medical exam sequence where Susan is asked to get undressed. My friends and I giggled like idiots (as did most of the theater) when she sits on the exam table and the doctor (who most people

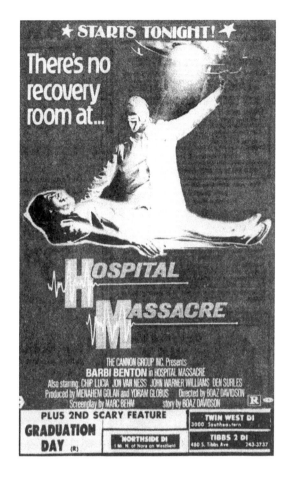

thought was the killer) removes her medical gown. Yep, there was one of my boyhood crushes naked save for her panties. Despite the nudity, it's a really creepy scene, partly due to the flaky doctor examining her and partly because I felt guilty for seeing this beautiful star of so many TV shows sink to such an exploitative level. Oh, who the hell am I kidding? I loved every second of it.

No one in the theater was surprised when the killer is revealed to be the young man from Susan's childhood, but the film does a decent job of making us think it was someone else. There are a lot of oddball characters (including a group of strange old ladies) and a room full of people in full body casts that was so comical it seemed way out of place. And after a way too long chase-around-the-hospital scene during the finale, Susan uses her cigarette lighter to set the killer on fire. While in flames he still comes after her but she ducks and he plunges

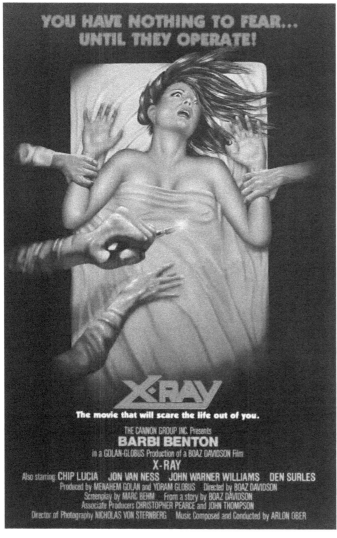

YOU HAVE NOTHING TO FEAR...
UNTIL THEY OPERATE!

X-RAY
The movie that will scare the life out of you.

THE CANNON GROUP INC. Presents
BARBI BENTON
in a GOLAN-GLOBUS Production of a BOAZ DAVIDSON Film
X-RAY
Also starring: CHIP LUCIA JON VAN NESS JOHN WARNER WILLIAMS DEN SURLES
Produced by MENAHEM GOLAN and YORAM GLOBUS Directed by BOAZ DAVIDSON
Screenplay by MARC BEHM From a story by BOAZ DAVIDSON
Associate Producers CHRISTOPHER PEARCE and JOHN THOMPSON
Director of Photography NICHOLAS VON STERNBERG Music Composed and Conducted by ARLON OBER

off the roof to his death. I guess the lesson here is smoking in hospitals should still be allowed? It paid off for Susan back in 1982, anyway!

HOSPITAL MASSACRE features a decent body count, a nude Barbi Benton, no surprises, a couple of grim kill scenes, and perhaps the most poorly lit hospital in cinematic history. Much of the film is quite dark, and I'm looking forward to revisiting this on the recently released Blu-ray edition (which is under its alternative title X-RAY). I'm interested to see if the restoration makes it any easier to see. I'd also like to know if the title would've been different had MY BLOOD VALENTINE not been used a year earlier, as the film revolves around a Valentine's Day theme.

For slasher film completists and Barbi Benton fans only.

MODERN MEMORIES: CHRISTMAS EVE AT THE LOONY BIN...

I first saw SILENT NIGHT, BLOODY NIGHT (1972) on TV when I was about 10 years old. NY/NJ's WOR TV usually aired it late on Saturday nights, but for some reason, this time it played on a Sunday afternoon. I did my best to see it every time it aired afterwards, and must've seen it a dozen times over the years until finally getting to see it on the big screen in December of 2014.

Since 2010, the Nitehawk Cinema in Williamsburg, Brooklyn has been screening some amazing film prints, and while I have seen quite a few gems there I couldn't believe my eyes when their website announced they'd be showing this beloved rarity from my childhood, two weeks before Christmas no less. I immediately ordered tickets (but wasn't too surprised to be one of only a dozen people in attendance for the midnight screening).

SILENT NIGHT, BLOODY NIGHT starts with an almost documentary type feel, as a narrator tells us about Wilfred Butler, a man who owned a mansion that had once been a lunatic asylum. We then see a flashback to 1950, where Wilfred comes running out of the house on fire then burns to death in the snow. As a kid this opening segment gave me the chills. It's done in such an eerie manner, especially when we learn his death took place on Christmas Eve.

Fast forward to today (which at the time would be 1972), and a lawyer (played by Patrick O'Neal, who bears an incredible resemblance to Richard Dawson, complete with turtle neck shirt) shows up in Butler's small town to meet with the local officials, who are looking to purchase the mansion. It turns out Wilfred's grandson Jeffrey has inherited the place and is looking to sell it for a mere $50,000.00, and that he'd like to sell it by the next morning upon his arrival.

Across town, someone escapes from the mental hospital by bashing staff members in the head with a pipe wrench and stealing a car. Was John Carpenter inspired by this scene for HALLOWEEN (1978)? Probably. And while we're on a side note here, although many cite 1974's BLACK CHRISTMAS as the prototype

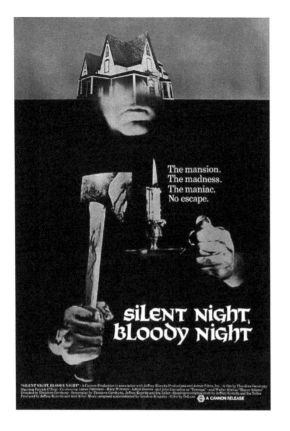

slasher film, I must disagree. SILENT NIGHT, BLOODY NIGHT was there two years earlier, and while it's not the better of the two films, it used many classic slasher film staples first.

The lawyer and his lady friend (the beautiful Astrid Heeren, who had a role in the original 1968 version of THE THOMAS CROWN AFFAIR), who we discover is his mistress, decide to spend the night at the Butler Mansion as they await their meeting with Jeffrey Butler. But as they have sex in the isolated house, a mysterious figure in a trench coat and black gloves who has been stalking them enters the bedroom and chops them up with an axe. Mercilessly.

Axe murders are nothing new to the horror genre, but this was one of the first ones I had seen in a film, and while not as graphic as what was to come in the genre, it's a grim and gory enough sequence that quieted the small but lively Nitehawk crowd. And when the killer places a crucifix in one of the victim's bloody, dead hands, the theater grew even quieter.

I sat there with a satisfied smirk on my face. I knew this scene was intense since I was a kid, and was thrilled to see an audience finally confirm it. I wasn't surprised, however, with how some in attendance reacted to the rest of the film, but we'll get to that in a bit.

So there's a killer on the loose, preying on the town's officials (one who is played by the legendary John Carradine). Many film commentators consider this a pre-slasher film slasher film, and while I agree with that, SILENT NIGHT, BLOODY NIGHT is more than your standard slasher fare.

After the town's mayor receives a call to go check out the mansion, his daughter Diane (Mary Woronov) is visited by Jeffrey Butler (James Patterson in his final screen appearance after a lengthy run on several TV series). She had

seen him earlier in the day on the side of the road, but she admits she didn't stop to help because he scared her. But after she realizes that he's Wilfred's grandson, they decide to take a ride back to the local cemetery (where Jeffrey says he saw the sheriff's abandoned car) and discover Wilfred Butler's grave has been ruined. General weirdness ensues as Jeffrey and Diane investigate the strange goings-on in the town.

I have seen this film at least 13 times, and I must admit it's still a bit confusing. But suffice it to say, when Jeffrey finally gets inside Butler Mansion, he finds Wilfred's diary, and a lengthy flashback scene begins. The sepia-toned sequence, to me, is the highlight of the film (some reviews I've read claim it tedious, but I strongly disagree). We learn Jeffrey was the result of an incestuous relationship between Wilfred and his daughter (surprisingly, neither this revelation nor the aforementioned axe murder were edited from the TV version). We also discover Butler Mansion had been turned into an insane asylum by Wilfred himself, who locked away his own daughter. On Christmas Eve of 1935, Wilfred couldn't take the guilt any longer and released all the inmates, who wound up murdering his daughter and all the staff workers. Guess who was among those released? Yep, the town's officials who are now trying to purchase the mansion (although at this point in the film most if not all of them have been murdered by our mysterious killer).

This wonderfully creepy flashback features members of Andy Warhol's old posse as extras, including Candy Darling as an inmate and Ondine as the lead murdering psychopath. As a kid this sequence was quite grim to watch, and as an adult sitting among other adults, it still gave me a disoriented feel.

After a quick and fatal showdown between Jeffrey and the Mayor, it turns out Wilfred Butler had never died, and was killing the town officials as revenge for the murder of his daughter. Looks like he wasn't too crazy his house was finally being sold, and I'll assume he found out about it through the local newspaper (Yep, Wilfred is the escaped lunatic/killer).

Directed by Theodore Gershuny, who at the time was married to star Mary Woronov, SILENT NIGHT, BLOODY NIGHT, while a slow burn, delivers some great old school scares (check out the sequence where the killer terrifies a phone operator at Butler Mansion, in the dark, with a flashlight and a severed hand), a quick but shocking dose of violence, and a generally depressed yet gloomy feel that gives off some amazing atmosphere considering the low budget. Gershuny

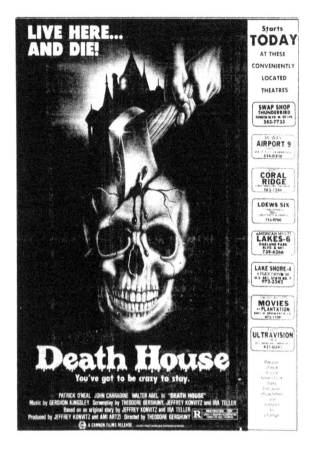

would direct the fantastic SUGAR COOKIES a year later, and both films show off the skills of this seldom talked about filmmaker, who sadly left the film world until the late 1980s when he directed several episodes of two TV horror anthology series, TALES FROM THE CRYPT and MONSTERS.

In true grindhouse fashion, my 2014 screening at the Nitehawk Cinema featured an incredibly scratchy 35mm print of the film, and although advertized in the theater and on the website as SILENT NIGHT, BLOODY NIGHT, the opening credits held one of its alternate drive-in titles, DEATH HOUSE. Confused whispering was heard around the theater, but it seemed everyone who hadn't seen the film before was with a fan, as further whispering silenced them. I overheard one woman say, "Man, that was really bad!" when the film ended, yet something kept her seated for the entire running time. The film is slow paced, yet even those who claim to dislike it can't say it isn't creepier than your average B-movie, and the performances are done quite well for a mostly unknown cast.

In 2014, a supposedly restored version from "35mm elements" was released to DVD, but reviews claim it doesn't look much better than version found on those "50 films for $9.99" sets. Hopefully someone will restore this to its g(l)ory and release it packed with extras. It truly deserves a wider audience.

You can keep your GREMLINS and DIE HARD. While they're great Christmas time films, for me, this obscure Long Island-lensed horror outing is my choice for the ultimate in Christmas Eve viewing.

MORE 80s HOSPITAL SLASHING

he television ads for 1982's VISITING HOURS promised the film was "So frightening you may never recover" and that it "Sets a new level of fright." In reality, it delivered a lower than mediocre snooze fest that even co-star William Shatner couldn't beam the audience out of. That's not to say this was a total turkey, but how it ever gained a reputation as an underrated slasher classic is anyone's guess. After I wrote the following column, I went back and revisited VISITING HOURS for the first time since it's opening night premiere 35 years ago. The verdict? My original opinion still stands.

My buds and I hit the (now defunct) Fox Twin Cinema just a month before our 8th grade graduation. Slasher films were being released nearly every weekend and we horror fans consumed them like we were at an all-you-can-eat pancake buffet. With the aforementioned TV ad promises fresh in our minds, we took our seats with high expectations.

(Note: my friends' names have been changed to protect the innocent)

About 5 minutes into the film, my buddy Mark found himself covered head to toe in a thick vanilla milkshake. We spotted his recently exed-girlfriend running up

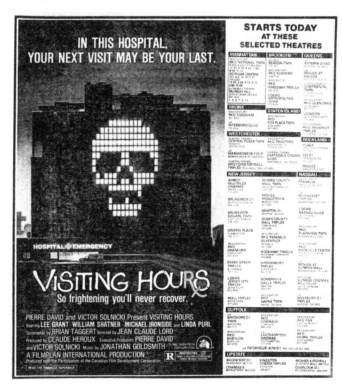

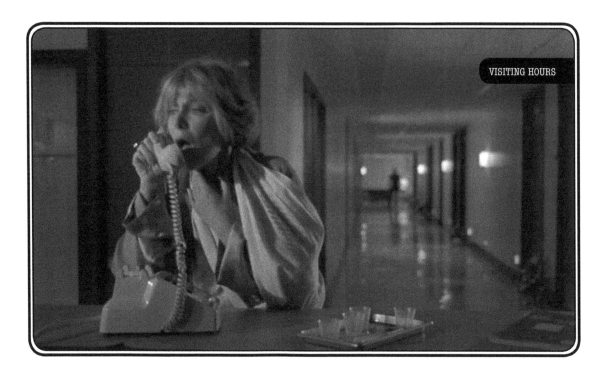

the aisle, and Mark and another in our 5 or 6 man crew took off after her. With some decent smelling sticky splash on my arm, I stayed put as a killer (played by Michael Ironside of 1981's SCANNERS) stalked a TV news personality (Lee Grant, former TV star who was later seen in AIRPORT '77, DAMIEN: OMEN 2 (1978) and even in David Lynch's 2001 classic MULHOLLAND DRIVE). It seems Colt Hawker (Ironside) simply hates women ever since his mother protected herself against his father's abuse by burning his face with boiling, extra virgin olive oil. And when he hears the famous Deborah Ballin (Grant) speaking out against domestic abuse on her nationally syndicated TV show, he decides to off her. But things don't go as planned and she ends up in the hospital where Colt spends the rest of the film's tedious running time trying to finish her off while sneaking around in various disguises (although he looks the same no matter what shirt or glasses he has on).

I'll give VISITING HOURS credit for focusing more on the killer and his childhood trauma back story (it seems his father may even have molested him as a child after his mom was gone) than on pot smoking, fornicating teen victims (which there are none of here). Ironside does a great job as the impotent killer

who likes to take photos of his victims as they die, then hang their pics on a wall in his apartment. When his crib is raided later on, the pics are discovered to be shaped like a skull. One sequence of Colt cutting an old woman's oxygen tube is quite cruel, as he sits there watching her suffocate. The audience was a bit uneasy over this, the only kill scene with any real emotion or fear behind it.

After Colt kills one of the nurses, my friend Mark returned from cleaning himself off in the men's room and several minutes of the film became a blur. But I knew Colt was also now after Deborah's main nurse Sheila (the lovely Linda Purl of TV's THE WALTONS and countless other television shows) and her two young children.

Despite being an early 80s slasher film, VISITING HOURS is very low on gore and contains no sex or nudity, which in itself made it stand out. But it's the tedious pace that had my friends and I (and much of the audience) groaning out loud. There are no surprises, and the fact we are told who the killer is from the get-go made this completely mystery and suspense free.

Again, after writing this column I was absolutely dumbfounded over the amount of 8-10 star reviews on IMDb, so I decided to revisit the film and found it didn't age very well at all. I'll admit one sequence where Deborah is wheeled in for surgery is a bit nerve wracking, but my 8th grade self had found it lame. William Shatner (as Deborah's boss and I THINK boyfriend, I'm still confused) is completely wasted here in a brief throwaway role anyone could've done. And I'm thinking said surgery sequence may have possibly inspired THE RAMONES' 1983 music video for their song 'Psychotherapy.' But we'll probably never know as the late Johnny Ramone was the big horror fan of the band.

VISITING HOURS is a film that tried, but in the end is a forgettable, tame, tedious slice of classic 80s false advertising. When your brightest memory of a film is your friend being embarrassed in the theater by his ex girlfriend's shake dumping skills, you know you're not dealing with Oscar worthy material.

Ironside has starred in almost 250 films (!!!), so of course they're not all going to be classics. But his role here is VISITING HOURS' one redeeming value.

For slasher film completists only.

A DOUBLE DOSE OF CHUCK

 bviously influenced by the then lucrative slasher film genre, action movie hot shot Chuck Norris (who had four successful martial arts oriented films prior) returned in SILENT RAGE (1982), where he plays a sheriff up against an axe-murdering lunatic who, after some experimental medical procedures, gains the ability to self-heal ALA Wolverine (and despite this being 18 years before the first X-MEN film, we comic geeks in the crowd let everyone around us know the similarities ... but more on that later).

The (now defunct) Amboy Twin Cinema featured SILENT RAGE on its opening weekend in a double feature with Norris' 1978 hit GOOD GUYS WEAR BLACK, which I was more excited to see as I wasn't able to attend any screenings during its initial release. And for the sake of this column, GGWB will be our focus here.

When GGWB hit American theaters in 1978, the TV commercials had this young film geek psyched. Scenes of Chuck Norris kicking some guy through the windshield of a car made me excited for a non-horror or sci-fi film for the first time I could remember. Unfortunately, I was at the end of the 4th grade and couldn't con anyone to take me to see it, including my dad who was a big action movie fan. I was puzzled (and annoyed) as the film was rated PG, but for whatever reason he just wasn't into it, nor were a couple of my older cousins. I chalked it up as a loss but continued to drool over the commercial, and newspaper ads that showed Chuck in mirrored sunglasses looking as cool as cool gets (the reflection in the glasses showed the aforementioned kick-through-the-windshield scene).

While I try my best to write this column from memory, I had to revisit GGWB as I had only seen it twice: at this double feature and again in the late 80s on cable TV. And after only two viewings I simply couldn't fully recall the convoluted plot, and still am not sure I do (!), but in a nutshell:

In 1973, a group of CIA assassins known as the Black Tigers were sent into Vietnam to retrieve a bunch of POW's. Headed by John T. Booker (Norris), half the group is killed. It turns out they'd been set up by an American senator (!) in a treaty signed with a negotiator from Vietnam. I'm still not sure I fully understand

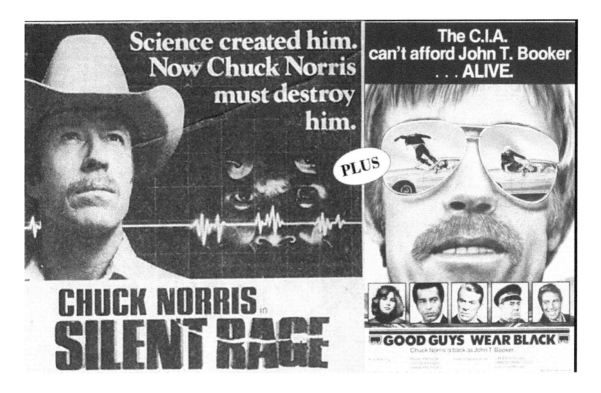

exactly WHY an American senator sold out his own men, but suffice it to say Booker and 5 other members of his 10 man team make it back to America.

GGWB then flashes forward to the present (which would be 1982), and Booker is now living in L.A., making a living as a professor at UCLA and spending his free time at the track racing cars. In retrospect I'm surprised this film hasn't become some kind of NASCAR cult classic, especially when we see Booker also owns a slick black Porsche.

A reporter named Margaret (the lovely Anne Archer) comes into his life, and informs him members of the Black Tigers are being killed all these years later. Booker continually questions how she knows so much, and the audience believes she is either the one killing them or in league with the killer(s). Either way, it doesn't stop Booker from doing a little under-the-sheets kung fu and eventually falling head over heels for her, although she ends up being a casualty of the Black Tiger assassination scheme.

The Amboy Twin was kind of quiet for GGWB, as the action scenes are well spread apart. I found it funny that Booker, each time he went to tell a member

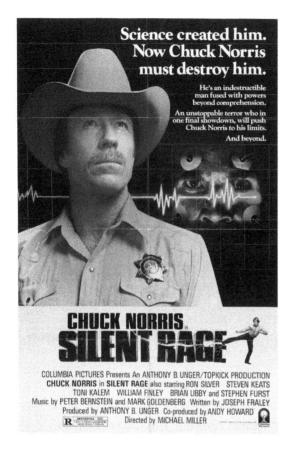

Science created him.
Now Chuck Norris
must destroy him.

He's an indestructible
man fused with powers
beyond comprehension.

An unstoppable terror who in
one final showdown, will push
Chuck Norris to his limits.

And beyond.

CHUCK NORRIS in
SILENT RAGE

COLUMBIA PICTURES Presents An ANTHONY B. UNGER/TOPKICK PRODUCTION
CHUCK NORRIS in SILENT RAGE also starring RON SILVER STEVEN KEATS
TONI KALEM WILLIAM FINLEY BRIAN LIBBY and STEPHEN FURST
Music by PETER BERNSTEIN and MARK GOLDENBERG Written by JOSEPH FRALEY
Produced by ANTHONY B. UNGER Co-produced by ANDY HOWARD
R RESTRICTED Directed by MICHAEL MILLER

of his old squad what was going on, just happened to be there the moment said member is shot in the chest from an unseen assailant. One sequence finds Booker warning one of his guys at a ski slope, and the second his buddy tells him he'll meet him at the bottom of the mountain, he does a small ramp jump and is shot in midair! The gunman runs off and jumps on a motorcycle, but Booker employs his karate skills to take the sucker out.

When we finally get to the kung fu kick-through-the-windshield scene I had been dying to see for 5 years, I enjoyed it but thought it all ended a bit too quickly. While I enjoyed the film well enough, you'd think there'd be a lot more action in light of the fun trailer. The opening scenes in Vietnam are very darkly shot, and upon my recent viewing I barely saw a thing that was going on. It's even darker than I remember it looking on the big screen.

My two friends didn't care for the film, but I liked it well enough (I thought it was a bit intense how Margaret is killed for a PG-rated film: she gets on a plane the Black Tiger assassin thought Booker was on, and as Booker watches the plane fly off, it explodes into a semi-believable looking fireball (hey, this was before CGI, folks)). The finale features Booker taking out the man responsible for killing his squad by driving him off a pier after he disguises himself as a limo driver! Kind of anti-climatic, and we all knew that was Chuck under that hat and sunglasses.

Weirdest of all, Booker appears in a black shirt early in the film, before his love making scene with Margaret. For most of the film, he wears a very uncomfortable looking white turtle neck under a too-tight brown corduroy

outfit. I'll assume the producers realized GOOD GUYS WEAR TURTLE NECKS just didn't sound as cool…

I was happy to have finally seen GGWB, and was hoping the pace of SILENT RAGE would be better.

I guess being a horror fan, it was only natural I enjoyed RAGE much more than the opening feature. And for whatever reason, the crowd came alive, right from the opening scene of our killer murdering two people with an axe! Norris shows up as Sheriff Dan Stevens and helps take down the killer who we quickly find out is mentally ill. Whenever I write these columns, I notice almost any film with an axe murder usually drew cheers from the crowd. Go figure. And it's safe to say Chuck enjoyed playing a law official as he returned as Walker, Texas Ranger in the 1993 TV series.

But back to the madness: the crowd laughed when we discovered killer John Kirby (played by Brian Libby, who had been in Norris' 1980 hit THE OCTAGON and then went on to much bigger roles) had been brought to an institution and handed over to doctors who were working on genetic experiments. Silly, silly stuff, but as mentioned earlier, this makes Kirby go on a more berserk killing spree, the highlight of which finds one of the doctors trying to kill Kirby by injecting him with acid! Of course Kirby takes the syringe and uses it against the doctor.

In the final battle between Kirby and Sheriff Stevens, Stevens delivers some serious kicks to the psycho's noggin, eventually causing him to fall down a well. Stevens and love interest Alison leave, sure John has been killed, but remember folks … this here is a horror film-inspired action flick. Needless to say, the final shot is of John splashing up from the bottom of the well.

While I enjoyed this blast of genre-mashing, I'm glad there wasn't a sequel.

A buddy of mine had yelled (during the first scene of John returning to the institute when we thought he had been killed), "What, did they turn him into Wolverine?" which caused me and my other buddy to laugh, but the people in front of us to turn around and give puzzled looks. "He's like a character in the X-Men comics," my buddy said to one older guy, who in return said, "Who gives a s___?"

That's New York for you folks.

And that was my first time experiencing Chuck Norris on the big screen. A 5-year wait fulfilled and a fun time at an action/horror hybrid.

I truly miss double features…

Appendix

S ince I've spent 99 percent of this book talking about the experiences I've had at my local theaters, I figured I'd take this time to reveal the top 10 grindhouse films (that I've seen either on TV or video) that I WISH I could've seen at a seedy theater or drive-in upon their *initial* release. While I enjoyed the following films for a variety of reasons, I'm sure each one of them would've been enhanced, surrounded by wise-cracking theater patrons during a scratchy, poorly-focused screening. Of course, I wouldn't have even been *old enough* to see most of these films upon their initial release, but work with me here folks ...

10 I think I was about 10-years-old the first time I saw DON'T LOOK IN THE BASEMENT (1973) on late night television. After a surprising opening, the film drags for a good fifteen minutes, then slowly builds to a finale that (at the time) was quite intense. The director's son claims to be directing a long-awaited sequel for release in 2015.

UPDATE: The sequel is out but as of this book I still haven't seen it.

9 SHRIEK OF THE MUTILATED is an extremely low budget 1974 Yeti thriller that goes in a direction few first-time viewers will see coming. I saw this on TV around 1979 and couldn't get enough. I'd love to have

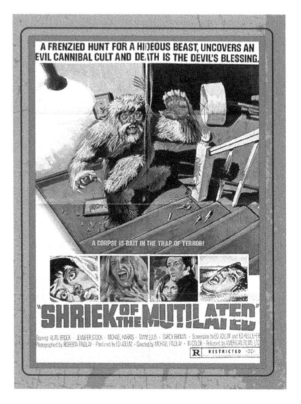

seen an audience's reaction to the twist ending.

UPDATE: I caught a 35mm screening in 2017 at the Nitehawk Cinema in Brooklyn as part of their "Deuce" series. It was marvelous.

8 Released in the summer of 1972, it must've been great to have been at a rural drive-in when NIGHT OF THE LEPUS first screened. This incredibly goofy film about giant rabbits attacking Janet Leigh, Rory Calhoun, and STAR TREK's DeForest Kelly must be seen to be believed, and must've had the crowds in stitches. What makes it so good is how serious the filmmakers took the whole thing...

7 Every cult film fan has a favorite Russ Meyer film. Mine is SUPERVIXEN (1975), which is basically a sexy

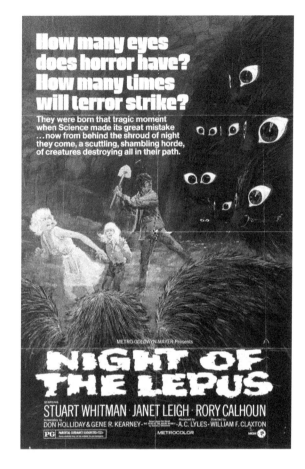

road trip chase film with a little MANIAC COP thrown in. But what blew me away was the dazzling editing during an early sequence split between a gas station and an apartment: every film maker should watch this at least once. There's a good chance you'll get dizzy trying to keep up with all the angles and shots. It's also genuinely hysterical.

6 There must've been something seriously dangerous in the air during the early 70s. Case in point is 1972's BLOOD FREAK, about a dope-smoking guy who eats turkey from an experimental turkey farm and is turned into a turkey-headed monster who needs the blood of other drug addicts to survive. Oh ... and it also has a pro-Jesus message and stars Steve Hawkes, who had starred in a few Spanish TARZAN films (got all that?). I can't even begin to think what theater

The People's Army Has
DECLARED WAR!

The Black Gestapo

Bryanston Presents "THE BLACK GESTAPO" starring ROD PERRY and CHARLES P. ROBINSON
Screenplay by LEE FROST and WES BISHOP • story by RONALD K. GOLDMAN and WES BISHOP
Executive Producer RONALD K. GOLDMAN • Produced by WES BISHOP • Directed by LEE FROST
R RESTRICTED • Color by DELUXE • A Bryanston Release

"BLACK GESTAPO"

goers must've thought of this, but thanks to the lunatics at Something Weird Video, adventurous cinephiles can obtain a deluxe DVD edition loaded with extras. I've watched it too many times to admit...

5 In the late 90s I found a used VHS copy of 1975's THE BLACK GESTAPO, a film I had never heard of despite being a life-long fan of blaxploitation cinema. But unlike other films in this subgenre, THE BLACK GESTAPO was just downright nasty and mean-spirited throughout its entire running time: tired of their women being raped by white guys, a group of black men get together and start taking their streets back. There's plenty of action, classic dialogue, and violence (including a bathtub castration sequence that pre-dates I SPIT ON YOUR GRAVE by four years) to keep any trash-film fan's interest. I'd hate to have been the only white guy at a screening of this, but then again it could've been a real blast!

4 While the idea behind THE CORPSE GRINDERS (1971) sounds better on paper than it translated to film, this early offering from director Ted V. Mikels is a real piece of cinematic insanity: a floundering pet food company—in an attempt to save money—dig up corpses and grinds them into cat food. In turn, cats start going crazy and attack their owners. A couple of moronic cops are on the case. The corpse-grinding machine was made out of a refrigerator box and looks beyond cheesy, yet somehow certain scenes in the graveyard have fantastic atmosphere. The cat attacks are unconvincing, the acting is horrendous, and I would've given anything to have seen this with a group of like-minded film freaks...

SATAN'S CHEERLEADERS

3 Since my initial Saturday afternoon TV viewing of SATAN'S CHEERLEADERS (1975), I've been hooked: a Satanist (who is also a janitor at a local high school) kidnaps four cheerleaders who get lost on a road trip. He's looking to sacrifice them in a ritual, but is killed by the Devil when he tries to rape one of them. A shady couple (the wife played by Yvonne DeCarlo of THE MUNSTERS fame) then attempt to finish the janitor's job, only to discover one of the cheerleaders is actually a closet witch. In many ways this is the ULTIMATE 70s exploitation film: backwoods Satanists, cheerleaders (played by four of the best looking actresses ever to grace a low budget feature), plenty of hokey acting and effects, all adding up to a true guilty pleasure. This slice of 70s sinema ends with the cheerleaders using their newfound powers to help their football team win! When I finally found a VHS copy of this sometime in the early 80s, I was surprised to see such a low nudity level (something most grindhouse films rely on), but the sheer nuttiness of this offering from director Greydon (BLACK SHAMPOO) Clark works well, despite its lack of skin.

2 When my family purchased our first VCR in 1983, I immediately ran to our local video store and rented 1963's BLOOD FEAST, a film I had been reading

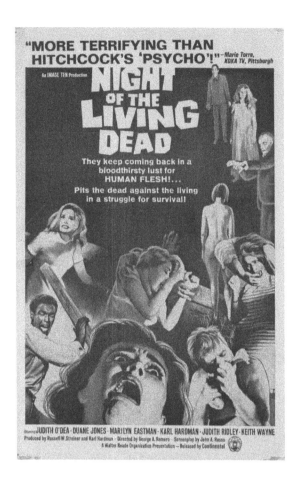

about in FANGORIA magazine since their fourth issue. In the middle of watching it, my dad came home from work and freaked out. He had seen this at a theater in Georgia a few weeks before he went to Korea with the army. He told me people—some, soldiers—actually passed out during a few of the gore scenes and most of the theater was empty by the time it ended. NO ONE had seen anything like this at that time, and it was amazing to have first-hand proof that the accounts I had read in FANGORIA were true. I can't even imagine what it must've been like to be in a theater when something so different and ground-breaking was unleashed for the first time. And being my old man was there, perhaps my love for this stuff was somehow passed through him to me?

1 Despite the ground-breaking nature of BLOOD FEAST, I thought long and hard about what the A-#1 grindhouse film I wish I could've seen in a theater should be. It might seem a bit typical, but I can think of no better film than NIGHT OF THE LIVING DEAD (1968). I remember reading an article from film critic Roger Ebert where he recalled his first viewing: a young child sat next to him, hiding his eyes and shaking in total terror, causing Ebert to write, "What kind of a parent drops their kid off at something called NIGHT OF THE LIVING DEAD?" I first saw it on late night TV when I was about 7-years-old, and it's the main film responsible for my love of the horror genre. George Romero's low-budget classic reinvented the zombie film, and, from all accounts that I've read, was one of the scariest experiences since 1960's PSYCHO for many theater goers. What more could any fan of grindhouse cinema ask for?

Acknowledgments

ndless thanks to David and everyone at Headpress for giving my debut film book such a beautiful home, Chris Poggiali for the newspaper ads and other info, David "Ghosty" Wills for the wonderful interview with Lydia Cornell, and to Carmine Capobianco, Frank Hennenlotter, Peaches Christ and Elijah Drenner for not only taking the time to speak with me but for keeping the spirit of exploitation cinema alive and well.

Huge thanks to L.L. Soares and Michael Arruda for taking my column on the Cinema Knife Fight website almost 10 years ago, and for L.L.'s fine introduction. This book probably wouldn't exist if not for them. Props to my trash film guru William Carl and everyone I've shared film panels with at various conventions. Thanks also to authors John Szpunar, Michael Marano and Shade Rupe for their great early reviews.

To my buds who accompanied me to most of the early films discussed here: Richard LaForgia, William Mulvey, Chris Iannace, Kenny DeGrasse, Robert Ippolito, Alex Armitage, John Lisa and Billy Jerome Hamill. They put up with some real cinematic turkeys, usually against their will. To my current theater-going crew: Chris Aiello, Matt Schwartz, and Frank Mirra. May midnight movies and retro screenings never die.

Finally, to all the theaters way back when who admitted this underaged, pimple-faced freak into R and unrated films: I LOVE YOU.

LASTLY: to my dad, Nick, for seeing BLOOD FEAST in 1963 while in basic training with the Army in Georgia right before leaving for Korea. I'm convinced this event hereditarily caused my love of trash cinema.

Lightning Source UK Ltd.
Milton Keynes UK
UKHW030644140521
383709UK00004B/46